Eighteenth-Century Prints
in Colonial America

Eighteenth-Century Prints in Colonial America

TO EDUCATE AND DECORATE

Edited by Joan D. Dolmetsch

Published by
THE COLONIAL WILLIAMSBURG FOUNDATION
Williamsburg, Virginia

Distributed by
The University Press of Virginia
Charlottesville, Virginia

Printed in the United States of America
Library of Congress Cataloging in Publication Data

Eighteenth-century prints in Colonial America.
Papers were originally presented at a symposium in
Williamsburg, Va., Mar. 1974.
Includes index.
1. Prints—18th century—United States—Addresses,
essays, lectures. 2. Prints, American—Addresses,
essays, lectures. 3. Prints—18th century—Addresses,
essays lectures. 4. United States in art—Addresses,
essays, lectures. I. Dolmetsch, Joan D. II. Colonial
Williamsburg Foundation.
NE506.E36 1979 769'.903'3074014 78-25921
ISBN 0-87935-049-0

Contents

	Page
Authors	vi
Illustrations	vii
Foreword	xvii
Graham Hood	
The Role of the British Eighteenth-Century Print at Williamsburg: Introductory Remarks	I
Graham Hood	
London's Images of Colonial America	I I
Sinclair Hitchings	
Views of Port Cities as Depicted by Vernet and Other Eighteenth-Century Artists	32
Harold W. Sniffen	
American Almanac Illustration in the Eighteenth Century	51
Georgia B. Bumgardner	
Embellishments for Practical Repositories: Eighteenth-Century American Magazine Illustration	71
Peter J. Parker and Stefanie Munsing Winkelbauer	
Bickham's *Musical Entertainer* and Other Curiosities	98
Nancy R. Davison	
The Portrait Engravings of Charles Willson Peale	123
Wendy J. Shadwell	
The Prodigal Son in England and America: A Century of Change	145
Edwin Wolf 2nd	
Political Satires at Colonial Williamsburg	175
Joan D. Dolmetsch	
Index	197

Authors

SINCLAIR HITCHINGS is the keeper of prints, Boston Public Library, Boston.

HAROLD W. SNIFFEN is the curator emeritus, Mariners Museum, Newport News.

MRS. GEORGIA B. BUMGARDNER is the Andrew W. Mellon curator of graphic art, American Antiquarian Society, Worcester.

PETER J. PARKER is the curator of manuscripts, Historical Society of Pennsylvania, Philadelphia.

STEFANIE MUNSING WINKELBAUER is the former curator of historical prints, Print and Photography Division, Library of Congress, Washington, D. C.

MRS. NANCY R. DAVISON is a doctoral candidate in American culture, University of Michigan, and an artist-printmaker, Pittsburgh.

WENDY J. SHADWELL is the curator of prints, New-York Historical Society, New York.

EDWIN WOLF 2nd is the librarian, Library Company of Philadelphia, Philadelphia.

MRS. JOAN D. DOLMETSCH is the curator of prints and maps, Colonial Williamsburg Foundation, Williamsburg.

Illustrations

Unless otherwise noted, dates in the following entries are the dates when the prints were published.

Page

1. *Razor's Levee, or ye Heads of a new Wig Ad---------n* [Administration] *on a broad Bottom.* Line engraving by J. S. F.; published in London, April 21, 1783, by Thomas Cornell. Colonial Williamsburg Foundation. 3

2. *BILLIARDS.* Stipple engraving designed by H. Bunbury, engraved by Watson and Dickinson; published in London, November 15, 1780, by Watson and Dickinson. Colonial Williamsburg Foundation 3

3. [Slowtime.] Etching by an unidentified maker; published in London about 1765. Colonial Williamsburg Foundation. 4

4. *Marriage A-la-Mode*, Plate II. Line engraving invented, painted, and published by William Hogarth, engraved by B. Baron; published in London, April 1, 1745. Colonial Williamsburg Foundation. 6

5. *Marriage A-la-Mode*, Plate V. Line engraving invented, painted, and published by William Hogarth, engraved by R. F. Ravenet; published in London, April 1, 1745. Colonial Williamsburg Foundation. 8

6. *Marriage A-la-Mode*, Plate VI. Line engraving invented, painted, and published by William Hogarth, engraved by G. Scotin; published in London, April 1, 1745. Colonial Williamsburg Foundation. 9

7. [The Bodleian Plate.] Engraved copperplate by an unknown maker; plate and date of making unknown, but presumed to be London about 1740. Colonial Williamsburg Foundation. 16

8. [Charles Town, detail.] Watercolor by B. Roberts; drawn about 1739. Colonial Williamsburg Foundation. 17

9. *A MAP of the most INHABITED part of NEW ENGLAND.* Detail depicting the "Konektikut" colony with an inset view of the "Plan of Boston Harbor." Presumed to have been made by Bradock Mead, alias John Green; published in

Page

London, November 1755, by Thomas Jefferys. Colonial Williamsburg Foundation. 19

10. A typical mid-eighteenth-century vue optique box with prints similar to those documented in colonial America. Colonial Williamsburg Foundation. 20

11. *The Parrot of Paradise* and *Red Wood*. Line engraving by Mark Catesby; published in London between 1731 and 1743. Colonial Williamsburg Foundation. 22

12. *A View in Hudson's River of Pakepsey & the Catts-Kill Mountains*. Line engraving, "Sketch'd on the SPOT by his Excellency Governor Pownal," painted and engraved by Paul Sandby; published in London, 1760–1765, by John Bowles, Robert Sayer, Thomas Jefferys, Carington Bowles, and Henry Parker. Colonial Williamsburg Foundation. 22

13. *A South West View of the City of New York, in NORTH AMERICA*. Line engraving, "Drawn on the SPOT by Capt. Thomas Howdell," engraved by P. Canot; published in London, 1760–1770, by John Bowles, Robert Sayer, Thomas Jefferys, Carington Bowles, and Henry Parker. Colonial Williamsburg Foundation. 23

14. *A PLAN of the CITY of NEW-YORK & its Environs*. Made by John Montresor; published in London, 1766 (second issue, 1775, shown), by A. Dury. Colonial Williamsburg Foundation. 26

15. *CHARLES LEE, Esqr.* Mezzotint engraving designed by Thomlinson, engraver unknown; published in London, October 31, 1775, by C. Shepherd. Colonial Williamsburg Foundation. 27

16. *GEORGE WASHINGTON, Esqr.* Mezzotint engraving "Done from an Original, Drawn from the Life by Alexr. Campbell, of Williamsburgh in Virginia"; published in London, September 9, 1775, by C. Shepherd. Colonial Williamsburg Foundation. 27

17. *BUNKERS HILL or America's Head Dress*. Etching attributed to M. Darly; published in London about 1776–1777. Colonial Williamsburg Foundation. 28

18. *THE LOSS of EDEN,!—AND EDEN,! LOST*. Etching attributed to Thomas Rowlandson; published in London, December 21, 1785, by W. Hinton. Colonial Williamsburg Foundation. 30

19. *Colossea statua Rhodi* (Statue of the Colossus at Rhodes). Line engraving by Georg Balthasar Probst; published in Augsburg about 1760. Mariners Museum. 34

20. *A View of CHARLES TOWN the Capital of South*

Carolina in North America. Line engraving by C. Canot from an original painting by T. Mellish; published in London about 1765 by John Bowles, Robert Sayer, Thomas Jefferys, and Carington Bowles. Mariners Museum. 35

21. *Vue du Port de Marseille* (detail). Etching by Charles Nicolas Cochin and Jacques Philippe Le Bas from an original painting by Claude Joseph Vernet; published in France in 1762. Mariners Museum. 38

22. *Le Port de Marseille* (detail). Etching by Charles Nicolas Cochin and Jacques Philippe Le Bas from an original painting by Claude Joseph Vernet; published in France in 1762. Mariners Museum. 39

23. *Vue de la rade d'Antibes* (detail). Etching by Charles Nicolas Cochin and Jacques Philippe Le Bas from an original painting by Claude Joseph Vernet; published in France in 1762. Mariners Museum. 40

24. *La Madrague, Golfe de Bandol* (detail). Etching by Charles Nicolas Cochin and Jacques Philippe Le Bas from an original painting by Claude Joseph Vernet; published in France in 1762. Mariners Museum. 41

25. *Le Port neuf, ou l'Arsenal de Toulon*. Etching by Charles Nicolas Cochin and Jacques Philippe Le Bas from an original painting by Claude Joseph Vernet; published in France in 1760. Mariners Museum. 42

26. *Le Port vieux de Toulon*. Etching by Charles Nicolas Cochin and Jacques Philippe Le Bas from an original painting by Claude Joseph Vernet; published in France about 1762. Mariners Museum. 44

27. *Vue du Port de Cette* (detail). Etching by Charles Nicolas Cochin and Jacques Philippe Le Bas from an original painting by Claude Joseph Vernet; published in France about 1762. Mariners Museum. 45

28. *Vue de la Ville et du Port de Bayonne* (detail). Etching by Charles Nicolas Cochin and Jacques Philippe Le Bas from an original painting by Claude Joseph Vernet; published in France about 1762. Mariners Museum.

29. *Vue de la Ville et du Port de Bayonne* (detail). Etching by Charles Nicolas Cochin and Jacques Philippe Le Bas from an original painting by Claude Joseph Vernet; published in France about 1762. Mariners Museum. 48

30. *Le Port de la Rochelle*. Etching by Charles Nicolas Cochin and Jacques Philippe Le Bas from an original painting by Claude Joseph Vernet; published in France about 1762. Mariners Museum. 49

31. Diagram of an eclipse from John Foster's almanac
for 1675. American Antiquarian Society. 55
32. Diagram of an eclipse from Saunders's almanac for
1693. American Antiquarian Society. 55
33. *The ANATOMY. Names and Characters of the 12
Sig*[ns] (Man of Signs) from *Poor Robin's Almanack* for
1762. American Antiquarian Society. 55
34. *Poor Richard improved.* Title page from the al-
manac for 1749, listing contents, by Richard Saunders. Pub-
lished in Philadelphia and sold by B. Franklin and D. Hale.
American Antiquarian Society. 57
35. *GULILLMUS LILLIUS* (William Lilly, astrologer).
Line engraving by William Marshall, first published May 1,
1602; this is the frontispiece of Lilly's *Merlini Anglici Ephe-
meris,* 1647. American Antiquarian Society. 59
36. *The Ladies Diary: or, the Woman's ALMANACK,*
frontispiece for 1726. Printed in London by A. Wilde. Ameri-
can Antiquarian Society. 59
37. *J--N D--K-NS-N, Esq.* (John Dickinson). Woodcut by
unidentified maker for the *Ames Almanack* for 1772. Ameri-
can Antiquarian Society. 61
38. *JOHN WILKES, Esq.* Line engraving by unidenti-
fied maker for *Bickerstaff's Boston Almanack* for 1769.
Printed in Boston by Mein and Fleeming. American Anti-
quarian Society. 61
39. *The wicked Statesman, or the Traitor to his Coun-
try, at the Hour of Deat*[h], frontispiece. Line engraving at-
tributed to Paul Revere from the *Massachusetts CALENDAR;
or an ALMANACK* for 1774 by Ezra Gleason. Printed in Bos-
ton by Isaiah Thomas. American Antiquarian Society. 63
40. *CORNWALLIS turned NURSE, and his MISTRESS
a SOLDIER.* Woodcut by an unidentified maker for the *Con-
tinental Almanack* for 1782. American Antiquarian Society. 63
41. *The Hieroglyphic.* Line engraving by an unidenti-
fied maker for *Francis Moore's Almanack* for 1756. 64
42. *The Wonderful MAN FISH.* Woodcut by an uniden-
tified maker for *Bickerstaff's Almanack* for 1772. American
Antiquarian Society. 67
43. Heads of New Zealand chiefs and New Zealand
war canoe. Line engravings by Joseph Callender for *Bicker-
staff's Boston Almanack* for 1774. Printed in Boston by Mills
and Hicks. American Antiquarian Society. 68
44. *THE PENNSYLVANIA MAGAZINE: OR, AMERI-
CAN MONTHLY MUSEUM.* Title page; MDCCLXXV (1775),

Page

Vol. I. Drawn by Pierre Eugène du Simitière and engraved by Robert Aitken; published in Philadelphia by R. Aitken. The photograph for this and the following illustrations through No. 56 were taken by the authors from publications located in various libraries in Philadelphia. 79

45. *Sir Wilbraham Wentworth*. Line engraving by Paul Revere; published in Boston in the *Royal American Magazine*, February 1774. 81

46. *DAMON, and MUSIDORA*. Etching by Samuel Hill; published in the *Massachusetts Magazine*, August 1792. 82

47. [A New invented Machine for the Spinning of Wool or Cotton.] Etching by Christopher Tully; published in the *Pennsylvania Magazine*, April 1775. 83

48. *Amelia: or the faithless Briton*. Line engraving by James Trenchard; published in the *Columbian Magazine*, October 1787. 85

49. *Love in a Village, or The Charms of Simplicity*. Line engraving by an unidentified maker; published in the *Westminster Magazine*, August 1793. 85

50. *View of the SEAT of his Excellency JOHN HANCOCK, Esqr. BOSTON*. Etching by Samuel Hill; published in the *Massachusetts Magazine*, I (July 1789). 87

51. *GREEN HILL. The Seat of Samuel Meredith Esqr. near Philadelphia*. Etching by Samuel Hill after a design by Jonathan Hoffman; published in the *Massachusetts Magazine*, IV (October 1792). 87

52A. *The Buffallo*. Line engraving by an unidentified maker; published in the *Massachusetts Magazine*, IV (May 1792). 88

52B. *MOOSE DEER*. Etching by an unidentified maker; published in the *Universal Magazine*, February 1786. 88

53. *PERSPECTIVE VIEW of the FEDERAL EDIFICE in the CITY of New York*. Line engraving by [Cornelius Tiebout]; published in the *New York Magazine*, March 1790. 90

54. *The Honble. JOHN HANCOCK. Esqr.* Line engraving by Paul Revere; published in the *Royal American Magazine*, I (March 1774). 91

55. *View of the CASCADE, of Velika Gubaviza*. Line engraving by an unidentified maker; published in the *Gentleman's Magazine*, January 1778. 92

56. *Veiw of a pass over the South Mountain from York Town to Carlisle*. Line engraving by Thomas Bedwell; published in the *Columbian Magazine*, 1788. 93

57. *The Universal Penman*, frontispiece. Line engrav-

Page

ing by Hubert Gravelot; published in London; sold by H.
Overton in 1741. Courtesy, Dover Publications, Inc. 101

58. *The Honest Merchant; or, Thorowgood to Trueman.*
No. XXX, pl. 121, of *The Universal Penman.* Line engraving
by G. B. [George Bickham], script by Bland. Courtesy, Dover
Publications, Inc. 103

59. *Industry.* Pl. 35 of *The Universal Penman.* Line en-
graving by G. Bickham, script by W. Clark. Courtesy, Dover
Publications, Inc. 103

60. *Commerce.* No. III, pl. 115, of *The Universal Pen-
man.* Published in single sheets by Bickham. Line engraving
by G. Bickham, script by Josephus Champion. Colonial Wil-
liamsburg Foundation. 104

61. *The Musical Entertainer.* Title page of Vol. I. Line
engraving by George Bickham, Jr.; published in London by
George Bickham, 1737–1739. Colonial Williamsburg Foun-
dation. 109

62. *The Return from the Chace.* Pl. 7 of *The Musical
Entertainer.* Line engraving by George Bickham, Jr. Colonial
Williamsburg Foundation. 110

63. *RURAL BEAUTY, or VAUX-HAL GARDEN.* No. VI,
pl. 21, of *The Musical Entertainer.* Line engraving by George
Bickham. Colonial Williamsburg Foundation. 113

64. *BRITANNIA.* Frontispiece of *The British Monar-
chy.* Line engraving by George Bickham, Jr., from a design
by Hubert Gravelot; published in London, October 2, 1747.
Colonial Williamsburg Foundation. 116

65. *A Short Description Of the American Colonies.* Sec-
tional title page of *The British Monarchy,* pl. 164. Line en-
graving by George Bickham, Sr.; published in London, De-
cember 19, 1747. Colonial Williamsburg Foundation. 118

66. *The American Colonies.* Pl. 165 of *The British
Monarchy.* Line engraving by an unidentified maker (pre-
sumed to be one of the Bickhams). Colonial Williamsburg
Foundation. 118

67. *Conclusion of the AMERICAN COLONIES.* Pl. 184
of *The British Monarchy.* Line engraving by an unidentified
maker (presumed to be one of the Bickhams). Colonial Wil-
liamsburg Foundation. 120

68. *Charles Willson Peale.* Oil on canvas by Benjamin
West; painted in London about 1768. The New-York His-
torical Society. 124

69. *The Peale Family.* Oil on canvas by Charles Willson

Page

Peale; painted in America between 1770 and 1808. The New-York Historical Society. 126

70. *Worthy of Liberty, Mr. Pitt scorns to invade the Liberties of other People.* Mezzotint engraving by Charles Willson Peale, state II, 1768. Colonial Williamsburg Foundation. 127

71. *HIS EXCELLENCY GEORGE WASHINGTON ESQR.* Mezzotint engraving attributed to Joseph Hiller, Sr., ca. 1776. Kennedy Galleries. 129

72. *His Excellency GEORGE WASHINGTON Esquire, Commander in Chief of the Federal Army.* Mezzotint engraving by Charles Willson Peale, state I, 1780. The Metropolitan Museum of Art, bequest of Charles Allen Munn. 131

73. [George Washington.] Oil on canvas by Charles Willson Peale; painted in America in 1780. Colonial Williamsburg Foundation. 132

74. *HIS EXCELLENCY B. FRANKLIN L.L.D. F.R.S. PRESIDENT OF PENNSYLVANIA* . . . Mezzotint engraving by Charles Willson Peale, 1787. Kennedy Galleries. 135

75. *The MARQUIS DE LA FAYETTE* . . . Mezzotint engraving by Charles Willson Peale, 1787. Kennedy Galleries. 135

76. [The Reverend Joseph Pilmore.] Mezzotint engraving by Charles Willson Peale, proof before letters, 1787. The Metropolitan Museum of Art. 136

77. *THE REVEREND JOSEPH PILMORE* . . . Mezzotint engraving by Charles Willson Peale, 1787. The Henry Francis du Pont Winterthur Museum. 136

78. [The Reverend Joseph Pilmore.] Mezzotint engraving by Charles Willson Peale, 1787, restrike. The New-York Historical Society. 137

79. [The Reverend Joseph Pilmore.] Mezzotint engraving by Charles Willson Peale, 1787, restrike. The Metropolitan Museum of Art. 137

80. *HIS EXCEL: G: WASHINGTON Esq:* . . . Mezzotint engraving by Charles Willson Peale, 1787, state II (black ink). The Henry Francis du Pont Winterthur Museum. 139

81. *Takes Leave of his Father.* Plate from The Prodigal Son series; copperplate signed W. P., possibly William Priest, ca. 1795. Library Company of Philadelphia. 147

82. *Returns home a Penit*[ent]. Plate from The Prodigal Son series; line engraving probably related to No. 81. Library Company of Philadelphia. 147

83. *The Prodigal Son (He receives his Patrimony).* Line engraving by W. P., printed in Philadelphia by J.

Brown, 1795. Related to Nos. 81 and 82. Library Company
of Philadelphia. 148

84. THE PRODIGAL SON RECEIVES HIS PATRI-
MONY. Mezzotint engraving by R. Purcell after a design by 153
Le Clerc; published in London by Robert Sayer about 1755.
Colonial Williamsburg Foundation.

85. The PRODIGAL SON TAKING LEAVE. Mezzotint
engraving by an unidentified maker; published in London by
Carington Bowles, January 2, 1775. Library Company of
Philadelphia. 155

86. THE PARABLE of the PRODIGAL SON. One sheet
of six scenes. Line engraving by an unidentified maker; pub-
lished in London by Carington Bowles, 1775. Collection of
W. S. Lewis. 157

87. THE PRODIGAL SON TAKING LEAVE. Mezzotint
engraving by an unidentified maker; published in London
by Carington Bowles, August 1, 1792. Library Company of
Philadelphia. 158

88. THE PRODIGAL SON revelling with Harlots. Mez-
zotint engraving by an unidentified maker; published in Lon-
don by Laurie and Whittle, May 12, 1794. The Historical So-
ciety of Pennsylvania. 160

89. THE PRODIGAL SON in Misery. Mezzotint en-
graving by an unidentified maker; published in London
by Laurie and Whittle, May 12, 1794. Library Company of
Philadelphia. 161

90. The PRODIGAL SON receives his PATRIMONY.
Line engraving by an unidentified maker; published in Lon-
don by M. Denton, January 10, 1795. Library Company of
Philadelphia. 163

91. The PRODICAL SON receives his PATRIMO[N]Y.
Line engraving by an unidentified maker; published in Lon-
don by Paul Barnaschina in 1799. The Old Print Shop. 164

92. The PRODIGAL SON taking leave of his FATHER.
Etching by an unidentified maker; published in America
about 1805–1815. Library Company of Philadelphia. 165

93. The PRODIGAL SON returned to HIS FATHER.
Etching by Amos Doolittle; published in Cheshire, Con-
necticut, December 1, 1814. The Historical Society of
Pennsylvania. 166

94. THE PRODIGAL SON RECEIVING HIS PATRI-
MONY. Lithograph by Nathaniel Currier; published in New
York by Currier about 1840. Library of Congress. 169

95. THE EUROPEAN STATE JOCKIES Running a
Heat for the BALLANCE OF POWER. Line engraving by an

unidentified maker; published in London, March 25, 1740. Colonial Williamsburg Foundation. 180

96. *BRITISH RESENTMENT or the FRENCH fairly COOPT at Louisbourg.* Line engraving by John June from a design by Louis Peter Boitard; published in London, September 25, 1755. Colonial Williamsburg Foundation. 181

97. *THE ASSES OF GREAT BRITAIN.* Etching by J. Jones; published in London by J. Williams about 1762. Colonial Williamsburg Foundation. 182

98. *LIBERTY TRIUMPHANT; or the Downfall of OPPRESSION.* Etching by an unidentified maker; published in London about 1774. Colonial Williamsburg Foundation. 185

99. *A New Method of MACARONY MAKING, as practised at BOSTON.* Mezzotint engraving by an unidentified maker; published in London, October 12, 1774. Colonial Williamsburg Foundation. 186

100. *A SOCIETY of PATRIOTIC LADIES, at EDENTON, in NORTH CAROLINA.* Mezzotint engraving attributed to Philip Dawe; published in London, March 25, 1775. Colonial Williamsburg Foundation. 188

101. *The Political Cartoon, for the Year 1775.* Line engraving by an unidentified maker; published in the *Westminster Magazine*, III (1775), p. 209. Colonial Williamsburg Foundation. 189

102. *THE COMMISSIONERS.* Etching by an unidentified maker; published in London by Matthew Darly, April 1, 1778. Colonial Williamsburg Foundation. 190

103. *A VIEW IN AMERICA IN 1778.* Etching by Mary Darly; published in London by Matthew Darly, August 1, 1778. Colonial Williamsburg Foundation. 191

104. *JOHN BULL TRIUMPHANT.* Etching attributed to James Gillray; published in London by William Humphrey, January 4, 1780. Colonial Williamsburg Foundation. 192

105. [York Town.] Line engraving by an unidentified maker; published in Holland about 1781. Colonial Williamsburg Foundation. 193

106. *BRITANIA'S ASSASSINATION.* Etching attributed to James Gillray; published in London by Elizabeth D'Archery, May 10, 1782. Colonial Williamsburg Foundation. 194

107. *The RECONCILIATION between BRITANIA and her daughter AMERICA.* Etching attributed to Thomas Colley; published in London by Colley (partially obliterated on the bottom left of the print) and then by William Humphrey about 1782. Colonial Williamsburg Foundation. 195

Foreword

PRINTS can easily persuade us, as we peruse them, that we are looking through small windows into a past that is still living, albeit largely black and white. They easily persuade us that we are looking at actual places and earlier times, at people who are real, if diminutive, convincing in their sense of physical presence, their gestures apposite, the clutter of their living authentic. In order for many prints to be successful from the start, they needed to convince potential purchasers that they were seeing themselves—or some more perfect but still attainable version of themselves—in recognizable situations, from which they might emerge with their self-esteem enhanced. Verisimilitude was at least as important an ingredient as hyperbole. Thus we acknowledge that it is prints from which we often draw the visual images for the pictures of the past that our minds' eyes are continually summoning up. It is prints that so often have supplied us with visual images that we have transformed into concrete facts in museums, restorations, and other endeavors where we have attempted to re-create some aspects of the past. For these reasons, prints of the eighteenth century have long been among Colonial Williamsburg's most useful research tools.

It was a happy conjunction, therefore, that brought together Colonial Williamsburg and the group of Print Curators for the latter's fifth annual symposium in March 1974. The topic chosen for the symposium, "English Prints of the Eighteenth Century in the American Colonies," enabled a group of scholars who had been exploring this particular aspect of print history to share the fruits of their research, and allowed Colonial Wil-

liamsburg, which had been quietly collecting such prints for almost fifty years, to share its extensive and largely unknown collections with them. Thanks to the generosity of the Trustees and President of the Colonial Williamsburg Foundation, the Print Curators were able to combine scholarship with conviviality, good food and drink being a feature of English eighteenth-century life frequently enlarged upon in prints of the period. Thanks also to the energy of Joan D. Dolmetsch, Curator of Prints and Maps for Colonial Williamsburg, the Print Curators enjoyed a special exhibition of prints from the Foundation's collections, which supplemented the large number of those to be seen in the exhibition buildings and operating taverns of Colonial Williamsburg.

If this were not fare rich enough, our good neighbor, the Mariners Museum in Newport News, invited the Print Curators to a special reception and viewing of the museum's extensive holdings of Vernet's views, following a paper on this subject by Harold Sniffen. To the director of the Mariners Museum, William D. Wilkinson, we express our gratitude.

The Print Curators are a remarkable group. Without recourse to formal structure or membership, without rules, by-laws, in-laws, or even (it seems) marriage vows, the group comes together effectively once a year, and now has a distinguished progeny of publications to prove that the unions took place. We hope this volume is worthy of its siblings.

Finally, on behalf of Colonial Williamsburg and all the Print Curators, I wish to convey a resounding vote of thanks to John and Julia Curtis of Surry, Virginia, who so generously provided the funds for the publication of this volume. If praise there be for our efforts herein, let it also redound to John and Julia.

GRAHAM HOOD
Director of Collections
The Colonial Williamsburg Foundation

The Role of the British Eighteenth-Century Print at Williamsburg: Introductory Remarks

Graham Hood

AMONG the extensive collections of Colonial Williamsburg is a superb group of British eighteenth-century prints. It is fair to say that its richness has gone unrecognized for years, but perhaps rather among scholars than the general public, for I will wager—in true British eighteenth-century style—that more prints are visible to the public here at Williamsburg at a given time than in any other museum in the world (caviar to the general!). Why they are visible is the subject of this brief introduction. That they become much better known among scholars was our ambition for the fifth annual Print Curators' Symposium and the publication of the papers that follow.

Colonial Williamsburg is widely known as the preservation and restoration of an eighteenth-century town. As there were European and American prints here two hundred years ago, so there are identical prints here today. In the front parlor of the Governor's Palace in 1770, for example, immediately following the death of the penultimate royal governor, Lord Botetourt, there were listed thirty-four scripture prints (unhappily not specified) in addition to Fry and Jefferson's Map of Virginia and both the Bowen and Mitchell maps of North America, as well as another Fry-Jefferson map in the closet. In the same year at the

Raleigh Tavern numbered among the prints were "11 old prints the Caesars." Perhaps they had been bought from the estate of John Burdett, who in 1746 at the Edinburgh Castle, only a few yards along Duke of Gloucester Street from the Raleigh, possessed "12 Roman Emperor prints." They may well have been similar, and may also have been hung in a similar fashion, to the emperors seen in Hogarth's view of the Rose Tavern, Drury Lane, in *The Rake's Progress*, plate III. (What of the unsubtle veneries that Hogarth so gleefully depicts in this print? Were they customary—or even recognizable—at the Raleigh Tavern?) There is a good deal of specific information about what prints were sold at the Printing Office on Duke of Gloucester Street, such as the extremely rare *Exact View of the Late Battle of Charlestown* of 1775 by Bernard Romans. We wish we could lay our hands on that one, to return it to the exact place it was sold almost two hundred years ago.

We use our prints, of course, for reasons rather more subtle (we trust) than simply that they happened to be here in the eighteenth century. We have hundreds of prints spread throughout many exhibition buildings in the Historic Area for purely pedagogic purposes. In the Wig Shop, for instance, we exhibit prints of eighteenth-century barber shop interiors, such as No. 1. In the Raleigh Tavern, where we have installed the type of billiards table that was in use in 1770, we hang a contemporary print that shows the game in progress, with the kind of equipment being used that we have actually reproduced for installation in the room (No. 2). In the three operating taverns in the Historic Area, King's Arms, Christiana Campbell's, and Josiah Chowning's, where the public can dine in as reasonable approximation to the colonial manner as a slender profit margin and the health and food laws of the Commonwealth of Virginia will allow, there are dozens of eighteenth-century prints of eating, drinking, and all manner of select diversions (No. 3).

That these prints can provide us with much information about the eighteenth century to complement documentary, archaeological, and other art historical evidence is, of course, well known to you all. They can flesh out our knowledge of eighteenth-century people and their milieu in fascinating ways. They

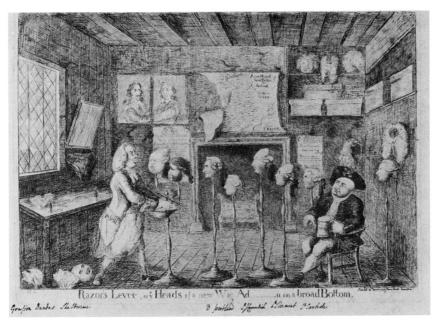

1. *Razor's Levee, or ye Heads of a new Wig Ad----------n* [Administration] *on a broad Bottom.*

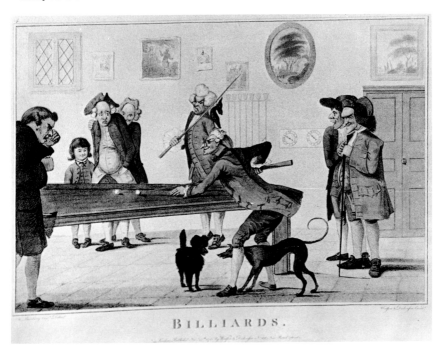

2. *BILLIARDS.*

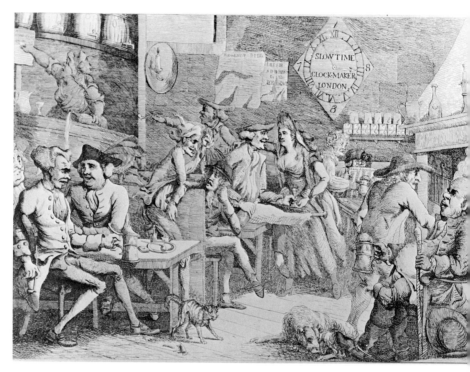

3. [Slowtime.]

can give us (who rely so heavily for our awareness of even modern life on still and moving pictures) the picture of what eighteenth-century people looked like doing what came normally to them, in environments they would never have stopped to question. In other words, prints can act as catalysts to make eighteenth-century people come alive—and not only ordinary people, but also historical personages, making them seem like us, human beings engaged in doing mundane, human, habitual things.

At Williamsburg we use old houses, gardens, streets, and vast collections of household objects to try and make particular historical personages seem immediate and real; prints have an especially important role to play here. Not only can they, being dated or datable, pinpoint style, fashion, custom, and habit, but they can also help us create settings that eighteenth-century

people would have felt thoroughly familiar in and that are, therefore, reflective of these people's beliefs, tastes, and aspirations. Quite simply put, prints guide us directly to eighteenth-century people and the ways they chose to surround themselves.

It may be simply put, but it is not simple to do; in fact, it has hardly been done at all. We have made a start at Williamsburg. I mentioned the billiards print by Bunbury at the Raleigh Tavern; not only does it show the game being played and the equipment being used, but it also illustrates the kind of room an eighteenth-century man might have expected when he wanted to play billiards in a public building. It is somewhat old-fashioned (the casement window), and unpretentious (the floor is either stone or covered with a simple patterned cloth). The way in which the prints (and perhaps a couple of modest paintings) are erratically disposed about the walls indicates a certain disregard for symmetry—an attitude apparent in virtually every print of the period, except for some very high style interiors from the third quarter of the century onward. In the corner stands an extremely plain cupboard.

The barber shop I also mentioned earlier is of a similar character—the irregularly displayed prints, the torn map and cracked plaster, the casement window with broken panes, in fact the kind of interior that if you found yourself in today would give rise to a certain trepidation for your personal safety. Notice how the looking glass is hung near the window so that you could sit at the table under the window and see yourself in it— a not uncommon practice of the time.

Of course, with such prints you have to be on your guard against that pervasive element of hyperbole. How much did the designer exaggerate to accentuate the point he wanted to make? I do not believe it is possible to generalize—I only advise caution.

I could, for these purposes, discuss hundreds of prints, but I shall focus upon three more—all from William Hogarth, with whom, I might add, the hyperbolic element was contagious. These are *Marriage A-la-Mode*, a series that we have every reason to believe was in Williamsburg by mid-century. Even in the high style interior of plate II (No. 4) the pictures in the inner room, which are of course hung very high on the wall as was the

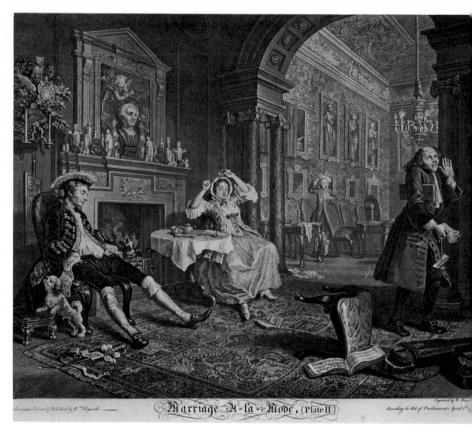

4. *Marriage A-la-Mode*, Plate II.

custom, are asymmetrically arranged—three long verticals of
saints at one end of the wall with a horizontal painting (sala-
cious enough to be covered by a curtain—again, not uncom-
mon) hung at a slightly different height. Even the looking
glasses below the paintings are not identical or exactly sym-
metrical. In this same room the semicomatose servant is en-
gaged in putting the chairs back in a line against the walls and
folding up the tables to put them against the walls also—a
custom that is rarely followed in "period rooms" today, but
which is quite provable. After all, with the clothes of the period
how else could one safely walk around in a room unless the

furniture was pushed back against the wall, which further ac-
counts for the widespread use of the chair rail at that time.
Candles are shown in the chandelier, but they are guttering
out; candles are virtually never shown in lighting implements
except when they are burning. Obviously they were not sup-
posed to be seen when not used—another contrast to accepted
practice in period rooms now. One notable exception to this
statement occurs in this print, in the vulgar sconce above the
debauched husband. It must be symbolic of the merchant's
daughter's ample means and limited taste, as the whole mantel
ensemble seems to be. Notice also the carpet in the foreground
—an uncommon feature in Hogarth, and not nearly so preva-
lent in eighteenth-century interiors as frequently supposed to-
day. Hogarth has added an amusing detail in the lower right
corner, again expressing, I believe, the imbalance between the
wife's means and sensibility—the carpet was too large for the
space and had to be cut to fit around the base of the pillars at
the right, part of it being left rolled up against the pillar.

In plate V (No. 5) the scene is the bagnio, hardly so high
style as the interior just discussed, although it obviously had
pretensions once, to judge by the tattered tapestry on the wall
showing the judgment of Solomon. The two paintings have no
relationship to each other or to the wall spaces—one hanging
high above the door, the other in blithe disregard of symmetry
high and near the window, while the looking glass is lower and
squashed next to it. Chairs, again of the back stool variety, are
once more shown lined up against the wall, this time in the
corner behind the door in the place that Hogarth occasionally
reserved for the tall case clock (see, for example, *Midnight
Modern Conversation* and *Tristram Shandy*). One baluster leg
dropleaf table and one cabriole leg table in the newer style (al-
though both are old-fashioned) are folded down, one away from
the wall and apparently having been used. As so often in Ho-
garth, a chair or stool has been knocked over to suggest capri-
cious or violent movement. For the design of its cornice and
hangings, the bed—again, Hogarth serves us well here—pro-
vides a model for the present-day installation of eighteenth-
century beds. In a room where the need for secrecy was ever-

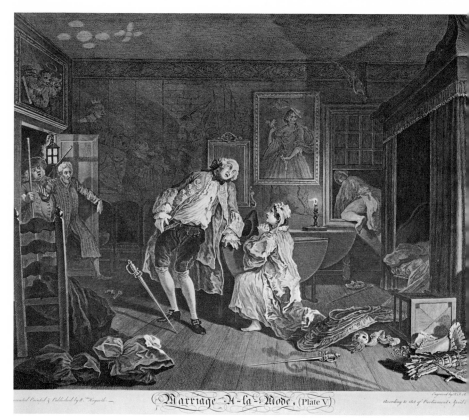

5. *Marriage A-la-Mode*, Plate V.

present, there are, surprisingly to us, no curtains on the windows; of course, there is only one candle in the room and a fire, which would give a very low level of light anyway.

In plate VI of *Marriage A-la-Mode* (No. 6) you see the rich merchant's taste expressed—a good deal worse than his daughter's. Paintings of low-life subjects are again hung high and asymmetrically on the wall; the one over the door is not centered in the space, while the other is partly covered by a smaller one of a man urinating in a corner that hangs from a single cord. That wall has been primarily devoted to utility, with the row of pegs, the almanac, and the old-fashioned clock. The

single hat on the pegs brings to mind Hogarth's great predilection for hats, whether in an enormous heap on the floor at the country dance (*Analysis of Beauty*, plate II); in a neat row hanging on the balcony inside the church (*Industrious Apprentice*, plate II); or on nails (probably) and some with wigs attached, all over the wall in *Midnight Modern Conversation*. Few interiors of this period are without the familiar three-cornered gentlemen's hats.

The overturned chair with its turkey work upholstery is as old-fashioned as the clock and the two-handled silver cup on the table—a small, round one, incidentally, which is covered

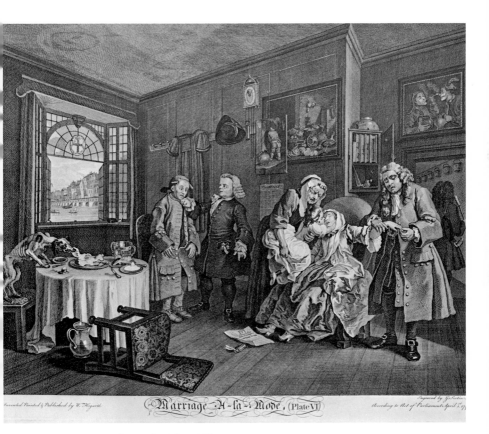

6. *Marriage A-la-Mode*, Plate VI.

with a large square cloth. The final touch of meanness in the interior is the little hanging corner cupboard, the ledgers inside turned presumably to protect the leather bindings, and a broken bowl upside down on top.

Looked at in this manner, British eighteenth-century prints form a virtually limitless resource for furnishing historic buildings, re-creating period interiors, or simply making the eighteenth century come alive. In only six illustrations we have traversed a wide range of activities and attitudes! Not only have we seen how profoundly different environments and occupations can be detailed, we have also perceived differences in social structure and subtler suggestions of personal proclivities. Eighteenth-century society was no less various than our own— probably, in fact, more so—and there is no reason to believe that people then were universally unclouded and serene; even historically important people might be misanthropic and vulgar. On the evidence of these prints we must believe that different attitudes and personalities showed in definable ways in people's surroundings. After all, people epitomize their own perceptions of themselves in the character of their belongings and the way they arrange them, as well as in the way they organize their environments. The eighteenth-century British print provides first-hand evidence of the multitude of ways in which this could be and was done.

London's Images of Colonial America

Sinclair Hitchings

In the age of Hogarth, London became one of the great graphic arts centers of the western world. Line engraving, line etching, mezzotint, stipple engraving, and, in the generations after his own, aquatint, white-line wood engraving, and lithography had many skillful practitioners. Their work included great illustrated books, especially in fields such as medicine, botany, and ornithology; a profusion of the handsomest maps and charts of any age (often distinguished for their accuracy as well, for they kept pace with revolutionary improvements in the instruments of surveying and navigation); portraiture, spilling over into areas such as the English love of theater; the engraving of city views and picturesque scenery, often with the European market in mind, and often, too, with specifications of size and color fitted for viewing through a camera obscura; popular caricature, etched or engraved and issued in such immense quantities that even that long-lived and steadily productive scholar, M. Dorothy George, could not catalogue it all; and an abundance of trade cards, bookplates, billheads, and other ephemera, which, with their borders of scrollwork and festoons of leaves and flowers, convey in miniature the classical styles of the times.

To study the emergence of professional printmakers in En-

gland's North American colonies, beginning about 1720, you need to plant one foot firmly in London, from which, after all, a number of the printmakers came—Francis Dewing, William Burgis, Peter Pelham, Lawrence Hebert, James Smither, Samuel Okey, and John Norman among them. Still other men as diverse in their objectives as James Franklin and Charles Willson Peale journeyed to London to acquire new skills and brought them back to the colonies. For those who never left their native cities, like Paul Revere, English book and magazine illustrations and single-sheet prints served as patterns and were unabashedly adapted or copied.

Hogarth, never a modest man, claimed a lion's share of credit for the flowering of printmaking in London, even though the seeds had been sown more than half a century earlier by no less a personage than Charles II. The restoration of Charles to the throne in 1660 brought a small migration of Dutch artists and craftsmen to England. They transformed English skills and capabilities in fields ranging from pottery to prints and painting.

Reminiscing about his career, Hogarth wrote that the copyright act, passed in 1735 on the strength of his one-man campaign, "Hath not only answered my own purpose, but made prints a considerable article in the commerce of this country, there being now more business of that kind done here than at Paris, or anywhere else." His own prints, he declared, "circulated not only through England but over Europe."[1]

Americans, too, bought prints by Hogarth. In the graphic arts, as in so many other fields, the American market grew quickly. "In 1772," writes Gerald Chapman, "English exports to America alone were nearly equal to the whole export trade of all England in 1704—a growth from about one twelfth to about one third of the whole, and that in the greatest trading nation in the world."[2] Prints, granted, were a tiny and insignificant ingredient of this growth of trade, but they seem very real when you begin to read accounts and inventories of well-to-do colonial American families. Some decorated their mansion houses with scores of English mezzotints and engravings. The market was there, and Joan Dolmetsch has described it for us in her articles in fascinating detail.[3]

To invoke the names of Hogarth and Gainsborough, Mortimer and Gillray, Rowlandson, Bewick, Blake, and Turner, among many Georgian artists who made prints, is to suggest the stature of London as a center of the graphic arts from the early eighteenth century through at least four generations. To grasp London's image of colonial America, however, we might invoke other names: Hermann Moll, William Mount and Thomas Page, Henry Popple, Thomas Jefferys, Henry Overton, William Faden, Henry Parker, Thomas Bowles, John Bowles, and Carington Bowles, to name a few. These men—mapmakers, map publishers, view publishers—were engaged in collecting visual information about America. They and a number of their compatriots possessed this information in abundance. They used it in prints rich in detail. They were proud of it; witness the *East Perspective View of Philadelphia* published by Carington Bowles, which contains the note, "Engraved from the Original Drawing sent over from Philadelphia, in the possession of Carington Bowles."

The major publishers of maps and views could well say, as the Whig statesman Edmund Burke wrote his Bristol constituents in 1777, "I think I know America. If I do not my ignorance is incurable, for I have spared no pains to understand it."[4] They had a wealth of knowledge and they communicated it, adding to the information already available in the teeming commercial crossroads and center of empire that was London. They were Londoners, first and last, and they did not break into their busy lives in London for visits to America. Instead, they seized upon the facts sent home, or carried home, by citizens of a more roving disposition. In the graphic arts, as in other fields, the numbers of these men-on-the-spot increased as the century went forward. A few, like Lewis Evans or Peter Jefferson, settled in the colonies or were born there, but most were Englishmen.

From Evans's experience as a mapmaker we can learn something of the relation of London to the colonies in the graphic arts. When his *Map of Pensilvania, New-Jersey, New-York . . . ,* full of new data, was published in 1749, Evans sent one to Peter Collinson in London, and Collinson returned his thanks in a letter to Benjamin Franklin. Later, Evans sent a supply of the

maps, and Collinson reported in a letter to Franklin written from London in June 1750, "Pray give my respects to Lewis Evans. I have not Time to write to Him but I putt his Mapps to Bowles one of the most noted Print and Mapp sellers near the Exchange—and He Tells Mee he has disposed of few of them the Price is so High."[5]

Obviously a print like this one, engraved by Lawrence Hebert in Philadelphia and published there, had to be expensive in London. Jobs were often scarce for an engraver in the colonies, and he might have to charge more, as a result, to meet his living costs, while in London, where the graphic arts were an industry with numerous practitioners, competition and steady work lowered the prices.

Although the original printing of Evans's map sold few copies in London, it was welcome there, nevertheless, and London map sellers paid it the compliment of pirating and reissuing it. Mapmakers have always done this, of course, in the practice of their cumulative art, so perhaps piracy is a harsh word. Evans was being paid a compliment, although unfortunately the compliment did not take the form of cash. Eventually, two decades after the author's death, Thomas Pownall rendered him full and elegant tribute by editing in London a reissue of the map with revisions and added information. Pownall seems to have obtained the original plate of 1755, no mean feat, and his changes were engraved on it. Folded, the revised map as newly printed was bound into Pownall's *A Topographical Description . . . of the Middle British Colonies*, first issued in London in 1776.

Pictorial information could be transmitted with remarkable speed across the Atlantic. King Philip's War was a life-and-death struggle for control of New England; no wonder William Hubbard's account, with John Foster's woodcut map of New England, was republished in London only months after publication in Boston in 1677. The 1756 London reengraving and reissue of Blodget and Johnston's 1755 *Prospective Plan of the Battle fought near Lake George* had behind it the same hunger for news and instinct for journalism. The so-called "Boston Massacre" of 1770 as portrayed by Henry Pelham and Paul Revere was also a pictorial extra, and it was in the interests of

the whigs in Boston to see that copies traveled quickly to London, where they were reengraved on type metal to illustrate accounts in broadsides and pamphlets. That now familiar image sent in haste across the Atlantic was well calculated to rouse disgust at the conduct of the troops and stir sympathy for the Bostonians.

We still do not know as much as we would like about the English copperplate (now in the Colonial Williamsburg collection) that depicts the Governor's Palace and other public buildings of the town, but the very existence of the plate is testimony to London's focal position (No. 7). An American wanting to publish this kind of visual information would be drawn toward London's engraving skills and the educated audience that existed there. This was still true in the 1820s when John James Audubon sought and found in London both printmaking expertise and monetary backing of a kind he had not found in the United States. Expert engraving in the colonies of complicated representations like Evans's maps or the map of the Maryland–Pennsylvania line prepared from their own observations on the ground by the English astronomers and surveyors Charles Mason and Jeremiah Dixon, crisply rendered on copper by James Smither in Philadelphia in 1768, was the exception rather than the rule.

In the introduction to the one-volume *American Historical Prints* that he edited in collaboration with Daniel Haskell, I. N. Phelps Stokes speaks of "the awe-inspiring appearance of 'Ye great town of Boston,' or of Philadelphia, or New York, as portrayed in that rare trio of Brobdingnagian early eighteenth-century 'prospects,'" and later Haskell describes them as "the fine trio of large engraved views—New York in 1716–46 and Boston before 1723, both drawn by William Burgis, and Philadelphia, by George Heap, published before 1754."[6] He goes on to mention the view of Charleston, drawn by Bishop Roberts, engraved in London, as the other views had been, and published in 1739 (No. 8). Like the others, it is not merely large. All four of the views were printed from multiple copperplates, and separate printed sections were joined to make the complete prospects. The New York view is more than six feet long, the Boston

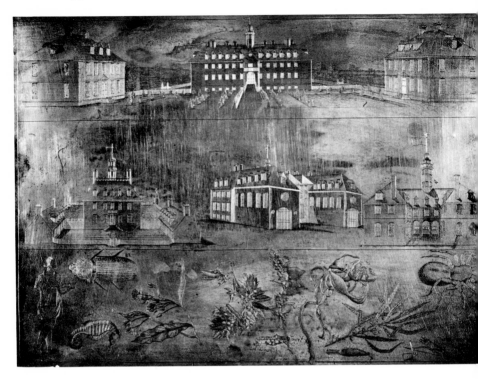

7. [The Bodleian Plate.]

view more than four feet, the Charleston view four and one-half feet, the Philadelphia view almost eight feet. The Brobdingnagians, in *Gulliver's Travels*, inhabited a country where everything was on a giant scale, and these panoramas might have fitted in very well.

There had been comparably extended views of London and other European cities in the past, and almost by definition they were expressions of local pride, for local consumption. Their size made them cumbersome, at best, for export. As a result, we have the paradox that most of these views drawn in America, engraved and printed in London, and published in America, usually by precarious subscription, were not necessarily well known in the city where they had been put on copper.

In the early 1730s Jonathan Belcher, Jr., Harvard 1728, son

of the then governor of the Massachusetts Bay province, was a resident of the Middle Temple in London, where he was studying for the bar. His father was eager that the expense of his favorite son's education should not be wasted, and he was also interested in procuring, both for himself and for Jonathan, Jr., the favor of influential politicians. In November 1731 he sent

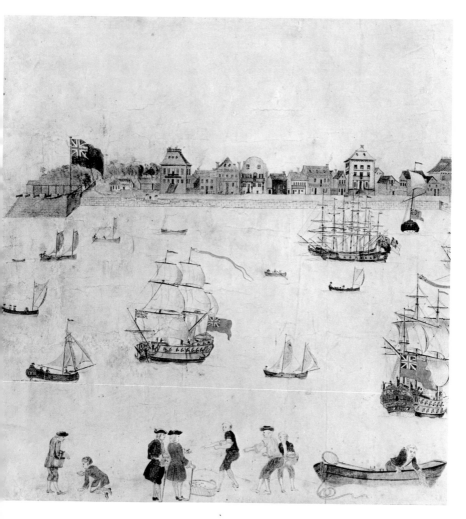

8. [Charles Town, detail.]

Jonathan his Harvard diploma, two pairs of wild geese each for the Duke of Newcastle and Horace Walpole the elder, and "4 cutts of the Colleges." Later, he shipped other gifts across the Atlantic, including "mapps and prospects of Boston," one each for the Duke of Argyll, Lord Ilay, Lord Wilmington, and Thomas Hollis. The likely identifications for these prints would seem to be the Burgis view of Harvard, one or both of the Burgis views of Boston, and either (or both) of the Bonner and Burgis maps of Boston. Apparently you could not sell these in London—not easily, at least—but you could give them away to advantage.

As with the Evans map of the middle colonies two decades later, however, the Burgis views of Boston and the Bonner and Burgis maps were welcomed by the resident establishment of printmakers, publishers, and printsellers. Once you had the visual information they contained, you could scale it down for reissue in smaller single-sheet prints, in engravings for magazines, and in the vignettes of major maps of all or part of the east coast of North America. Repeatedly, these London maps contained small inset charts of the harbors of Quebec, St. John's, Boston, New York, Charleston, Port Royal, Havana, and other ports. Sometimes they contained inset views. The big Burgis view of New York, for instance, was simplified and miniaturized and became one of the insets, most of which were harbor charts, on the enormous Popple *Map of the British Empire in America with the French and Spanish Settlements adjacent thereto* of 1733. Thomas Jefferys's *A Map of the most Inhabited part of New England* of 1755 did not include a view of Boston but did show, in separate insets, both a plan of the town and a chart of the harbor (No. 9).

The views, both large and small, could be reengraved for issue as single-sheet prints in a size roughly 18 inches by 10 or 12 inches, for use at home in ways that presage our slide viewers and slide projectors. In the 1880s in Boston, Eliza Susan Quincy owned a copy of the so-called Carwitham view of Boston that was part of a set of pictures imported in the eighteenth century by Ebenezer Storer, treasurer of Harvard College, to be looked at in an instrument with magnifying glasses. In 1750 James Buck, the Boston printseller, advertised "prints com-

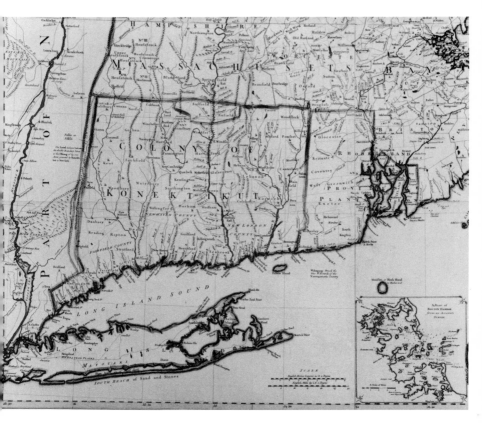

9. *A MAP of the most INHABITED part of NEW ENGLAND.*

pletely coloured, proper for view in Camerae Obscurae." Harvard still owns both the camera obscura and magic lantern it acquired in the 1760s, and varieties of these devices are reproduced in eighteenth-century prints (No. 10).

Englishmen in the middle decades of the eighteenth century could know as much or as little of the British North American colonies as Americans know about Canada or Mexico today—and we are famous for ignoring both of them. Still, many of us have been to both.

This is a defective comparison, but a necessary disclaimer, for if you enter the world of learning in eighteenth-century England and her American colonies, you are a constant witness to

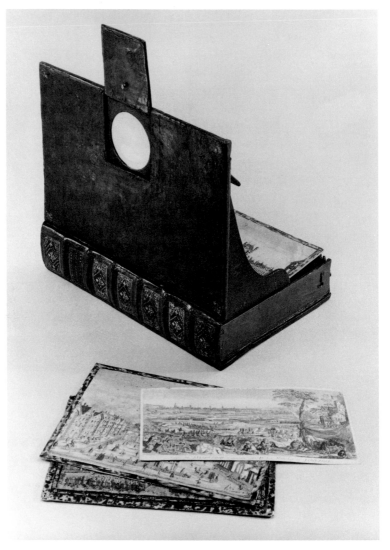

10. A typical mid-eighteenth-century vue optique box.

the sharing, trading, and publishing of rapidly increasing quantities of information about America. I want to trace these processes further, always with the proviso that they prove the availability of information to literate Englishmen, but not necessarily a high level of accurate information in the population at large.

To Lewis Evans and to Burgis, whose drinking, wining, desertion of his wife, and flight from creditors are known to us in court records and provide a florid backdrop to his accomplishments as a topographical draftsman and engraver, we might add three other men-on-the-spot, travelers all, who joined curiosity and energy with real skills in recording and delineating what they saw.

Mark Catesby, in America from 1710 to 1719, and again from 1722 to 1726, was an early pilgrim from London on behalf of science, journeying to the New World with specific objectives and returning to England to communicate his findings. *The Natural History of the Rarer Lepidopterous Insects of Georgia . . . Collected from the Observations of Mr. John Abbot*, by James Edward Smith, issued in London in 1797 with handsome hand-colored engravings of Georgia butterflies after Abbot's watercolors, can be seen as one of a succession of books, varying in subject matter and degree of specialization, for which Catesby's *Natural History of Carolina, Florida, and the Bahama Islands*, published in London in 1731 and 1747, pointed the way (No. 11).

Thomas Pownall, governor of Massachusetts between 1757 and 1760, had carried out other jobs in New York and elsewhere for the British government for several years previously. In his later career as a British administrator in Europe, and a member of Parliament from 1767–1780, he continued to cultivate his expertise on the colonies. Although history remembers him for his offices and his writings, including *The Administration of the Colonies*, first published in London in 1765, he also contributed to London's store of visual images of America. Six of the prints in the *Scenographia Americana* series were from his drawings, engraved by Paul Sandby (No. 12). The series, aimed at a large audience, is comparable to the series of prints for home projection or viewing with magnifiers, which includes the views

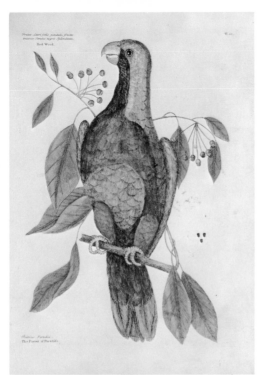

11. *The Parrot of Paradise* and *Red Wood*.

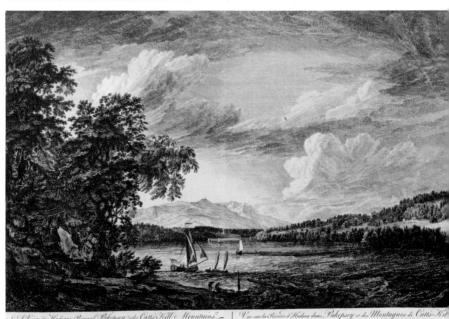

12. *A View in Hudson's River of Pakepsey & the Catts-Kill Mountains.*

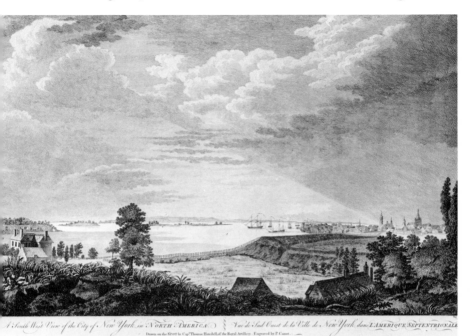

A South West View of the City of New York, in NORTH AMERICA. Vue du Sud Ouest de la Ville de New York, dans L'AMÉRIQUE SEPTENTRIONALE
Drawn on the SPOT by Cap.ᵗ Thomas Howdell of the Royal Artillery. Engraved by P. Canot.

13. *A South West View of the City of New York, in NORTH AMERICA.*

of New York and Boston engraved by Carwitham on the basis of earlier views by Burgis. The *Scenographia Americana* views, however, do not look as if they were planned from the outset to be colored, for in black and white they have sparkle, style, and sophistication—an effect of color comparable to Piranesi's prints and others coming out of mid-eighteenth-century Rome. Pownall's accomplished draftsmanship was well served by his engraver. He might symbolize a good many British civil servants—Guy Johnson, for instance, nephew and assistant of Sir William Johnson and the delineator in 1759 of *A North View of Fort Johnson*, later engraved and published in London, or Captain Thomas Howdell of the royal artillery, who in the 1760s drew views of New York City, also engraved and published in London (No. 13).

Evans the mapmaker, Burgis the viewmaker, Catesby the ornithologist and botanist, and Pownall the civil servant who counted drawing among his disciplines and pleasures were only a few of the surprisingly large number of intermediaries between London and the colonies in the graphic arts. The most numerous group of these pilgrims might be symbolized by J. F. W. Des Barres. This cantankerous man turned himself into an exceptionally proficient marine surveyor and in the pursuit of his calling spent many summers banging about in schooners and pinnaces off the coasts of Canada. During the Revolutionary War he was in London putting together the surveys of various British officers and seeing them into print in the *Atlantic Neptune* series of charts, an enterprise he lifted to the level of art. It is not easy to grasp the reach of the operations of which he was a part. Mary Blewitt sums it up in this way in her *Surveys of the Seas*:

> The wars against the French, terminating in the Peace of Paris in 1763, had made it only too apparent that a survey of the east coast of North America, from the West Indies to Labrador, was essential. There was no organization for launching marine surveys so that the task fell partly upon the governors of various provinces, partly on the Board of Trade and Plantation and partly on the Admiralty. The next twelve years, . . . saw a tremendous attempt to get the work completed. The St. Lawrence River and much of Newfoundland were surveyed by James Cook between 1760 and 1767, followed in the same area by Michael Lane and Joseph Guilbert, working for Sir Hugh Palliser, Governor of Newfoundland and Labrador. To the east Samuel Holland, Surveyor-General of the Northern District of America, and his assistants, Thomas Hurd (later Hydrographer of the Navy), William Brown, C. Blaskowitz and many others surveyed, on the orders of the Board for Trade and Plantation large sections of the coasts of Nova Scotia and the coast of the United States as far south as Rhode Island, while Colonel Des Barres, working with his assistants for the Admiralty, charted much of Nova Scotia and the off-lying islands. To the south George Gauld for the Admiralty covered Florida, the bays of Pensacola and

Mobile, Louisiana, the Mississippi and some of the West Indies.[7]

Another important figure, although Blewitt does not mention him in this particular context, was Willem Gerard De Brahm, who from the late 1750s was surveyor general of the Southern District of the colonies. His *Map of South Carolina and a Part of Georgia containing the whole Sea-Coast*, published by Jefferys in London in 1757, was one of the very few accurate reports already in hand when the east coast surveys began on a large scale in 1763.

Many others contributed to the surveys. On their heels came the military engineers—Montresor (No. 14), Page, and others —who were assigned to the British armies in North America during the Revolutionary War, and whose constant activity and great skill produced in a short time a wealth of visual material not fully comprehended to this day. As the war went forward, London's images of America were numerous indeed. In London, Des Barres, writes his biographer, G. N. D. Evans, "was encouraged to hire as many assistants as possible, and at the peak of the operation he crowded two houses with them."[8] When British captains were ordered to the American station, they apparently received from their compatriots the advice to pay a call on Des Barres. During conversation the surveyor pulled off the shelves whatever charts seemed needed, and the visiting captain later had these bound up as his own set of the *Atlantic Neptune.*

Since the interest in America far exceeded the very substantial amount of information that existed, London publishers like Thomas Hart employed their wits and their imaginations (and sometimes pro-American sentiments as well) to cater to the British audience (Nos. 15–16). Hart's 1775 series of mezzotints of American heroes makes use of an all-purpose human face, something a London pictureman at home with the current theories of physiognomy could do quite naturally. The heroes are decked out in handsome hats and uniforms and are presented with the help of various props—flags, cannons, background ships, and so on. These are pure confection, but everybody loves a good parade, and invariably people swallow Mr.

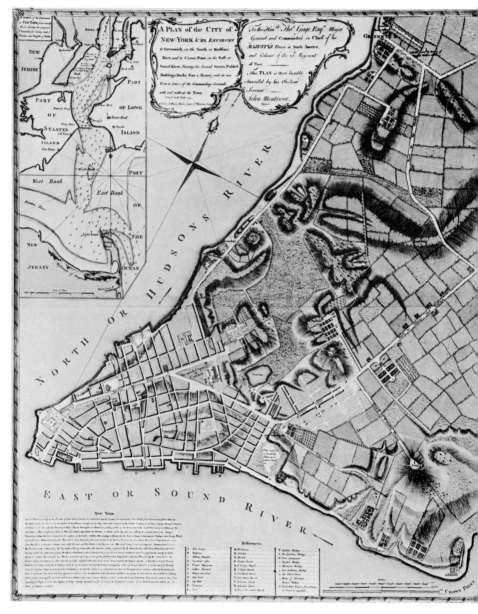

14. *A PLAN of the CITY of NEW-YORK & its Environs.*

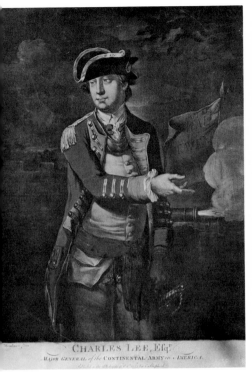

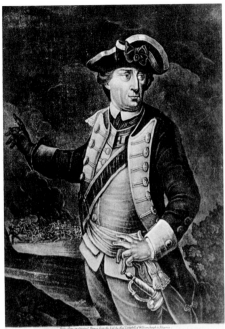

15. *CHARLES LEE, Esqr.*　　　16. *GEORGE WASHINGTON, Esqr.*

Hart's shrewd playacting and begin to feel patriotic and pro-American as they view a fine figure of a man like Admiral Hopkins, with a rattlesnake and a liberty tree on flags behind him and the words "Don't tread on me" and "An appeal to Liberty." After all, a few years later, it was this same Esek Hopkins, in his real person, who got Washington across the Delaware.

A similar delight may be found in a small prewar engraving from the *Gentleman's Magazine*. It shows pompous ministers in a London boardroom. On the wall, a map of America is bursting into flames.

Bunkers Hill or America's Head Dress, issued in London in the spring of 1776, presents a London lady with a caricaturist's vision of the enormous coiffure then fashionable; on it, the bat-

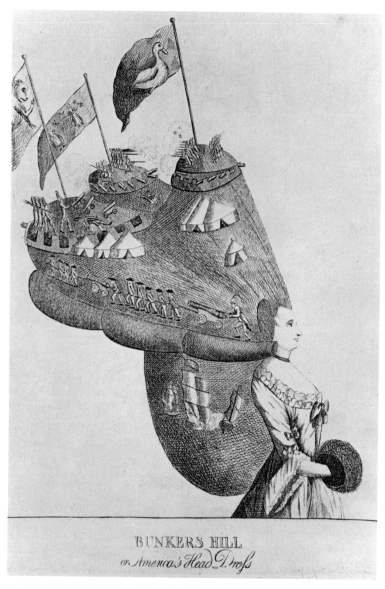

17. BUNKERS HILL or America's Head Dress.

tle is taking place (No. 17). All the soldiers on the hilltops, or hairtops, wear British uniforms; they fire at each other, and above their heads on the three flags appear an ape, two women holding darts of lightning, and a goose. Later the same print was copied and adapted with the title *Noddle-Island Or How Are We Decieved*. In this, the Americans have flags bearing a crocodile and a bow and arrows; the emblems on the English flags are an ass and a fool's cap and bells. The "How" in the title is a pun on the name of the British general, and the print satirizes his evacuation of Boston on March 17, 1776. The name of an island in Boston Harbor is used to imply that the British are a bunch of noddleheads. As Horace Walpole wrote of London newspaper stories that attempted to put in a good light Howe's strategic advance to the rear, "nobody was deceived." Recently Draper Hill discovered that the artist who drew the caricature may have used no less a source than Des Barres's chart of Boston Harbor.[9] Referring to Matthew Darly, the publisher of the print, he writes, "One wonders how many of Darly's customers associated the shape of the lady's coiffure with the general contour of Noddle Island," and he goes on to show in detail that the caricaturist "adjusted his design to fit geographic circumstance, even to the line of bluffs which are serving as British batteries." Hill concludes, perhaps a bit regretfully, "We can only speculate on how much of this made sense to an informed London contemporary, but it underscores the highly perishable nature of graphic satire, created of and for a specific moment in time."

Let us examine a last pair of London images, the first a mezzotint of 1775 from that familiar series of pro-American figures with all-purpose faces and patriotic props. Arnold is shown in the character of an American hero; Quebec can be seen behind him.

The second image dates from 1785, a decade later and two years after the end of the war in America. Titled *The Loss of Eden!—and Eden,! Lost*, it is an etching by Thomas Rowlandson picturing Benedict Arnold and a one-time friend to Ireland, William Eden (No. 18). Eden rushes toward Arnold, who receives him with open arms. Verses underneath tell the story:

Two PATRIOTS (in the self same Age was Born,)
And both alike have gain'd the Public scorn,
This to America did much pretend,
The other was to Ireland a Friend,
Yet SWORD, or ORATORY, would not do,
As each had different PLANS in Veiw,
AMERICA lost! ARNOLD, & Alass!
To loose our EDEN now is come to pass.

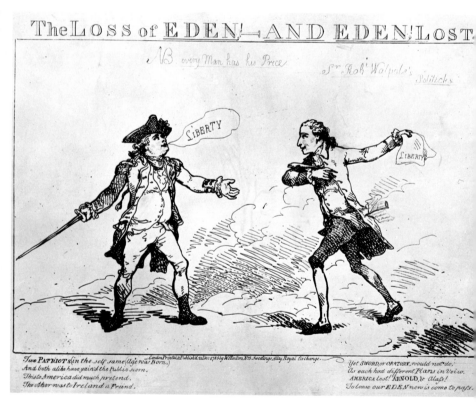

18. *The LOSS of EDEN,!—AND EDEN,! LOST.*

NOTES:

[1] *The Works of William Hogarth*, I (Philadelphia, 1900), pp. 86, 88.

[2] Gerald W. Chapman, *Edmund Burke, The Practical Imagination* (Cambridge, Mass., 1967), pt. 19.

[3] Joan Dolmetsch, "Prints in Colonial America: Supply and Demand in the Mid-Eighteenth Century," in John D. Morse, ed., *Prints in and of America to 1850*, Winterthur Conference Report 1970 (Charlottesville, Va., 1970), pp. 53–74.

[4] Edmund Burke, *On the American Revolution: Selected Speeches and Letters*, ed. Elliott Robert Barkan (New York, 1966), p. 182.

[5] Leonard W. Labaree et al., eds., *The Papers of Benjamin Franklin* (New Haven, Conn., 1961), III, p. 484, IV, pp. 318–319.

[6] I. N. Phelps Stokes and Daniel C. Haskell, *American Historical Prints* (New York, 1933), pp. x, xxv.

[7] Mary Blewitt, *Surveys of the Seas* (London, 1957), p. 25.

[8] G. N. D. Evans, *Uncommon Obdurate: The Several Public Careers of J. F. W. Des Barres* (Salem, Mass., 1969), pp. 22, 20.

[9] Draper Hill, "School of London," paper presented at the Boston Public Library, May 5, 1973.

Views of Port Cities as Depicted by Vernet and Other Eighteenth-Century Artists

Harold W. Sniffen

By the mid-eighteenth century European engraving had reached a technical perfection that picture-hungry Americans would strive to imitate. How then was the knowledge of these engravings and the technique of producing them to reach the colonies?

Important was the bid that the new land made to the already trained engraver, the man who came in search of new opportunity. The greater number of English-trained American engravers worked in the nineteenth century, too late for the period covered by this symposium, but several came earlier. Perhaps the best known is the important artist, William Burgis, who arrived in America about 1716. But others such as Robert Aitken, who came from Scotland before the Revolution and did some maritime work, and Alexander Lawson, also from Scotland, must not be overlooked. Another was Edward Savage, engraver of the 1799 print of the battle between the *Constellation* and the *Insurgent*, who learned the art of engraving in England, although he was a native of Massachusetts.

The periodical was certainly one of the most likely vehicles to bring knowledge of engraved illustrations to America. The *Britannic Magazine*, which called itself "a depository for Heroic Adventures," had pictures appropriate to nautical subjects, and

the *Oxford Magazine* of 1770 printed a rare picture of the "press gang" at its dirty work. A view of Table Mountain at the Cape of Good Hope, for instance, must have intrigued families in more than one colonial home. A 1716 issue of the *London Magazine* gave its readers an idea of one American city by publishing a view of Philadelphia.

It seems that geography books also crossed the ocean. Many an Englishman who sailed to America from Portsmouth, England, would have been stirred by a likeness of that city as it appeared in *The Modern Universal British Traveller* of 1779, or from similar illustrations in Charles Middleton's *A New and Complete System of Geography*, 1777, or George Millar's *New and Universal System of Geography*, 1790.

The series of books containing charts, landfalls, and numerous views of colonial ports printed and published in England by J. F. W. Des Barres were familiar publications. During the Revolution the *Atlantic Neptune*, as it was called, would have been a classified document for use on British ships operating off American coasts. Thus it was probably well after 1781 before copies came to these shores.

The Mariners Museum library in Newport News, Virginia, owns a book containing views by Samuel and Nathaniel Buck, published in London in 1745. These panoramic engravings are grouped under the title *Views of Ports, Harbours, Docks, and River Scenery of Great Britain with Brief History and Description*. The same is true of the engravings of John Boydell of London. His whaling subjects, for instance, would have been interesting to New Englanders where this industry was growing.

Captain James Cook, the explorer, was admired in eighteenth-century America as well as in his native England. The accounts of his voyages, especially those of the third, so well illustrated by John Webber, appeared in book form in 1785 to broaden the pictorial experience of some Americans.

A subject appropriate to discuss in the context of scenic engraving would be peep show prints, better known as "vues d'optique." The wonders of the world were carried on the back of itinerants in the form of engravings, with a viewing box, the "optique." The viewer peeped through a hole fitted with a magni-

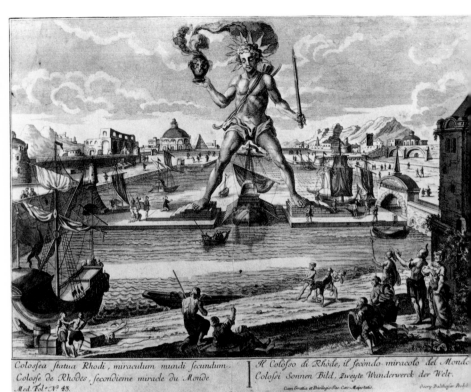

Colossea statua Rhodi, miraculum mundi secundum. | Il Colosso di Rhode, il secondo miracolo del Mondo
Colosse de Rhodes, secondieme miracle du Monde | Colossi Sonnen Bild, zweyte Wunderwerck der Welt.
Med. Vol° N° 43. | Cum Gratia et Privilegio Sac. Cæs. Majestatis. Georg Balthasar Probst.

19. *Colossea statua Rhodi.*

fying glass and saw, reflected in a mirror, wonderful scenes
such as the illustration of the colossus at Rhodes (No. 19).
Most of these "vues d'optique" were imaginative, crude, and in-
accurate, although some were gracefully done. Peep show itin-
erants were active in America in the eighteenth century as indi-
cated by more than one reference.[1] This would have been a
perfect way for the work of European engravers to become
known to the American people.

Subjects most likely to have reached this country in the op-
tique form were American views, allowing the colonists the plea-
sure of seeing their own towns and surroundings in picture
form. How beautiful they must have found John Carwitham's

engraving *Fort George with the City of New York* published by
Carington Bowles. The Mariners Museum's collection contains
nearly fifty such prints published by Bowles. His series called
Twelve Remarkable Views of North America included one of
Charleston, South Carolina, which most surely was known to
the people of that city (No. 20). Similarly there were the Pierre
Fourdrinier view of Savannah, published in London about
1734, the Nicholas Scull–George Heap view of Philadelphia by
Thomas Jefferys about 1756, and the Archibald Robertson–
Francis Jukes view, *New York from Hobuck Ferry House*, to
mention but a few of the many such prints that came out not
in the form of book illustrations, but as separate items.

Similar engravings from the European continent would also

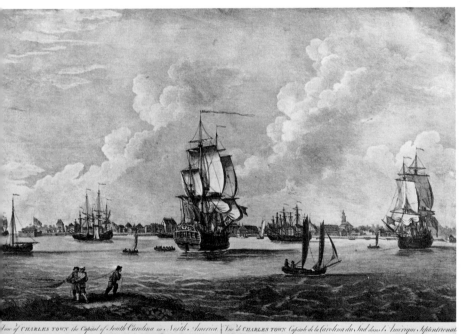

20. *A View of CHARLES TOWN the Capital of South Carolina in
North America.*

have affected the tastes of early Americans. Early in the eighteenth century Pieter Schenk, a Dutch mapmaker, published a book called *Hecatomopolis*, which contains one hundred views of cities all over the world. This book, and other equally charming separate prints and maps by Schenk, could well have reached American cities, as might copies of another Dutch publication, *Views of Ports and Harbours of the Netherlands*, engraved by Mathias de Sallieth after drawings executed by D. de Jong.

Other valuable works followed. Nicholas Ozanne was an engraver who did a variety of subjects such as harbor views, shipyards, and launchings, all with great attention to details. Early in the nineteenth century *Recueil de Petites Marines* was published in France by Jean-Jérôme Baugean. This is a valuable record of European watercrafts. But the recognized tastemaker for French engravers was Joseph Vernet, whose well-known series of the *Ports of France* was engraved by Jacques Philippe Le Bas and Charles Nicolas Cochin.

In 1714 Claude Joseph Vernet was born to a large family of modest circumstances in Avignon, France.[2] His father, a decorator of sedan chairs, lintels, and doors, perceived early his son's artistic talent. By eight years of age he was drawing well, and by fifteen he was studying art seriously. His work on some decorations of a chateau of a noble lady near Avignon resulted in her sponsoring him for study in Rome in 1734. Here hard work and natural talent soon made it possible for Vernet to go his own way.

Possessed of an outgoing personality and always quick to make friends, Vernet was ever alert to situations that would better his social position. His marriage in 1745 to the beautiful Virginia Parker, daughter of a Roman Catholic Englishman serving in the papal navy, was most advantageous to his ambitions.

Among the influential people Vernet was to meet was the Marquis de Vandières, the brother of Madame de Pompadour, mistress of Louis XV. She was equally ambitious for her young brother and sent him to Rome to polish his education, and it was there that the two first met. When the Marquis de Vandières returned to France, he was given the title of Marquis de Marigny

and was appointed to a position that today would be called direc-
tor of fine arts.

Vernet painted a canvas for Marigny and two for Louis XV.
He also had some of his works exhibited in Paris salons. Press-
ing to become even better known, Vernet moved to Paris in
1753, where his works were soon in great demand and were
well received at court. One of his more effective gestures had
been to flatter Marigny by dedicating an engraving to him.
Vernet's biographer believes that this represented one of his
best works, and the engraving was done by one of the finest
makers of the period, Jean Joseph Baléchou. Thus by the time
Marigny decided to have someone create a series of paintings of
the ports of France, Vernet was well known to him. Vernet was
contracted to do twenty such paintings, probably his most im-
portant contribution to art and to history.

Awarded the title "His Majesty's Marine Painter," Vernet now
took his family to Marseilles in October 1753 to begin the series.
This was to occupy the next nine years of his life. Fifteen works
came from this period, which may seem few until the 5 by 8 foot
size and the complexity of the canvases are considered. In order
to live in the style to which he had become accustomed, Vernet
also found it necessary to paint other pictures during this period.

The view of the entrance to the port of Marseilles was the first
print of the series (No. 21). Depicted is sun-drenched southern
France, warm and carefree enough for people to be swimming
nude in the harbor. The ship being aided by rowboats is of great
interest. There were then no tugs to tow a vessel to waters deep
enough to maneuver by sail. It is just such personal and mari-
time details that make these prints so important to social and
nautical historians.

This print is a good one with which to start, since it intro-
duces the viewer to the artist and his family. Joseph Vernet is
seated near the center of the picture, sketchbook in hand.
Standing behind him is his father-in-law, perhaps helping with
some of the nautical details. In front of the artist stands one of
his four sons. Vernet looks toward his wife, Virginia, who is
introducing him to an old fisherman, whose name, Annibald
Comaus, is known. It is easy to believe that this is an actual

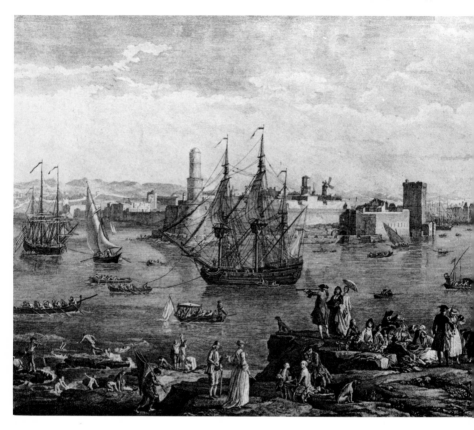

21. *Vue du Port de Marseille* (detail).

likeness of Comaus, as Vernet's own likeness is so similar to a known engraved portrait of the artist.

Vernet was most skillful in handling small figures, but even more so were the engravers who worked from his paintings. The prints so profusely peopled with these little figures were all faithfully reproduced to scale, and their occupations as part of the port life are all easily recognizable.

Another example of an item of interest to personnel of museums such as the Mariners might be the pottery jugs that appear in the view of the print of the interior of the port of Marseilles (No. 22). There are in this museum's collection two such

large jugs that are believed to have carried liquids aboard eigh-
teenth-century ships, one coming from Georgetown, British
Guiana, and one raised from a British warship sunk at Yorktown
in 1781.

There is in the print a detail of a ship being careened (see
No. 28 for a detail). This was done in a period before dry docks
were known. Ships had to be hauled down by the masts until
they floated on their sides in order to expose the bottoms for
cleaning and treatment. Scenes of this operation appear seven
times in the series. It is also interesting to note that Jacques
Philippe Le Bas, one of the engravers of the Vernet "Ports,"
produced another print in which careening is the subject.

As impressed as one is by the detail Vernet was able to portray
in his canvases, one must find equally amazing the abilities of

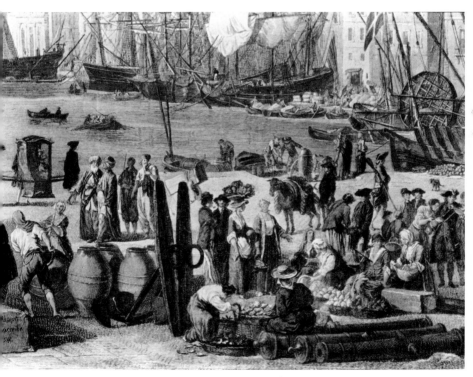

22. *Le Port de Marseille* (detail).

the two engravers who reduced the 5 by 8 foot paintings into prints 18 inches by 28. It is not known how the collaboration between the two engravers was arranged and to whom the grace of the miniature figures can be attributed. Joseph Strutt says of Jacques Philippe Le Bas, "His great force seems to lie in landscapes and small figures, which he executed in a superior manner."[3] Bryan's *Dictionary of Painters and Engravers* also says of Le Bas that "he excelled in landscapes and small figures, which he touched with infinite spirit and neatness."[4] But Bryan's *Dictionary* also speaks of Charles Nicolas Cochin's "wonderful skill in the representation of vast crowds in motion," which might indicate an ability to engrave people in miniature. The same reference lists among Cochin's works "the etchings of the Ports of France after Joseph Vernet, which were completed by Le Bas."[5] Interestingly, the Mariners Museum owns a proof before the burin work was added to the engraving of Antibes, and the grace of the tiny figures is present (No. 23). So if this much was done only by Cochin, then the credit should be his. Furthermore,

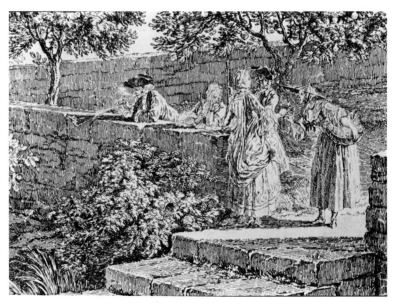

23. *Vue de la rade d'Antibes* (detail).

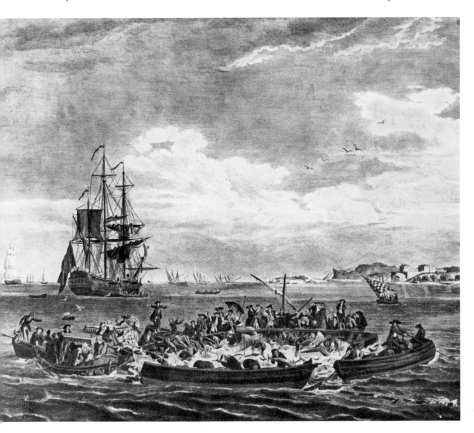

24. *La Madrague, Golfe de Bandol* (detail).

the human figures in Le Bas's "careening" print are inferior. Was this because the delineator of that engraving was less skillful than Vernet, or because Le Bas was less skillful than Cochin? Did an engraver attempt to reproduce exactly what the artist of the original told him to do? Before leaving this question, it should be noted that there will be a later reference to another series of engravings of human figures by Le Bas which, although of larger scale, are most skillfully done.

The Gulf of Bandol is but a few miles from Marseilles, and thus it was not far for Vernet to go to fulfill Marigny's wish for a pictorial record of tuna fishing (No. 24). His painting shows that the seine contained a remarkable catch, and that the fish-

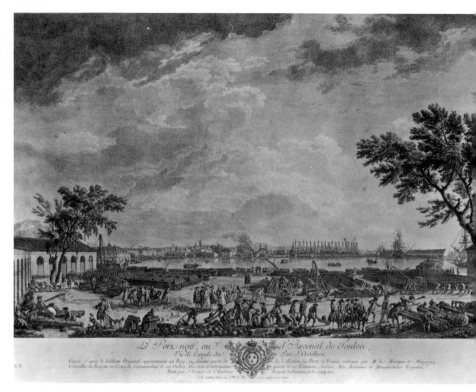

25. *Le Port neuf, ou l'Arsenal de Toulon.*

ermen had a wet time heaving them into the boats. The ele-
gantly attired audience watching the scene from their craft on
the other side of the net is most unusual, and it is possible that
they came at Vernet's suggestion to add color to the scene.

Marigny instructed Vernet as to the aspects of the ports that
he wanted recorded in the paintings. Marigny was indeed quite
specific in many cases. Vernet, on the other hand, was not al-
ways careful to follow instructions, sometimes for good reasons,
sometimes for bad. The maritime historian may regret that, in
the case of Toulon, Vernet chose not to depict the marine ac-
tivity suggested—squadrons of ships entering and leaving the
harbor and a ship launching.

One of the views that Vernet did choose, which was not re-

quested by Marigny, is a scene of the well-known arsenal of Toulon (No. 25). The painting and engraving show remarkable details of typical eighteenth-century arsenal activity. In order to open the vent hole, four men are drilling a gun highly decorated with fleurs-de-lis, dolphins, and a coat of arms. (See lower right corner of print.) A mock-up of a ship's deck and bulwarks have been set up on land with a team shown at gun drill. Cannon are shown at position for loading, firing, and stowing while at sea. There is also a group of officers being instructed in the use of mortars. Some unusual triple-barreled guns appear among the other artillery pieces. Men move bombs about with specially designed wheelbarrows. The diameters of the bombs are checked with calipers before being sent to the fleet. The cleaning of gun barrels, the use of two-wheeled carts for lifting and moving cannon, neat pyramidal piles of cannon balls, the stockpiling of cannon, muzzle to breech, at the water's edge, and other details too numerous to list all make this print an encyclopedia on artillery. Although to the trained eye some things may seem wrong with the mechanics of some of the operations, the principles of the processes are well illustrated.

The second of Vernet's three views of Toulon, called the *Old Port*, is a more peaceful scene showing a quay at which not only produce is unloaded from a craft, but also cows, a pig, and sheep (No. 26). It would be nice to believe that some of the barrels on a cart were for milk, but a man is shown drinking liquid from a stemmed glass indicating that these were more likely for wine. On the right side of the print large, round cheeses are shown, and one of them is quite literally being wheeled away.

Vernet's next port-of-call was the countryside just on the outskirts of Toulon. Here Vernet substituted a view of a country home in place of Marigny's suggested launching scene. The harbor shows only incidentally in the distance. The print is a pleasant scene of guests being greeted, entertained with bowling and hunting, and fed luncheon on a terrace overlooking the city. A fountain is shown with the water flowing from the mouth of a dolphinlike sea animal reminiscent of the whale depicted in Vernet's rendering of the Jonah story. One wonders if the fountain's dolphin was not the source of his whale.

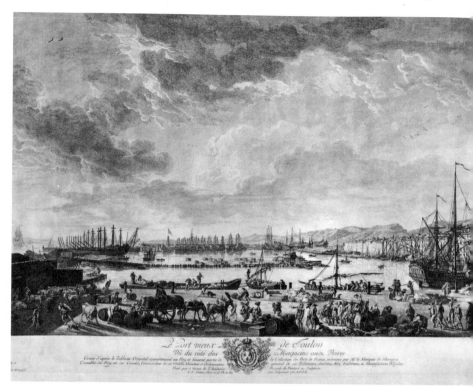

Le Port vieux
Vû du coté des

de Toulon
à Maugaisux aux Prires

26. *Le Port vieux de Toulon.*

 In his writing on Vernet, Thiervoz considers the view of An-
tibes the best of the series. He describes the palm-shaded terrace,
the sea, the snow-capped Alps in the distance, and the "smiling
softness of the South" depicted in this print. But the harmonious
scene is broken by soldiers entering the city from the left. There
is no military order, one soldier carrying his musket with the
stock upward, while another steals a kiss from a passing girl.
A dog is shown carrying a pack on his back. A family with house-
hold goods and a dog ride on a two-wheeled cart, while the road
ahead of them shows crowds entering the city gates.
 The painting of the next port scene, Cette (the present-day
Sète), was the occasion for a difference of opinion between
Vernet and Marigny (No. 27). Marigny wanted the port, sur-

passed in beauty only by Bordeaux and Marseilles, to be the focal point of the work. However, Vernet had wanted to paint a stormy sea for at least one of these works, which meant that he had to view it from the outside looking in, with only a small portion of the port to be seen. Vernet was adamant, and Marigny, although annoyed, finally gave in. The next thing Marigny knew, Vernet was writing to tell his patron that he intended only to sketch the concept in Cette and paint in Bordeaux. Angry now, Marigny wrote, "The King pays for your paintings in a manner that requires all possible perfection. And you could not finish it any better than by being at exact lo-

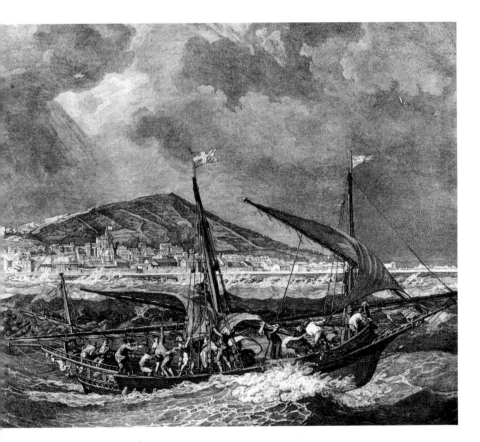

27. *Vue du Port de Cette* (detail).

cation."[6] So Vernet had to spend six months in what he called "the mean little town" of Cette, which had not received him as graciously as he expected.

One writer believes that Vernet had himself bound to the mast during a violent storm in order to record the scene indelibly in his mind.[7] This smacks of legend, but, if true, would be the experience behind this engraving. Thiervoz thought the painting "monotonous and naked, showing Vernet's bad humor."[8] The xebec shown in the foreground of the print might redeem it for the nautical minded. The rocks are close and the craft has been forced to go before the wind. It practically planes down the following seas, and the skipper, speaking trumpet in hand, shouts orders to his crew, who are trying to bring down the mainsail. The men struggle as the wind tries to lift the sail again. So great is the strain on the rudder that the captain has assigned two men to the tiller. However, one is left with the feeling that the crew's efforts will avert disaster.

Vernet's second view of Bordeaux is from the Château Trompette, a Louis XIV fortress overlooking the Garonne River. It was built after the city was attacked several times by the British. Against this background military activities concerned with the manning of the fort are shown. However, social activity is not forgotten as officers and their ladies promenade in the formal garden within the fortress.

This engraving served as an inspiration for Jacques Philippe Le Bas for a genre work in which several details are extracted and reengraved. He chose three groups of figures from the scene and placed them within new backgrounds as part of a twelve-view series.

South of Bordeaux on the Adour River near the Spanish border is Bayonne, scene of two more Vernet views. One holds great interest for the maritime student as well as those interested in eighteenth-century life. Here the best depiction of the careening process, spoken of earlier, is shown (No. 28). Depicted is the heating of tar over an open fire, and the carrying of it in buckets in small boats to the large vessel, which has half of its bottom exposed for treatment.

The second Bayonne print pictures the Allée de Bouffleurs

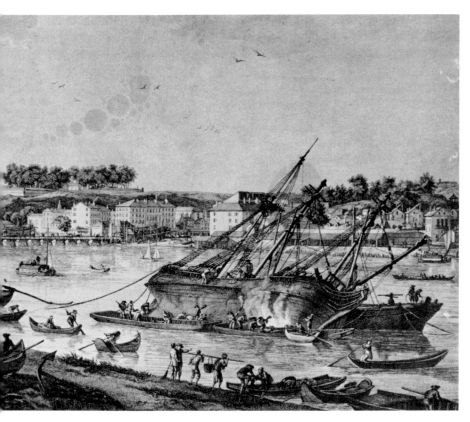

28. *Vue de la Ville et du Port de Bayonne* (detail).

(No. 29). On this pleasant border road French and Spanish meet and sport. In the center a group are playing a game, tou-piole, in which people toss a pottery jug rather than a ball around a circle. Behind this group two women riding a horse are making use of a cacolet, a double sidesaddle on which two riders sit facing forward, one on each side, their feet resting on a step. Le Bas also made use of this group in one of his later engravings. General Thiervoz identifies the man with the oar as a "tillolier," a sailor who mans a "tillole," a fishing craft peculiar to the Adour River.

In 1761 Vernet took a studio in La Rochelle where he did the

29. *Vue de la Ville et du Port de Bayonne* (detail).

paintings of this port and that of nearby Rochefort. These works reflect the peaceful atmosphere of his surroundings, which changed so little over the centuries (No. 30). However, during the period Vernet spent here the port was under blockade by British ships as part of the Seven Years' War. It was an important naval base for supplies during these hostilities. The print shows naval vessels being loaded with supplies, bundles of sails ready for shipment, and to the left a milling operation.

After his stay at La Rochelle, Vernet returned to Paris in July 1762, nine years of luxurious gypsy life over. In Paris he claimed the use of a studio at the Louvre to which he was entitled as marine painter to the king. For three years he did other work, postponing the final paintings in the ports of France series. Finally, in 1765, he went north to the port of Dieppe for

the fifteenth painting of the series, another elegant view and genre study. The fishing and the market where the catch was sold served as both back- and foreground for the work.

The Dieppe scene was the last of the series of port paintings done under his contract with the Marquis de Marigny and Louis XV. (Later he would do other ports and have them similarly engraved, but without royal sanction.) The Seven Years' War had drained the state treasury at a time when Vernet, with his expensive tastes, found that what seemed a generous 6,000 livres per painting was not enough. But it was not a time when he could ask for more. The constant moving had become tiresome, and his wife had become inflicted with a mental illness. So both sides were content to call off the agreement.

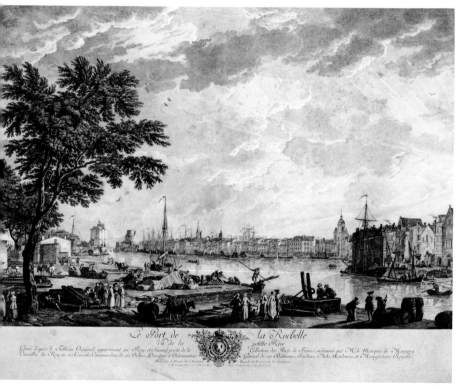

30. *Le Port de la Rochelle.*

The test of time has not been as kind to Vernet as to some of his contemporaries. His charming works, so beautifully translated into prints by Le Bas and Cochin, although admired for the myriad of detail they provide, are not considered masterpieces. The insight into nautical activities and the life of port cities depicted in these works, however, will always provide material to be studied by historians. Most of the original oils of the ports are owned by the Musee de la Marine, Palais de Chaillot, Paris. Two are in the collection at the Louvre. Impressions of the engravings are available in many of the print rooms in museums around the world.

NOTES:

[1] Joan Dolmetsch, "Prints in Colonial America: Supply and Demand in the Mid-Eighteenth Century," in John D. Morse, ed., *Prints in and of America to 1850*, Winterthur Conference Report 1970 (Charlottesville, Va., 1970), pp. 53–74; Florence Thompson Howe, "Early American Movies: Peep Shows and Peep-Show Prints," *Antiques*, XXIV (September 1933), pp. 99–101.

[2] The information that follows on the life and work of Vernet is derived principally from General Thiervoz, "Les ports de France de Joseph Vernet," *Neptunia* (Paris, 1960), Nos. 57, 58, 59.

[3] Joseph Strutt, *A Biographical Dictionary; Containing An Historical Account of All the Engravers . . .* , I (London, 1785), p. 68.

[4] Michael Bryan, *Bryan's Dictionary of Painters and Engravers*, ed. George C. Williamson, rev. ed. (London, 1925–1957), III, p. 191.

[5] Ibid., I, pp. 306–307.

[6] Thiervoz, "Les ports de France," *Neptunia*, No. 58, pt. 2, p. 13.

[7] E. Bénézit, *Dictionnaire critique et documentaire des Peintres, Sculpteurs, Dessinateurs et Graveurs*, III (Paris, 1955), p. 984.

[8] Thiervoz, "Les ports de France," *Neptunia*, No. 58, pt. 2. p. 13.

American Almanac Illustration in the Eighteenth Century

Georgia B. Bumgardner

EARLY book illustration is one aspect of American graphic arts that has received scant analytical attention.[1] Since many of the illustrations that graced the productions of the colonial press had English editions as their sources, such a lack of scholarly interest is perhaps justifiable. One needs only to mention the work of Paul Revere in the *Royal American Magazine* or the use that Isaiah Thomas made of John Newbery's children's books in order to understand the derivative nature of much American illustration. Want of originality in graphic invention as well as in the other arts is not to be unexpected in a colonial culture. Yet, in spite of a second-hand character, a crudeness, and an all-too-frequent deficiency of aesthetic qualities, these illustrations are a valuable tool in any inquiry into the nature of colonial society.

The illustrations that appeared in almanacs constitute a significant percentage of the total number printed in colonial books.[2] Although quantitative research into colonial printing and its diffusion is still in its infancy, the historical and socio-logical importance of the widely read literature of the street has become apparent in recent years. Cheap and produced in a handy format—generally comprising a gathering of eight to twelve leaves—almanacs were found in nearly every household.

Even in the seventeenth century they accounted for a large portion of the output of New England presses. Cotton Mather took notice of them, stating in the preface to his own almanac for 1683 that "such an anniversary composure comes into almost as many hands as the best of books."[3] Such an extended readership raises questions about the degree of literacy among the colonists that are outside the scope of our inquiry. It is undeniable, however, that almanacs, along with broadsides and gravestones, were the most readily available source of visual images for the average unlettered settler in the New World.

Comparison of the potential number of almanac readers with the number of customers for separately published prints underlines the importance of almanac illustration as a cultural phenomenon. As is the case for books, little documentation has been established concerning the sizes of editions of prints in the colonial era. Paul Revere's account books reveal that he printed two hundred impressions of the *Boston Massacre* and that he engraved two illustrations for Susannah Carter's *The Frugal Housewife*, pulling five hundred impressions of that plate.[4] Andrew Oliver's researches have disclosed that John Singleton Copley considered three hundred subscribers necessary to publish his proposed mezzotint portrait of Dr. Joseph Sewell.[5] By 1798 the number of clients for an edition had increased considerably. In that year Edward Savage wrote from Philadelphia that he hoped to realize ten thousand dollars from the sale of his stipple engraving of the Washington family.[6] For the greater part of the eighteenth century, a printing in the neighborhood of two to five hundred copies of a plate seems to have been the average. One might legitimately wonder whether the size of an edition might not have been determined as much by the medium as by the potential number of customers and would have been unlikely to exceed a thousand copies, as was the case with magazines.[7]

Printers of almanacs, on the other hand, were not averse to reusing a plate when circumstances demanded it or when it was merely convenient. Isaiah Thomas's *Massachusetts Calendar* for 1772 featured a portrait that purported to be of Christian VII, king of Denmark. But, as Sinclair Hamilton points out, the

same cut appeared on the verso of the title page of *The Death of Abel*, printed four years earlier in Boston by Z. Fowle and N. Coverly, when, curiously enough, it possibly represented George III.[8] While such reuse may simply reflect the haste with which printers prepared their almanacs, such plates as the folding frontispiece to *Weatherwise's Town and Country Almanack* for 1782 were reprinted because of the demand for either the plate or the almanac. Two versions of Weatherwise's cartoon depicting *America Triumphant and Britannia in Distress* are extant in copies of the almanac at the American Antiquarian Society. It can be conservatively estimated, based on Hind's assumption that between one and three thousand copies can be successfully taken from a copperplate, that four thousand impressions of the cartoon were circulated.[9] The greatest of all the almanac printers, Benjamin Franklin, wrote in his autobiography that he endeavored to make *Poor Richard's Almanack* "both entertaining and useful, and it accordingly came to be in such demand, that I reap'd considerable profit from it, vending annually near ten thousand."[10] Franklin's production represents that of only a single printer, so one might well imagine how many almanacs were printed in a single year throughout the colonies. By way of indication, in France, whose population was larger than that of the colonies by a factor of ten, individual almanacs were printed at the rate of 150,000 to 200,000 yearly.[11]

Intended as they were for a large and unsophisticated public, almanac illustrations were nevertheless not restricted to simply understood astronomical diagrams and anatomies. In the middle of the eighteenth century, American almanacs began to include a prodigious number of illustrations. Calendar page vignettes, portraits, political cartoons, and genre scenes made their debut. Although much of this material was ultimately derived from English sources, they were from sources other than almanacs, for only the diagrams, anatomies, and portraits are seen with any regularity in English almanacs. The relative poverty of illustration in English almanacs, which devoted many of their pages to astrology and prognostications, is the result of the differing intentions of the English and the American compilers.

In its most primitive form, the almanac was a method of organizing time so that, knowing what each week, month, and season was to bring in the way of celestial and meteorological events, the countryman and the husbandman might not be caught unprepared. Futurity was its essence, and many were the compilers who styled themselves astrologers and prognosticators. This traditional approach to the compilation of an almanac had obtained in England since the fifteenth century, becoming more inflexible over the centuries as the Company of Stationers staunchly fought to hold onto the monopoly that they had over the publication of almanacs.[12] Not bound by any guild tradition, American printers and compilers were freer to fill their pages with an encyclopedic variety of knowledge. In their tables of useful information, their practical advice, and their scientific and literary essays, they brought the eighteenth century's much admired scientific method to bear on craft knowledge, in this case the craft of husbandry. Franklin heeded the educative role of the almanac in colonial life, observing that "scarce any neighborhood in the province being without it, I consider'd it as a proper vehicle for conveying instruction among the common people, who bought scarcely any other books."[13]

In line with Puritan theology, which dictated that man should not attempt to forecast natural phenomena and their effects, compilers, especially in the seventeenth century, paid little heed to prognostications, but sometimes included eclipse diagrams. The first American diagram appeared in John Foster's almanac for 1675 (No. 31). It conforms to tradition, although English printers often included diagrams for all the eclipses, reflecting the greater length of their almanacs. Foster's, like most American almanacs, contained only one diagram.[14] The more talented American printers also adhered to English tradition in decorating the planets, suns, and moons with humorous and whimsical faces (No. 32). More frequently encountered, however, throughout the colonial period were diagrams consisting only of black circles and lines.

The man-of-signs, or the anatomy, was a traditional staple (No. 33). This figure symbolically represented the whole system of astrological medicine. Both the educated and the illiter-

31. Diagram of an eclipse
from John Foster's
almanac for 1675.

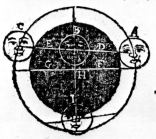

FOur *Eclipfes* of the two greater *Luminaries* will this year be vi-
fible to the Inhabitants of this *Earthy Star*, two of the *Sun*
and as many of the *Moon*.
 The firſt in Order will be of the *Sun*, June 13. Almoſt in the
Meridian of our *Antipodes*. and therefore Inviſible to us, The
ſecond will be a total *Eclipfe* of the *Moon*, June 26. ,The whole
whereof will (if the weather permit) be ſeen in our *Hemiſphere*.

Begin.Eclipfe	09 05	38
Begin.total dark.	10 17	12
End total dark.	11 32	14
End of ʒ Eclipfe	12 43	48
Contin. tot. dark.-01	15	02
Contin. cf Eclipf.03	38	10
Digit. Eclipted	·	15 0
☽ Initial Lat.	1 59.	N,
☽ Final Lat.	23 44	N.

A Type of this *Eclipfe* you may here behold, in the annexed Di-
agram : *A* The *Moon* entring the *Earths* ſhadow, *B* The
Moon paſſing through the ſhadow, *C* The *Moon* got out of the
Earths ſhadow, *D E*, the *Moons* way, *F G*, the way of the ſha-
dow, *H* Center of the ſhadow.
 The third will be of the *Sun December* 6. about Noon, but In-
viſible to us in *New-England* by reaſon of the *Moons* South Lati-
tude.
 The fourth and laſt will be of the *Moon December* 21 about ten
at night which will be Viſible.

	h.	m.	fe.	
beginning	09.	31.	03.	You may behold a Type of this E
middle	10.	37.	32.	clipfe in the Figure above, I the
end. Total	11.	51.	51.	Moon in its true oppoſition paſſing
duration	02.	20.	49.	through the under part of the Earths
digits e-	04.	00.	00.	ſhadow.
clipfed.				

The Suns Ingreſs into the four Cardinal points.

The Sun Enters
 ♈ March 9 17 43.
 ♋ June 10 20 01.
 ♎ Septem. 12 11 51.
 ♑ Decem. 10 33 31.

S. AUNDER, 1693.

dle of the Eclipfe at	3	51	53
end of total darkneſs at	4	41	58
full end of the Eclipfe at	5	43	04
ns Latitude at the beginning, South aſc.		02	49
ns Latitude at the end, South aſc.		14	49

A Type of the Moons Eclipfe, January. 12.

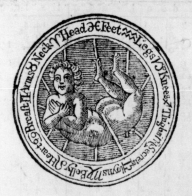

n this Figure, the great Circle A, B, C, D, repreſenteth the
he ſhadow, through which the Moon paſſing is thereby
pfed ; the Line E. E. repreſenteth the Ecliptick, the Line
, the way of the Moon in her Orb ? The utmoſt Moon to
right-hand ſheweth the Moons place at the beginning of the
pfe, with South Latitude 2 min. 49 ſeconds aſcending ;
irſt within the ſhadow ſheweth the Moons place at the be-
ing of total darkneſs ; the middlemoſt Moon ſheweth the
ns place at the middle of the Eclipfe ; the utmoſt within
ſhadow to the Left-hand is the Moons place at the end of
darkneſs, where when the Moon cometh the immediately
ns to recover light on the Eaſt ſide of her Body ; that on
Left-hand, and without the ſhadow, is the Moons place at
end of the Eclipfe, having then 14 min. 9 ſec. of South La-
e aſcending, where when the Moon cometh, by leaving the
ow, ſhe recovereth her full Light.
 he ſecond Eclipfe is of the Sun, it happeneth the 23th day
June, 36 min. Afternoon, but it will appear no great Eclipfe
in *England*, notwithſtanding the late 20 years *Ephemeris*
faith

2. Diagram of an eclipse from
aunders's almanac for 1693.

33. *The ANATOMY. Names
and Characters of the
12 Sig*[ns].

Poor Robin, 1762.
The ANATOMY.

Names and Characters of the 12 Sig
Houſes.

ate understood it, George Kittredge wrote, for "each sign of the zodiac 'governed' an organ or part of the body, and, in selecting a day to treat any ailment, or to let blood, it was necessary to know whether the moon was or was not in that sign."[15] The degree of seriousness that colonists attached to such astrological influences is hard to determine. Samuel Clough is apologetic about including a man-of-signs in his almanac for 1702. "I have," he wrote, "at the desire of several Country People, added the Anatomy, with the Moons place, and parts of Mans Body she governs as she passeth through the 12 signs (a thing omitted the last year) which is of use to them in cutting their Creatures." One can only conjecture that the country people clamored for an illustration with which they were familiar in English almanacs. Clough expressly limits its usefulness to bleeding animals, not men, and cautiously advises his readers "to mind the Weather as well as the sign." Clough had copied the man-of-signs that John Foster had published in 1678—the first in America.

Variations among the anatomies were few. Once a printer adopted a particular design, he maintained it even though he may have had to recut it several times over a period of years. The figure was usually either erect or seated on a globe, a "flying" anatomical figure such as appeared in the English *Poor Robin's Almanack* for 1762 (copied in *Poor Will's Almanack* in Philadelphia in the 1770s) being a notable departure from tradition. The most innovative man of signs, free of any English sources, was published in Benjamin Banneker's almanac for 1795. Here the figure represents a black man, all the more striking because Banneker himself was a free black.

Calendar page illustrations were introduced to the colonies by way of a different pictorial tradition. Notably absent from English almanacs, cuts of this nature were first printed on this side of the Atlantic in *Poor Richard's Almanack* for 1749, and provided the format and the iconography for many subsequent almanacs (No. 34). Sinclair Hamilton remarks that "it is possible that Benjamin Franklin himself engraved these cuts although Nichols is of the opinion that they were bought in Germany."[16] Their use the same year in the *Neu-Eingerichteter*

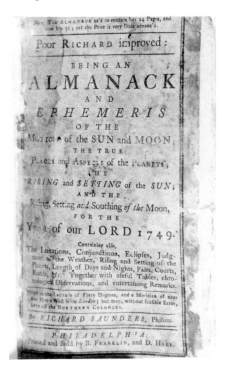

Note, This ALMANACK us'd to contain but 24 Pages, and now has 36; yet the Price is very little advanc'd.

Poor RICHARD improved:

BEING AN

ALMANACK

AND

EPHEMERIS

OF THE

Motion of the SUN and MOON;

THE TRUE

PLACES and ASPECTS of the PLANETS;

THE

RISING and SETTING of the SUN;

AND THE

Rising, Setting and Southing of the Moon,

FOR THE

Year of our LORD 1749.

Containing also,

The Lunations, Conjunctions, Eclipses, Judgment of the Weather, Rising and Setting of the Planets, Length of Days and Nights, Fairs, Courts, Roads, &c. Together with useful Tables, chronological Observations, and entertaining Remarks.

Fitted to the Latitude of Forty Degrees, and a Meridian of near Five Hours West from London; but may, without sensible Error, serve all the NORTHERN COLONIES.

By RICHARD SAUNDERS, Philom.

PHILADELPHIA:

Printed and Sold by B. FRANKLIN, and D. HALL.

34. *Poor Richard improved.*

Americanischer Geschichts-Calendar indicates a probable German origin. Further, the cut for October, true to Continental tradition, depicts a vintner harvesting and stomping his grapes, an activity alien to England and America. Similar representations of the works and pleasures of the months and seasons reach back into antiquity and were especially widespread in medieval sculptural programs and manuscript cycles. Once transplanted to the German-speaking regions of the colonies, these images flourished, lending themselves particularly to the recurrent theme of husbandry in our almanacs.

Not all of the calendar page illustrations are based on those that appeared in Benjamin Franklin's almanac. In 1789, for example, Isaiah Thomas introduced a new iconography while maintaining the earlier format of a zodiac sign flanked by two vignettes. He evidently considered the illustrations a noteworthy

and unusual addition to his almanac, for he wrote in the intro-
duction to it that "the cuts on the lunar pages are descriptive
of the months they are in." Each month's decoration depicts two
activities: one for men, and one for women. Some show men
working at occupations appropriate to the months, while others
show pleasant recreations—sleigh rides in January, dancing
around the maypole and fishing, swimming, reading, and prom-
enading during the hot summer months, hunting and horseback
riding in the fall months, and skating in December.

Portraits appeared sporadically in both English and Ameri-
can almanacs. Most common in England were portraits of al-
manac compilers such as George Parker, William Lilly, George
Wharton, and John Cadbury, all seventeenth-century astrolo-
gers. The range in style is quite broad. On the one hand is an en-
graved likeness of William Lilly, astrologer to Charles I, which
appeared as the frontispiece to his *Merlini Anglici Ephemeris*
for 1647 (No. 35). Executed by William Marshall, whom Hind
describes as an imitator of the unambitious book illustrator
style of the Droeshouts,[17] this portrait is far more complex than
any colonial frontispiece and is certainly drawn with more skill.
On the other hand, relatively crude relief cuts were also used
on title pages of English almanacs. An engraved portrait of
George Parker appeared in seventeenth-century editions of his
almanac. In the eighteenth century, long after he had died, his
name continued to be used. Instead of a copper engraving, a
relief cut was substituted. The portrait is greatly simplified and
loses the elegance and subtlety of the earlier engraving.

The earliest portrait in an American almanac was that of
Queen Anne, which appeared on the title page of Nathaniel
Whittemore's *Farmers Almanack for the Year 1714*. Hamilton
notes that this illustration was the "first woodcut of any conse-
quence to appear in a book in this country in the eighteenth
century."[18] It seems to have been derived from the engraved
portrait of an unnamed woman on the title page of *The Ladies
Diary: or, the Woman's Almanack*, which started publication in
England in 1703, one year after the accession of Queen Anne
to the throne (No. 36). The colonial version explicitly identifies
the woman as Queen Anne with the addition of the initials

"A. R." and with the incorporation of a crown in the oval frame.

Few portraits of compilers were included in American almanacs. One noteworthy exception is the portrait of Benjamin Banneker, the black almanac compiler. The likeness was used in his 1795 almanac and was accompanied by a biographical sketch written by James McHenry.

> I consider this Negro as a fresh proof that the powers of the mind are disconnected with the colour of the skin, or in other words, a striking contradiction to Mr. Hume's doctrine, that the negroes are naturally inferior to the whites, and unsusceptible of attainments in arts and sciences. In every civilized country, we shall find thousands of whites, liberally educated, and who have enjoyed greater opportunities of instruction than this Negro, his inferiors in those intellectual acquirements and capacities that form the most characteristic feature in the human race.

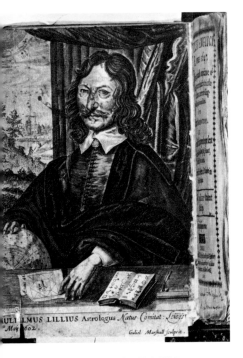

35. *GULILLMUS LILLIUS.*

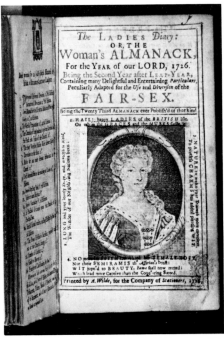

36. *The Ladies Diary: or, the Woman's ALMANACK.*

These lines explain the striking and unusual anatomy that also appeared in this almanac. In the illustration the black man is clothed, leans back in a chair, and writes on a scroll. The portrait itself, although simple in style and execution, is significant because very few images of blacks are extant from the eighteenth century, particularly in the form of portraits.[19]

More popular were portraits of literary, historical, or political significance (No. 37). Thus, Oliver Cromwell, John Dickinson, James Otis, John Dryden, John Hancock, Catharine Macaulay, Pasquale de Paoli (commander of the Corsican forces in their struggle for independence from the Genoese), William Pitt, and George Washington, among others, all made an appearance in American almanacs. In the years preceding the Revolution, many of the likenesses were included for political reasons.

John Wilkes's portrait was used on the title page of *Bickerstaff's Boston Almanack* for 1769 (No. 38). In 1768 Wilkes had been imprisoned as a result of charges brought against him in 1763. Englishmen as well as Americans felt that their constitution was in jeopardy and Wilkes became the personification of liberty to them. This portrait of Wilkes is far more complicated in its symbolism than most, which was a source of concern for the compiler who included an explanation for his readers.

A half Length Figure of the celebrated Patron of Liberty John Wilkes, Esq; crowned with Laurel, supported by Britannia, in the Dress of Minerva, the Goddess of Wisdom, on one Side; and by Hercules the God of Strength, in his proper Dress, the Lion's Skin and Club, on the other Side ——underneath is a Serpent, the Emblem of Envy, which Hercules is treading under his Feet—A Cupid, with the Cap of Liberty—A Shield with St. Georges's Cross, representing the Arms of England—and two Books opened, on one of which is engraved Locke's Works, and on the other Sidney on Government; the first of these is an Author not less famous for his Writings in favour of Liberty, than for his Philosophical Works:—the second, Algernoon Sidney, (Brother to the Earl of Leicester) a Man in whom the Spirit of the antient Republics revived, was beheaded during the

Reign of Charles II for being concerned in the Rye-House Plot; at his Trial as only one Witness, Lord Howard, a Man of a very bad Character, appeared against him, these very Discourses on Government were, by Judge Jefferies and the Jury, deemed equivalent to another Evidence, as they were written in Defence of Liberty and inculcated Republican Principles.

In addition to the portraits of political import, other illustrations dealt with the turbulent affairs of the Revolution and the years leading up to the ratification of the Constitution. Between 1770 and 1789 the pages of American almanacs were often devoted to essays and poetry dealing with questions of liberty, loyalty, and patriotism. Bernard Bailyn, writing on the ideological origins of the Revolution, emphasizes the Revolutionaries' use of every medium of written expression. "Almanacs," Bailyn

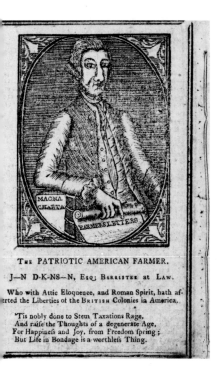

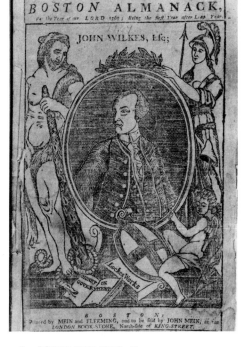

37. *J--N D--K-NS-N, Esq.* 38. *JOHN WILKES, Esq.*

writes, "workaday publications universally available in the colo-
nies, carried, in odd corners and occasional columns, a con-
siderable freight of political comment."[20] Of course, relatively
few of the essays on politics lent themselves to being illustrated,
but nonetheless, the considerable number of political cartoons
must have reinforced the meanings of the essays.

Isaiah Thomas was one of the rebellious Americans. During
the 1770s Thomas published much Revolutionary propaganda.
His first almanac was *The Massachusetts Calendar* for 1772,
which contained a woodcut of the Boston Massacre attributed
to Paul Revere. Under the cut is an eight-line poem relating the
massacre to the cause of justice and freedom. The same illus-
tration was reused in March of the same year on *A Monumental
Inscription on the Fifth of March*, a broadside issued by Isaiah
Thomas to commemorate both the murder of Christopher Seider
and the Boston Massacre. The illustration establishes, in both
of its uses, Thomas's early involvement with the patriot cause.

Paul Revere, a critic of British policy in America since the
Stamp Act crisis,[21] engraved a second political caricature for
Isaiah Thomas that was used on the title page of *The Massachu-
setts Calendar* for 1774 by Ezra Gleason (No. 39). The illustra-
tion is accompanied by a short statement on patriotism and the
wretchedness of disloyalty. The conclusion reads, "Look at the
Engraving of the first Page, and endeavour to form some faint
Idea of the Horrors that Man must endure, who owes his Great-
ness to his Country's Ruin, when he is about taking Leave of
this World, to receive a just and proper Punishment for his
Crimes. Let the Destroyers of Mankind behold and Tremble!"
Bernard Bailyn has recently identified the subject of the illus-
tration as Thomas Hutchinson.[22] The native-born governor of
Massachusetts was unpopular with the colonists, first for his
stand on the Stamp Act and then in 1773 for his enforcement
of the tea tax. Hutchinson was considered by many colonists to
be a traitor, and he returned to London in 1774. This cut is not
mere decoration, but represents an attempt to politicize the
readers and to intimidate loyalists.

Other publishers were also motivated by patriotism in select-
ing material for their almanacs. In Boston the almanacs of

Nathaniel Low, Bickerstaff, and Abraham Weatherwise included political cartoons. In Philadelphia *The Continental Almanack* printed by Francis Bailey contained several political cartoons including a plate depicting Benedict Arnold's effigy being paraded through the streets (1781), *Cornwallis turned Nurse, and his Mistress a Soldier* (1782) (No. 40), and *Tory turned Rope-Dancer* (1783). Although some of these illustrations are crude, they were useful in disseminating political views to a wider audience than could be reached by magazines or newspapers.

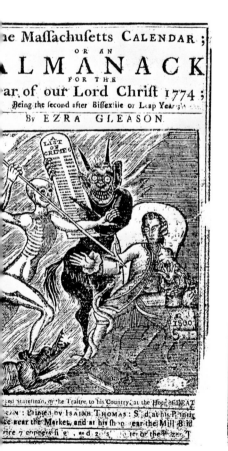

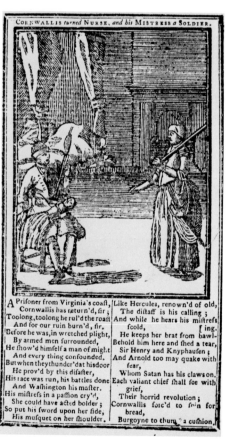

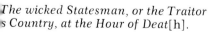

The wicked Statesman, or the Traitor s Country, at the Hour of Deat[h].

40. CORNWALLIS *turned* NURSE, *and his* MISTRESS *a* SOLDIER.

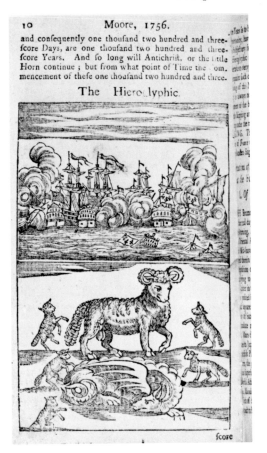

41. *The Hieroglyphic.*

The inclusion of political material in American almanacs was not without precedent. However, what political cartoons are found in English almanacs are oblique in their references and lack the forthright vigor of their American counterparts. A series of almanacs compiled by Francis Moore in London contained what were called hieroglyphics. The political significance of these figures, which are based on emblem books, is of course not readily apparent.[23] Without Moore's explanation, one would be hard pressed to draw the conclusion from his 1756 hieroglyphic (No. 41), for instance, "that by a Ram, (as in the lower

Part) is always noted to signify England, under the Government of the best Monarch in the World, and the lambs skipping and dancing, represent the People rejoicing under the mild Government of a good and gracious King. The Dragon crying shews the Pride and Power of France will be humbled, etc. etc." The rarity of political commentary in English illustration is in no way attributable to any lack of radical attitudes toward authority in the British Isles. One need only to mention the activities of George Townshend and the savage caricatures depicting Fox and Bute. *The Public Advertiser* bemoaned the fact that in London "every window of every printshop is in a manner glazed, and the shop itself papered, with libels."[24]

In the eighteenth century especially, almanacs were considered to be more than mere tools for calculating longitude and latitude or the hour of the day. With their useful information as well as their essays on a variety of subjects, they resembled the encyclopedic magazines of the era, but on a much smaller and less expensive scale. Nathaniel Ames stated in his *Astronomical Diary* for 1765, "I have been very anxious to have it become as useful as possible to those whose Oracle is an Almanack, such as are destitute of any other periodical Performance, as Magazines, or the like, or even News Papers." Compilers considered their works as classrooms for the common man, libraries for the poor and uneducated. Referring to an "Essay on Regimen," Ames wrote in 1754, "I don't pretend to direct the Learned,—the Rich and Voluptuous will scorn my direction and sneer or rail at any that would reclaim them; but since this Sheet enters the solitary Dwellings of the Poor & Illiterate, where the studied Ingenuity of the learned Writer never comes, if these brief Hints do good, it will rejoice the Heart of your humble Servant." Isaiah Thomas believed in the same concept and wrote in the preface to his *Massachusetts, Connecticut, Rhode Island, New Hampshire and Vermont Almanack* for 1783, "I could wish my constant readers would not throw away their Almanacks after the year for which they are calculated is ended, for by preserving them from year to year they may find it much to their advantage as they will often have occasion to turn to many things contained in them."

Almanacs were also designed to entertain and amuse the reader. Numerous genre scenes, wild beasts, and freaks of nature appeared, ranging in subject from *The English Farmer brought home drunk* to *The Wonderful Man Fish* (No. 42). These were generally accompanied by explanatory essays or narratives. Such illustrations never were a popular feature in English almanacs, probably because of the presence of a well-developed street literature tradition—cheap illustrated broadsides, chapbooks, and inexpensive prints. The sources for the American illustrations were diverse and included magazines, books, and prints.

Probably the most thorough explanation of the appearance of an illustration in an almanac was inserted in *Weatherwise's Town and Country Almanack* for 1782. The letter from T. S. to the printer explains how some printers obtained material for their almanacs as well as the intention of the illustration.

Messrs. Printers,
As I understand you are engaged in printing an entertaining Almanack for the ensuing year, which, will no doubt be embellished with some curious engravings;—a short time since I was favoured with the perusal of some late English Magazines, and having observed a very humorous Picture in one of them, entitled, *The English Farmer brought home drunk with his Welcome from his Wife and usual Attendants*, of which scene, the ingenious Artist says he was an eye-witness, at a farmhouse. I imagine, that piece would afford some amusement to your customers, therefore have sent it; hoping, that if you have no drawing in contemplation, that will give greater satisfaction, you will favour it with a place.—It was customary among the Romans, to make their slaves drunk, and then exhibit them in that condition before their children, that they might detest the vice of drunkenness.—Perhaps the present Engraving may have the like beneficial effects on some of your readers, which will be a great happiness to your friend and servant,

Boston, *Sept.* 10, 1781. T. S.

We are much obliged to Mr. T. S. for the Engraving sent,

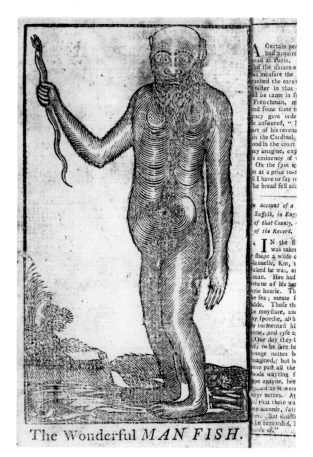

42. *The Wonderful MAN FISH.*

and have complied with his request, in presenting it to our Readers, on the opposite page.—It will always afford the Printers pleasure to gratify any ingenious correspondent in a future Almanack.

Often there was only a short lapse of time between the publication of a book in England and its inclusion in an American almanac. *Bickerstaff's Boston Almanack* for 1774 contained an essay taken from John Hawkesworth's account of Captain Cook's voyages.[25] The almanac contained a folding frontispiece engraved by Joseph Callender of a New Zealand war canoe and

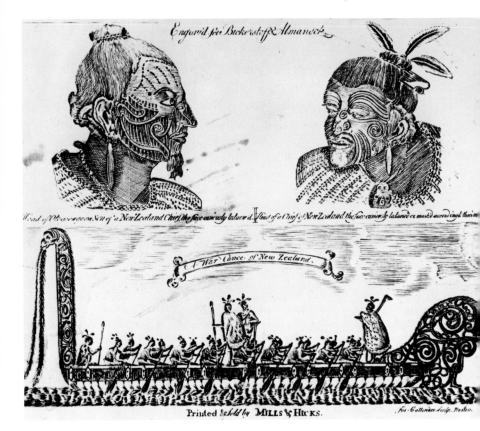

Engrav'd for Bickerstaff's Almanack

Head of Otegoowgoow, Son of a New Zealand Chief the face curiously tataowd. Head of a Chief of New Zealand the face curiously tataowd or mark'd according to their m

A War Canoe of New Zealand.

Printed & sold by **MILLS & HICKS**.

43. Heads of New Zealand chiefs and New Zealand war canoe.

two natives (No. 43). The three illustrations were copied from the plates that accompanied Hawkesworth's narrative published in London. Since the almanac was ready to be distributed in the fall of 1773, the English edition of Captain Cook's travels was available and known in the colonies quickly. The next year *Bickerstaff's Boston Almanack* again featured a plate and an essay taken from Hawkesworth's account. In this instance, however, the plate was copied after an American edition of Cook's voyages printed in New York by James Rivington in 1774.

Readers of the almanacs must have enjoyed the illustrations. Nathaniel Ames, after seeing *Bickerstaff's Boston Almanack* for

1768, which contained illustrations of Patagonian giants from South America and *A Sachem of the Abenakee Nation, rescuing an English officer from Indians*, decided that he too needed to include illustrations in his almanac to retain the large readership that purchased fifty thousand copies of his almanac annually.[26] The almanac trade was very competitive, but also very lucrative. Therefore, compilers and printers spared no effort in attracting readers by making their almanacs both instructive and entertaining.

NOTES:

[1] Recent studies include two articles in John D. Morse, ed., *Prints in and of America to 1850*, Winterthur Conference Report 1970 (Charlottesville, Va., 1970), "Seventeenth-Century American Prints" by Richard B. Holman, and "Prints and Scientific Illustration in America" by Charles B. Wood III. At the conference held by the Colonial Society of Massachusetts in 1971, Charles Wood discussed "American Scientific Illustration, 1675–1775." This article, published in *Boston Prints & Printmakers, 1670–1775* (Boston, 1973), was particularly helpful for its careful discussion of the early almanac diagrams. Sinclair Hamilton, *Early American Book Illustrators and Wood Engravers, 1670–1870* (Princeton, N. J., 1968), is a magnificent source of information about individual book illustrations in the eighteenth century. See also Elizabeth Carroll Reilly, *A Dictionary of Colonial American Printer's Ornaments and Illustrations* (Worcester, Mass., 1975).

[2] This is evident in Elizabeth Reilly's recently published volume. I am grateful to her for the use of her notes and photographs that she collected in the preparation of the *Dictionary.*

[3] Charles L. Nichols, "Notes on the Almanacs of Massachusetts," American Antiquarian Society, *Proceedings*, N.S., XXII (April 1912), p. 18.

[4] Clarence S. Brigham, *Paul Revere's Engravings* (Worcester, Mass., 1954), pp. 43 and 73.

[5] Andrew Oliver, "Peter Pelham (c. 1697–1751), Sometime Printmaker of Boston," in *Boston Prints & Printmakers*, p. 138.

[6] Harold E. Dickson, *John Wesley Jarvis, American Painter, 1780–1840* (New York, 1949), p. 47.

[7] Brigham, *Revere*, p. 81. Revere's accounts reveal that he made 1,000 copies of each engraving for the *Royal American Magazine*, 1774–1775.

[8] Hamilton, *Early American Book Illustrators*, p. 16. Isaiah Thomas had been apprenticed to Zachariah Fowle in 1756 and eventually took over Fowle's printing business. In fact, Thomas had made a number of cuts for Fowle; it is possible that he made the one of George III/Christian VII. The ultimate source for the portrait may be an engraving of Frederick the Great, which appeared simultaneously in the New York and Phila-

delphia editions of *Father Abraham's Almanack* for 1759. Stauffer was unable to identify the engraver who signed himself "J. M.," although he surmised that he was an apprentice to James Turner, who was in Philadelphia at that time.

[9] A. M. Hind, *A Short History of Engraving & Etching* . . . (Boston, 1908), p. 15. This use of two different plates is not unique. The engraving by Joseph Callender used as a frontispiece to *Bickerstaff's Boston Almanack* for 1774 was copied as a relief cut, and the same thing happened the following year.

[10] Quoted in Robb Sagendorph, *America and her Almanacs: Wit, Wisdom & Weather, 1639–1970* (Dublin, N. H., 1970), p. 76.

[11] Geneviève Bollème, *Les almanachs populaires aux XVIIe et XVIIIe siècles* (Paris, 1969), p. 14.

[12] "English Almanacs; Their History and Present State," *London Magazine* (December 1828), p. 1.

[13] Sagendorph, *America and her Almanacs*, p. 76.

[14] There were, however, verbal descriptions of all the eclipses.

[15] George Lyman Kittredge, *The Old Farmer and His Almanack* (Boston, 1904), p. 53.

[16] Hamilton, *Early American Book Illustrators*, p. 9.

[17] Hind, *Short History*, p. 138.

[18] Hamilton, *Early American Book Illustrators*, p. 5.

[19] Ellwood Parry, *The Image of the Indian and the Black Man in American Art, 1590–1900* (New York, 1974). "The Black man was rarely heroized in this age of heroes and Hero-worship. Negro servants continued to appear beside their masters in a few Romantic portraits, . . . despite a rising interest in the independent existence of freed slaves and free-born Blacks." P. 36.

[20] Bernard Bailyn, *The Ideological Origins of the American Revolution* (Cambridge, Mass., 1967), pp. 1–2.

[21] See Revere's prints, *View of the Year 1765* and *A View of the Obelisk.*

[22] Bernard Bailyn, *The Ordeal of Thomas Hutchinson* (Cambridge, Mass., 1974), p. 4. One key to the identification of the illustration is the piece of paper with £1500 written on it, representing Hutchinson's disputed salary "drawn from the income of the tea duty in America." P. 259.

[23] In Moore's almanac for 1777, he explains that a few years before, "A Gentleman presented me with a large Volume of Hieroglyphicks, and so I shall print one yearly." He went on to advise "all honest men to be loyal to Government, and as for the other Sort let them take their Fate with the rebellious Americans." This is one of the few direct references to colonial affairs in the English almanacs that I examined.

[24] John Wardroper, *Kings, Lords and Wicked Libellers: Satire and Protest, 1760–1837* (London, 1973), p. 29.

[25] John Hawkesworth, *An Account of the Voyages . . . Undertaken for Making Discoveries in the Southern Hemisphere*, 3 vols. (London, 1773).

[26] Nichols, "Almanacs of Massachusetts," pp. 35, 37.

Embellishments for Practical Repositories: Eighteenth-Century American Magazine Illustration

> "We are destined to create what our predecessors in this walk had only to duplicate."
>
> ROBERT AITKEN, 1775

Peter J. Parker and Stefanie Munsing Winkelbauer

WE make no pretense that this study of American magazine illustration will tell you much about eighteenth-century American printmaking. Indeed, even though the techniques are much the same, we are tempted to call them different media, created for dissimilar markets. No one of the caliber of Edward Savage, for example, engraved for magazines. Nor do we think that anyone of his ability would have thought it appropriate to do so. Magazine plates were artisan work, subject to temporal, thematic, and financial limitations frequently beyond their creators' control. Publishers employed artisan illustrators much as they would journeymen printers or subscription peddlers—the object was to produce a magazine that did not lose the publisher's investment.

There were artistic limitations as well. Most American illustrators were self-taught. Many copied from printed models. The fact that they learned and worked outside of a self-consciously creative artistic community, such as that of the Academicians,

suggests that some would be satisfied with minimal technical competence. And the models they chose undoubtedly influenced and perhaps limited their conceptual vocabulary. Yet, despite these limitations, there were a number who, by the end of the century, had mastered their skills sufficiently to produce works that were much more than poor imitations of English originals.

Because so few magazine illustrations could stand on their own as artistic or narrative entities, we have treated them as artifacts, deriving their importance from the context in which they were created and in which they appeared. To learn something of that context we have surveyed five leading American magazines: two from Boston, the *Royal American* and the *Massachusetts Magazine*; the *New York Magazine*; and two from Philadelphia, the *Pennsylvania Magazine* and the *Columbian*. We chose these because each circulated widely beyond its city of origin, because each possessed vitality and comparative longevity, and, frankly, because they were readily available to us. We have attempted to construct a composite of American magazine engravers and their work. To determine whether there was anything uniquely American about them we have attempted a similar identi-kit from the five leading English competitors: the *Gentleman's*, the *London*, the *Town and Country*, the *Universal*, and the *Westminster* magazines, all of which Robert Aitken cited opprobriously in his apologia for the *Pennsylvania Magazine* in 1775.[1]

Early American magazine illustration has not received much analytical scholarly attention.[2] The reasons for this academic oversight are clear: much of it was poorly done. Moreover, there simply are not very many illustrations with which to deal. When we examined the surviving bound volumes on the shelves of the Library Company of Philadelphia and the Historical Society of Pennsylvania, we discovered that a fair number of plates had been removed by earlier generations of readers. What was left seemed rather crude and derivative. More than once we were prepared to acquiesce to the wisdom of scholarly inattention.

We were, however, bothered by several facts that simply would not be waved away. Readers *had* removed plates. We

could not tell whether the removed prints had gone on walls or into scrapbooks, but that was unimportant. What was significant was that some magazine illustrations had assumed different uses, had taken on different roles. They had become decorative art objects. As such they must have had some merit not readily apparent to the twentieth-century eye. Quite possibly they appealed to some political if not aesthetic sense.

We noticed, too, that the American magazines with the longest publishing histories were generally those with the most numerous plates. We concluded that illustrations increased a publisher's chances for success. Robert Aitken thought so. His proposals for the *Pennsylvania Magazine* announced: "First. The work will consist of six half-sheets octavo, stitched blue paper. Secondly. A copper-plate will be given with every number, or on particular occasions, as encouragement offers."[3] Evidently there was no lack of encouragement, for the magazine, complete with a plate in each issue, appeared regularly until July 1776 when wartime shortages and uncertainties caused Aitken to suspend publication.

Ten years later the proprietors of the new *Columbian Magazine* followed Aitken's example. Their proposal, issued in the *Pennsylvania Gazette* in August 1786, boasted that their magazine would be "adorned with *two* engravings on copper-plate, executed by an American artist."[4] The artist was James Trenchard, one of the proprietors, who lived up to his promise. The original proprietorship, a complicated partnership of Mathew Carey, William Spotswood, Thomas Seddon, Charles Cist, and Trenchard, did not last as long as the magazine. In November 1786 Carey withdrew to begin his own magazine, the *American Museum*.[5] After several other hivings-out only Trenchard remained. Indeed, one of the erstwhile partners, Thomas Seddon, went mad.[6] Competition had taken its toll of the partners, but the *Columbian* flourished for three more years until increased postal rates rather than a dearth of illustrations caused it to cease publication.

Both Aitken and the publishers of the *Columbian* hoped that the promise of illustrations would attract subscribers. This is not to suggest that they imagined that the plates they provided

would ever become decorative art. Neither they nor their public confused the two. Good prints were available and Americans bought them in considerable numbers.[7] Each major city had at least one book- and printseller where "gentlemen for furniture, and shopkeepers to sell again, may be furnished with a very neat assortment Of new and useful Maps, from Four Pounds cash to Three and Nine-pence each; curious and entertaining prints, . . . Glazed Pictures in the present English taste, . . . Amongst which are, scriptural, historical, humorous and miscellaneous designs."[8]

American magazines were illustrated because English magazines were. The widespread availability of well-illustrated magazines such as the *Gentleman's* or the *Westminster* had habituated American readers to a particular format and to the presence of plates. The successful American magazine consciously aped English format and content, providing a potpourri with a strong local flavor. Aitken, for example, hoped that his *Pennsylvania Magazine* would be a "nursery for Genius" and a "market for wit and utility." He continued: "The British magazines, at their commencement, were the repositories of ingenuity: They are now the retailers of tale and nonsense. From elegance they sunk to simplicity, from simplicity to folly, and from folly to voluptuousness. . . . They have added to the dissolution of manners, and supported Venus against the muses."[9] Despite Aitken's Presbyterian rancor against the contents of his English models, in matter and form he certainly patterned his own after English originals. The *Pennsylvania Magazine* first appeared in January 1775. It contained an engraved emblematic title page, was printed in two columns, and contained "departments" of articles culled from English and American books, magazines, and newspapers. Even the plate for the December issue was borrowed. The "Machine for delivering persons from burning houses" Aitken etched after an earlier appearance in the *London Magazine.* One could multiply the Aitken example many times: Noah Webster's *American Magazine*, Isaiah Thomas's *Royal American*, and the *Columbian* all followed the English pattern. They all practiced what Frank Luther Mott has called "the eclectic system" and were, if you will, prototypes for the *Reader's Digest.*[10]

The eclectic system did not rule out original American illustrations or articles. But, considering the publisher's production expenses, one doubts that engravers were paid very much or that authors were paid at all. Unhampered by the niceties of copyright illustrators, editors and publishers used whatever came to hand. After all, piracy is cheaper than payment.

Money, or the lack of it, was the persistent problem plaguing magazine publishers. Many of them were their own manufacturing printers. Of the forty-three magazines listed by Mott as appearing before 1800, we know that most were produced in the printing houses of their publishers. All these printer-publishers engaged in a wide variety of printing and book work. Carey of the *Columbian* and the *Museum* published a newspaper, the *Pennsylvania Herald*, for several years. In 1775, the first year of the *Pennsylvania Magazine*, its publisher, Robert Aitken, published at least seven books and pamphlets, executed job printing, and bound a seemingly endless stream of books for his customers. Magazines offered only one string to the busy bows of these printer-publisher entrepreneurs.

Because their resources were limited, these businessmen could ill-afford to tie up capital in unsold magazines. They were too expensive to produce. By extrapolating from figures in Aitken's wastebook and from a 1795 contract between Isaiah Thomas and a Boston printer we can estimate that the annual costs for printing the *Columbian*, the *Massachusetts*, or the *Royal American* would have been about £350. Because magazines carried no paid advertisements, publishers had to recover costs from their subscribers. Subscriptions were relatively expensive—from 12s. a year before the Revolution to as much as $3.50 a year after the war.[11] At these rates Aitken would have needed 584 subscribers simply to pay for the printing of his *Pennsylvania Magazine*; this makes no allowance for illustration, distribution, or capital costs.

Because these subscription rates represented as much as two days' pay for an eighteenth-century artisan or mechanic, we can surmise that the market of potential subscribers was small and had to be cultivated intensively. Two characteristics of that market deserve comment. Financially its members were at least

of the middling sort. They were also more than Bible-literate. Yet we must bear in mind that their information horizons, the variety and diversity of learning and tastes, were certainly more limited than today. Not only were there practical limits to learning, but there were also correct ways of articulating that learning. In law, for example, Blackstone opined that "where there is no writ there is no remedy," and a Scottish literary critic, William Duff, in 1767 defined original genius as "distinguished by regularity, clearness, and accuracy."[12] As familiar as we are with such statements of eighteenth-century attitudes we should also consider their consequences on the creation of American magazine illustration. Rather than mold cultural attitudes, publishers catered to them. Just as there was a right way to parse a sentence or plead a tort so there was a right way to describe nature. Middle-brow subscribers to American magazines had learned at least this much from English magazines.

These then were the realities of magazine publication in eighteenth-century America: high production costs, a limited market, and competition from English magazines that were often models of "regularity, clearness, and accuracy." Some American publishers had a difficult time meeting the challenge. In November 1775, for example, "N. T. R." warned Aitken: "Your Magazine was doubtless intended to be, and, if well conducted, will certainly prove, an useful repository of information and instruction, on various subjects, to those who purchase it. At the same time, it is to be considered as a nursery for young authors, who may easily try their strength in short essays, with little loss of time, and no great risk in point of reputation. That it may answer both these purposes effectually, it is necessary that you should be cautious what you admit . . ."[13] If their literary content were somewhat uneven, at least publishers could fall back upon illustrations, but at the expense of even higher production costs.

Benjamin Lewis lists 468 illustrations appearing in thirty-one magazines published before 1800. Most were etched rather than engraved, and it is obvious why this was so. The author of the article on "Etching" in Thomas Dobson's 1798 *Encyclopaedia* states that it was "practised by painters and other artists, who could much sooner form their hands to, and attain a faculty of,

working in this way, than with the graver."[14] Unfortunately, there is not an abundance of evidence concerning production costs. American magazine publishers presumably sought cheap illustrations for their offerings. Benjamin Lewis lists thirty-one engravers whose signed work appeared before 1800. From Groce and Wallace and Stauffer we have learned that two were born in England and sixteen were born in America.[15] Only two received formal training in London. Six are known to have served American apprenticeships. Of the twenty whose birth dates we could discover, six began their magazine work before they were twenty and seven more before they reached the age of twenty-five. (A tabular summary appears as Table I.) Their comparative youth and lack of formal training meant that publishers could have their work rather cheaply. And, although eight worked for more than one magazine, it is clear from available biographical information and their newspaper advertisements that these illustrators could not make a living from etching alone. Twenty-four of the thirty-one are known to have had at least one more trade. Many, like Revere, practiced other metal trades. Joseph Callender was a die-sinker, James Poupard traded as a goldsmith, while Tanner and Tiebout both engraved bank notes. One, Caleb Lownes, even became a petty bureaucrat on the Philadelphia Board of Health. One wonders whether a Hogarthian horror of the pox led him into this career!

To test whether our composite of American engravers was indeed American—except by accident of location—we sampled the leading English competition. Unlike those of American magazines, we discovered that the vast majority of English plates are unsigned. A random sampling produced fourteen engravers who did sign their plates and who had biographies in Thieme and Becker.[16] They had astonishingly similar backgrounds: four studied at and most exhibited at the Royal Academy. Many were members of the Society of Artists and one, Robert Pollard, even became a director. In short, they represented the establishment of English printmaking.

Indeed, the presence of so many unsigned plates confirms our impression of a professionalism in English magazine illustration. Magazine plates were hardly the master works that a Coll-

yer or Cook would sign. Moreover, many of the English engravers we found in Thieme–Becker had students themselves. It is probable that many of the unsigned plates were executed in the studios of the masters, where criticism and correction insured technical competence and encouraged virtuosity. This was not necessarily the case. Admittedly Aitken, Doolittle, and Revere counted heavily upon English models before the Revolution. But the subject matter of their work—such as the deliberately American title page of the *Pennsylvania Magazine* (No. 44), drawn by du Simitière and engraved by Aitken—introduced an unconscious freedom from English models. After all, what English engraver could rejoice "Juvat in sylvis habitare"?

To complete our composite of American magazine illustration we have counted and arranged them into several categories. The categories are self-evident: views, natural history, natural philosophy, history and biography, maps, and a miscellaneous category for curiosities and emblematic views. Lewis, of course, did much of the counting for us, but the categories are ours. Thus all medical illustrations as well as those of plants, animals, and fossils fall into natural history. Natural philosophy encompasses astronomical drawings and scientific and practical machinery. Fire engines and eclipses are lumped somewhat unnaturally in this category. Portraits fall under the rubric of history and biography, as do engravings of tombs, archaeological artifacts, and armorial bearings. Table II compares the subject matter of American illustration with that of the *Gentleman's Magazine* for selected years.

As our counting progressed we became aware of some rather striking differences between American and English magazines. As might be expected, American magazines carried few armorial bearings. Nor do Americans seem to have been very interested in the graves of the glorious dead. The *New York Magazine* published three illustrations of tombs, but it seems to have been alone in its necromancy. Similarly, Americans had little interest in the treasures of Herculaneum or Pompeii. Indian bones from the shores of the Ohio satisfied the American taste. Robert Aitken provided the explanation. "It should also be observed that we are altogether deprived of one considerable fund of enter-

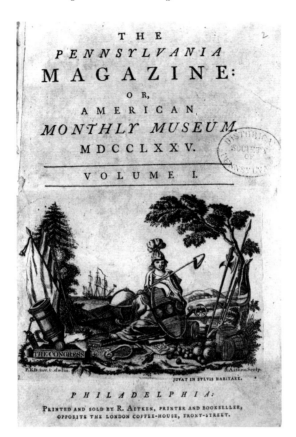

44. *THE PENNSYLVANIA MAGAZINE: OR,*
AMERICAN MONTHLY MUSEUM.

tainment which contributes largely to the embellishments of
the Magazines in Europe, *viz*. Discoveries of the curious remains
of antiquity; the descriptions of which often lead to interesting
confirmations of historical facts, or plainly point to the rites and
ceremonies of former ages."[17] This much is self-evident. But
Aitken continues, somehow making a virtue of necessity. "A
new settled country cannot be expected to afford any entertain-
ment of this kind. We can look no farther back than to the rude
manners and customs of the savage *Aborigines* of *North Amer-*
ica. Nevertheless . . . even these may afford many curious par-

ticulars,"[18] providing, of course, that these particulars were
drawn with "regularity, clearness, and accuracy." Let us now
examine some of these particulars.

First, it will become clear that one man in each establishment
was chiefly responsible for the magazine's illustrations. As Table
I makes clear, he neither had nor could expect multitudes of
fledgling engravers to do his bidding; the rewards simply were
not there. Second, the illustrations that appear in American
magazines reflect that individual's own reading of eighteenth-
century aesthetics, his familiarity with English magazines, and
the breadth and depth of his own experience. Each of the fol-
lowing magazines was the result of this experience.

*The Royal American Magazine, or Universal Repository of
Instruction and Amusement* was the first colonial effort manag-
ing to sustain itself beyond one or two issues that consciously
adopted the English format of including monthly illustrations
for the readers' delectation. The plates, largely executed by the
silversmith Paul Revere, were decidedly provincial in style while
unabashedly derivative in content. In the magazine's first issue,
January 1774, Revere's *View of the Town of Boston* showing the
landing of the British troops hit as close to home as any subject
could. Virtually identical to his earlier prints after Christian
Remick's 1769 watercolor, the *Royal American*'s version lacks
the languishing Indian adorning the cartouche and the identifi-
cation key. The February issue contained *Sir Wilbraham Went-
worth* (No. 45), a typical example of the direct copy of literary
illustrations much favored by the *Royal American*. Although
this picture is better than the average of Revere's copies, it typi-
fies many of his technical drawbacks. Revere's engraving in
copying English illustrations was labored at best; the human
form did not flow from his burin as gracefully as did the rocaille
swags of armorial bearings on bookplates or silverware. Unused
to perspective drawing, his line lacked the easy definition mas-
tered by even the most pedestrian London engravers. This lack-
luster character is true of all direct American copies of English
illustrations. The example of Revere suggests that the inexperi-
enced and untrained provincials were unable to reproduce with
vitality and equal proficiency the variety of styles reflected in

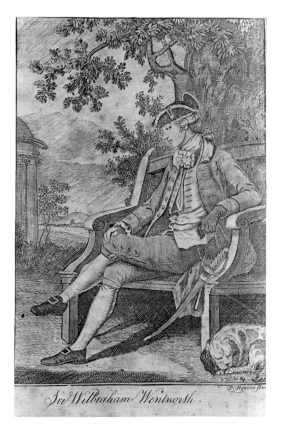

45. *Sir Wilbraham Wentworth.*

their foreign competition. Occasionally this naiveté has its own charms, such as in *Damon, and Musidora* (No. 46), etched by Samuel Hill for the August 1792 *Massachusetts Magazine,* but one must not confuse maladroitness with art.

Close on the heels of the *Royal American* came Robert Aitken's *Pennsylvania Magazine, or American Monthly Museum.* Its seventeen issues, beginning in January 1775, illustrated a wide variety of subjects, emphasizing practical machinery and the events and places of the War for Independence. Aitken engraved most of the plates himself, including the magazine's allegorical frontispiece, designed by Pierre Eugène du Simitière

(No. 44). Aitken hoped that his magazine would become a "nursery for genius"; in that spirit he gave preference to American designs. One of the first was the etching, *A New invented Machine for the Spinning of Wool or Cotton*. Unusually elegant lettering identified the plate as "Engraved for the Pennsylvania Magazine By Christopher Tully, who first Made and Introduced this Machine into this Country" (No. 47).

Among the best-known plates for the *Pennsylvania Magazine* is *A Correct View of The Late Battle at Charlestown* in the September 1775 issue. This was wartime art at its most journalistic.

46. *DAMON, and MUSIDORA.*

Published several months after the event, the depiction was nevertheless one of the most stirring scenes to appear in an eighteenth-century American magazine. Previous issues of the *Pennsylvania Magazine* had set the scene with maps of Boston and its environs, and it is easy to imagine Aitken's readership clamoring for a more graphic representation of the battle. Aitken undertook the arduous task himself, sparing no pains to fill the plate with rows of firing soldiers, heaps of dead and wounded, and billowing smoke from burning houses. Yet the *Battle at Charlestown* is not art; Aitken's dry style was better suited to houses than soldiers, and it was best suited to the scientific illustrations that appeared throughout the *Pennsylvania Magazine*'s short-lived history.

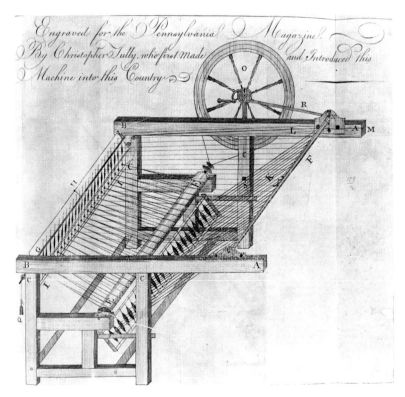

47. [A New invented Machine for the Spinning of Wool or Cotton.]

No New York publication of purpose and dimensions similar to the *Royal American* or *Pennsylvania Magazine* is known to have existed during the Revolutionary era, but both publications were available in New York, and any prospective publisher was doubtless daunted by the competition in a period of acute shortages. Nor was New York noted for the number of resident engravers. It was not until 1790 that a publication was started to compete with the already well-established *Columbian Magazine* of Philadelphia and the fast-rising *Massachusetts Magazine* of Boston, all of whose illustrations were to compete closely during the last decades of the eighteenth century.[19]

James Trenchard, one of the founders of the *Columbian Magazine*, was trained as an engraver by James Smither, one of Philadelphia's more competent early printmakers. His magazine lived up to its subtitle, "a Monthly Miscellany," in the diversity of illustrative material. It covered a greater range of subject matter than any of its leading competitors, coming perhaps closest to the true spirit of the English omnia gathera. Also included were the previously neglected topics of archaeology and armorial bearings (now no longer those of the aristocracy but of the new states).

The first American narrative illustration to accompany a literary effort in a magazine, *Amelia; or the faithless Briton* (No. 48), made its appearance in the *Columbian* in October 1787. It should be noted that this was the *Columbian*'s only literary plate, while the *New York* and *Massachusetts* magazines relied heavily on lugubrious illustrations to writings now happily in oblivion. None of the American prints, however, had quite the range of titillating enticements as those found in English magazines such as the *Ladies'* or *Westminster*, where bosoms fairly heaved with passion as in *Love in a Village* (No. 49), *Westminster Magazine*, August 1793. This was frank eroticism much in the manner of tabloid journals today.

Like Aitken, Trenchard engraved most of his own plates and rarely cited his sources. There was, not surprisingly, a strong emphasis on views of Philadelphia and Pennsylvania, an increased interest in localism quickly noted by the publishers of the *New York* and *Massachusetts* magazines. In an unstinting

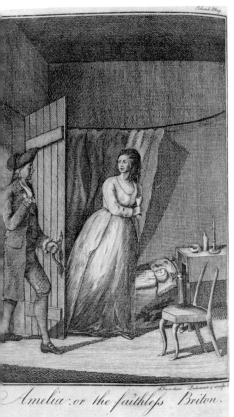

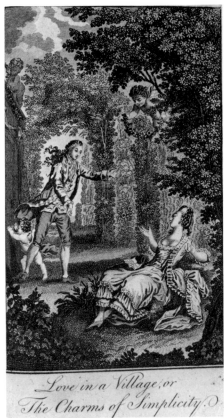

48. *Amelia: or the faithless Briton.*

49. *Love in a Village, or The Charms of Simplicity.*

effort to attract a visually minded audience, Trenchard increased the number of illustrations per issue, sometimes including as many as four plates. By spring 1788 the work of providing some of the illustrations had fallen to one of Trenchard's partners, John Vallance, better known in his later career as a bank note engraver.

The *Massachusetts Magazine* began publication in January 1789. The chief engraver was Samuel Hill, known only to us through these plates, book illustrations, and some certificates. Judging by the quality of his draughtsmanship, his artistic

training was minimal. While the plates he etched after his own drawings evinced a vitality born out of the joy of creation, those copied from other sources are starkly lifeless. Compare the lushly vegetated garden surrounding the *View of the Seat of his Excellency John Hancock*, etched after his own drawing[20] (No. 50) to the bleakly disinterested rendering of *Green Hill. The Seat of Samuel Meredith Esqr. near Philadelphia*[21] (No. 51) etched after the design of Jonathan Hoffman. Clearly there was a difference in Hill's handling of his media where his own imagination was involved.

Hill's counterpart at the *New York Magazine*, begun in 1790, a year after the *Massachusetts Magazine*, was Cornelius Tiebout. He was one of the few native eighteenth-century engravers to have received European training, although not until after he had worked for the *New York Magazine* for three years. Trained as a silversmith, Tiebout brought to his handling of the media the same technical background as Revere. Some of his plates show an aching lack of facility in drawing; however, Tiebout's London training corrected the situation sufficiently for him to become one of America's better early intaglio printmakers. Like Hill, Tiebout did a better job when copying his own designs, such as *The Seat of the Vice President of the United States*, not unlike Hill's *Seat of John Hancock* in style and composition. Notice the title—instead of democratically calling the picture "Mr. John Adams's House," it became *The Seat of his Excellency the Vice President*—so ingrained was the habit of derivation and deference.

These magazines were truly repositories, spiced with taxonomic illustrations to entice the information-thirsty reader to buy the magazine. As with today's magazine marketing, one looked for the novel and the unusual: places, animals, gimcracks; indeed, all of those sights that an isolated American could not expect to see in his "back forty."

While there may have been elk or buffalo grazing near the reader's fields, surely none looked quite like the quizzical beast chained to a tree stump depicted in the *Massachusetts Magazine* of May 1792 (No. 52A). The proud *Moose Deer* (No. 52B) in the February 1786 *Universal Magazine* resembled his model far

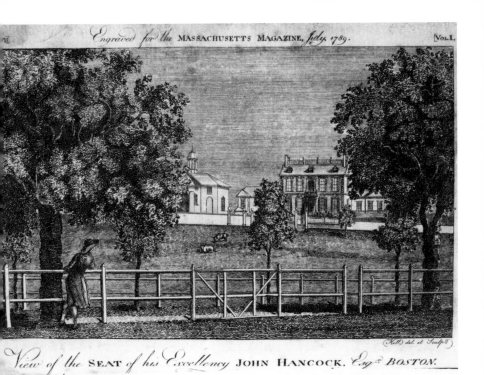

View of the SEAT of his Excellency JOHN HANCOCK, Esqr. BOSTON.

50. *View of the SEAT of his Excellency JOHN HANCOCK, Esqr. BOSTON.*

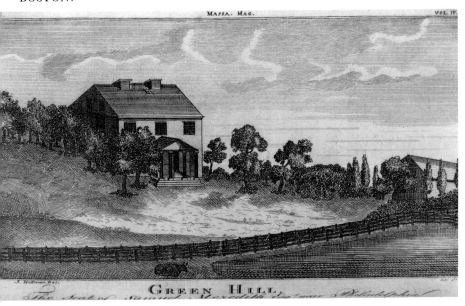

GREEN HILL,
The Seat of Samuel Meredith's Esqr. near Philadelphia.

51. *GREEN HILL. The Seat of Samuel Meredith Esqr. near Philadelphia.*

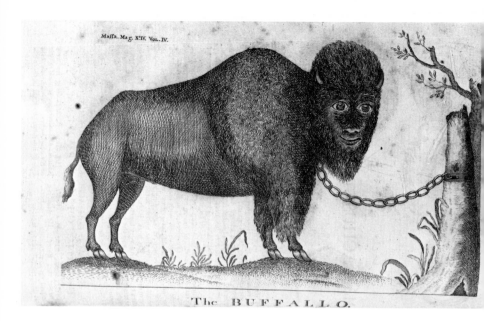

52A. *The Buffallo.*

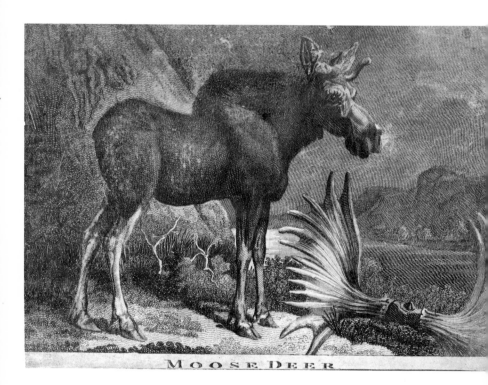

52B. *MOOSE DEER.*

more closely. Birds were consistently well engraved by American printmakers in magazines, as exemplified by *The Baltimore Oriole* from the *Massachusetts Magazine* of May 1791 and *The Titmouse* in the December 1789 *Columbian Magazine*.

It is important to remember that eighteenth-century Englishmen and Americans referred to the sciences as "natural history" and "natural philosophy." The unconscious empiricist on both sides of the Atlantic looked for graphic descriptions of the nature which he could not control as well as the machines with which he could control nature. *A New Machine to Go without Horses* from the *Supplement* of the 1774 *Universal Magazine* and *A Plan of Mr. Fitch's Steamboat* in the December 1786 *Columbian Magazine* are examples of the type of illustration that might delight devotees of *Popular Mechanics* even today, although their details are not always as readily comprehensible to the modern eye as they doubtless were to the eighteenth-century tinkerer.

It would be interesting to speculate on what kind of an optical device Cornelius Tiebout might have used to reduce one of the large versions of Federal Hall in New York for his plate bound with the March 1790 issue of *New York Magazine* (No. 53). It is noteworthy that the *Massachusetts Magazine* was far more timely in its illustrations than the *New York Magazine*. Samuel Hill produced a view of the edifice nine months before Tiebout managed to produce a plate, and another version appeared in the August 1789 *Columbian*.[22] Amos Doolittle's depiction of the inauguration of President George Washington on the balcony of the Federal Hall appeared in 1790; it is possible that he simply added figures and four chimneys to the structure outlined by Hill.

The *Massachusetts Magazine* continued to be on top of the news with a view of the Bastille issued only five months after its storming and fall; Tiebout's exact copy lagged a full nine months longer. Yet another identical version was etched by Thomas Clarke for the *American Universal Magazine* of Philadelphia as late as September 1797.

Topical portraits occasionally graced American magazine pages, although the French minister of finance Jacques Necker appears to have lost his teeth in the October 1789 *Massachusetts*

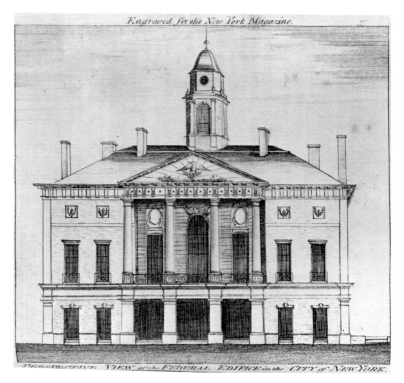

Engraved for the New York Magazine.

PERSPECTIVE VIEW of the FEDERAL EDIFICE in the CITY of NEW YORK.

53. *PERSPECTIVE VIEW of the FEDERAL EDIFICE in the CITY of NEW YORK.*

Magazine when compared to the original print engraved by Thomas Cooke in the *Universal Magazine* of September 1785— four years without a dentist had taken their toll.

It is worth mentioning that no portraiture as stirringly grand as that of *Peter the Great* from *Gentleman's Magazine*, February 1783, or as graceful as that of botanist Carl Linnaeus, *Westminster Magazine*, April 1778, with the charming gardening vignette below the bas-relief head, appeared in American magazines. Revere's *The Honble. John Hancock. Esqr.* (No. 54)[23] makes a bold stab at baroque grandeur, but the stance is negated by the lean, hungry quality of the line. No other American magazine engraver attempted portraiture in this grand manner. Whether it was beyond his technical capabilities is probably

immaterial; it seems that his conceptualizations of portraiture and of nature were based upon a vocabulary and experience different from those of his English counterparts.

This is nowhere more clear than in the handling of wilderness scenes. The English view of the exotically wild *View of the*

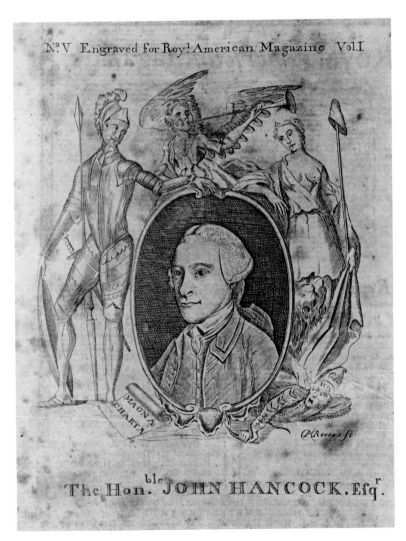

54. *The Honble. JOHN HANCOCK. Esqr.*

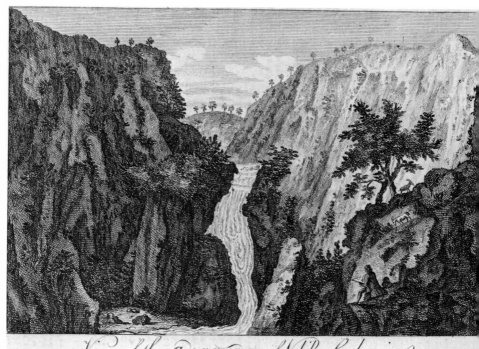

55. *View of the CASCADE, of Velika Gubaviza.*

Cascade, of Velika Gubaviza (No. 55) from the *Gentleman's Magazine,* January 1778, has a texture that reaches out toward the viewer. The manipulated composition has a pleasing verisimilitude, whereas the *Veiw of a pass over the South Mountain from York Town to Carlisle* (No. 56) was probably as starkly overawing as Thomas Bedwell's view in the May 1788 *Columbian Magazine.* One feels that the lone artist or fisherman perched on a rock in the English scene was at peace with his spectacular surroundings; the more restless Americans had to people their vast landscapes. Two views of Passaic Falls in New Jersey made the point more succinctly. Captain Thomas Davies drew the view engraved for the *Scenographica Americana* while on detail to the American colonies with the British Army. His

artistry sprang from the tradition of English military water-color drawings, topographically correct, to supply immediate information on possibly hostile terrain. Davies's newfound wilderness is peopled by an Indian family that hunts with the white man's gun. A view of the same scene etched by John Scoles for the February 1795 *New York Magazine* replaced the Indians with a white settler fishing for his supper, a tidy house with fenced garden in the near distance. Even in the handling of pacified nature the differences between English and American pictorial expression are evidenced in magazine prints.

Our research has convinced us that the successful American magazine needed illustrations. Magazine publishers had to rely upon quondum craftsmen or halfway journeymen who nevertheless took sufficient pride in their work to sign it. In our choice of documentation we have been as eclectic as the magazines we have described. Exceptions, even contradictory evidence, may exist. However, we may say of American magazine illustrators

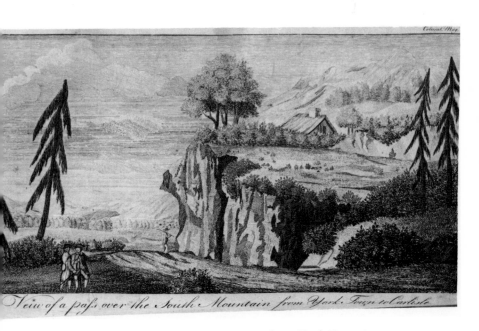

56. *Veiw of a pass over the South Mountain from York Town to Carlisle.*

of the eighteenth century that it was not their expertise but their ability to communicate in a language familiar to their readers that made their magazines both provincial and successful. American magazine illustrators, after all, spoke the same language as their English progenitors, but with a different dialect.

NOTES:

[1] *Pennsylvania Magazine*, I (January 1775), p. 10.

[2] The basis of this and all other studies of early American magazine illustrations is Benjamin M. Lewis, *A Guide to Engravings in American Magazines, 1741–1810* (New York, 1959). Lewis lists engravings by magazine, subject, and engraver. In the course of our research we were not able to find one "not in Lewis" item. Clarence S. Brigham, *Paul Revere's Engravings* (Worcester, Mass., 1954), treats all of Revere's work, but cannot be considered analytical. Frank Luther Mott, *A History of American Magazines*, I: *1741–1850* (Cambridge, Mass., 1938), and Lyon N. Richardson, *A History of Early American Magazines, 1741–1789* (New York, 1931), are excellent introductions to magazines, but not to their illustrations. Two recent dissertations, Jack F. Schoof, "A Study of Didactic Attitudes on the Fine Arts in America as Expressed in Popular Magazines during the Period 1786–1800" (Ohio University, 1967), and J. Meredith Neil, "Towards a National Taste: The Fine Arts and Travel in American Magazines from 1783 to 1815" (Washington State University, 1966), should be consulted for critical attitudes toward the fine arts generally. Neither, however, pays analytical attention to the illustrations in the magazines they use as evidence.

[3] *Pennsylvania Gazette* (Philadelphia), November 23, 1774.

[4] Ibid., August 9, 1786.

[5] Mott, *History*, p. 32.

[6] In 1790 William Spotswood reported to Jeremy Belknap that "the bookseller you have heard to have been insane is Thomas Seddon . . . who has been visited in this most distressing of human situations very suddenly. I had been with him late in the afternoon previous to the day of his indisposition appearing, when I found him, as I thought, as well as ever I had seen him. The next day, however, he was so outrageous as to render it necessary to bolt him down with irons to the floor of his apartment. Shortly after his indisposition, through the negligence of those who had the care of him, he contrived to get at his eyes, which he injured in such a manner as to leave no hope of his ever seeing the light." Spotswood to Belknap, Belknap Papers, 161.B, Massachusetts Historical Society, Boston.

[7] Joan Dolmetsch, "European Prints in Eighteenth-Century America," *Antiques*, CI (May 1972), pp. 858–863.

[8] *Pennsylvania Chronicle* (Philadelphia), December 12, 1768, quoted by Alfred Coxe Prime in *The Arts and Crafts in Philadelphia, Maryland, and South Carolina, 1721–1785* ([Topsfield, Mass.], 1929), p. 33.

[9] *Pennsylvania Magazine*, I, p. 10.

[10] Mott, *History*, p. 33.

[11] Ibid., pp. 33–35.

[12] Blackstone, *Commentaries*, III, pp. 117–118, was not alone in pronouncing this dictum. English legal commentators from Bracton to Bentham have noted the corollary "Where there is no remedy there is no wrong." See F. W. Maitland, *The Forms of Action at Common Law* (Cambridge, Mass., 1962), p. 5. For a discussion of eighteenth-century critical theory see Albert C. Baugh, *A Literary History of England* (New York, 1948), pp. 981–982.

[13] *Pennsylvania Magazine*, I, p. 513.

[14] *Encyclopaedia; or, a Dictionary of Arts, Sciences and Miscellaneous Literature . . .*, VI (Philadelphia, 1798), p. 735.

[15] George Groce and David Wallace, *The New-York Historical Society's Dictionary of Artists in America, 1564–1860* (New York, 1957); David N. Stauffer, *American Engravers Upon Copper and Steel* (New Haven, Conn., 1907).

[16] Ulrich Thieme and Felix Becker, eds., *Allgemeines Lexikon der bildender Künster, von der Antike bis zur Gegenwart* (Leipzig, 1907), I–XXXVII.

[17] *Pennsylvania Magazine*, I, preface.

[18] Ibid.

[19] Economic vicissitudes of the immediate postwar years discouraged putative magazine publishers until 1784 when the *Boston Magazine* managed to enjoy a two-year run. See Mott, *History*.

[20] *Massachusetts Magazine* (July 1789).

[21] Ibid. (October 1792).

[22] Ibid. (September 1789).

[23] *Royal American Magazine* (March 1774).

TABLE 1 Comparative Biographical Data of Eighteenth-Century American Engravers

Key:
B = Boston
NY = New York City
P = Philadelphia
O = Other

Name	City	Decade of Birth					Place of Birth					Apprenticeship				Age Began Work					More than one magazine	More than one city	Other Trade(s)	Remarks
		Before 1750	1751–1760	1761–1770	1771–1780	1781–1790	America	Scotland	Ireland	Britain	Continent	Known American	Known English	London	Unknown	Under 20	21–25	26–30	31–35	36 and older				
Aitken, Robert	P	×					×	×					×		×	×				×			×	Printer, binder
Anderson, A.	NY				×		×								×	×					×		×	M.D., miniaturist
Barker, William	P						×					×			×								×	Architect
Bowes, Joseph	P		×							×												×	×	Die sinker
Callender, Joseph	B		×				×					×	×				×		×				×	Die sinker
Clarke, Thomas	O						×				×				×					?	×	×	×	Jeweler, etc.
Doolittle, Amos	P						?					×	?		×				×		×		×	Bank note engraver
Harrison, Wm.	B				×		×		×			×			×				×		×		×	Copperplate printer
Hill, Samuel	P																							
Houston, H. H.	P						×						×		×					×	×		×	Die sinker, etc.
Lownes, Caleb	P				×			×				×							×	×			?	Painter (?)
Martin, David	NY			×											×		×					×	×	Printer, seal cutter
Maverick, Peter (Sr.)	NY						×								×			×			×	×	×	Publisher
Norman, John	B		×							×		×	×					×				×	×	Goldsmith
Poupard, James	P	?									×				×			×					×	
Ralph, William	NY	×					×								×		×					×	×	Silversmith
Revere, Paul	B											×	×			×				×			×	Inventor
Roberts, John	P				×									×	×	×							×	Painter
St. Memin, C. B.	NY						×				×				×							×	×	
Scoles, John	NY						×								×		×						×	Printer
Seymour, Joseph	B						×					×			×		?						×	Circulating library
Shallus, Francis	P				×		×					×			×		×				×	×	×	Seal cutter
Smither, James	P			×			×							×	×		×				×	×	×	Bank notes
Tanner B.	NY			×			?								×		×				×	×	×	Stationer
Thackara, James	NY				×		×					×		×	×		×				×	×	×	Bank notes, teacher
Tiebout, Cornelius	P						×					×				×					×	×	×	Die sinker
Trenchard, James	P				×		×								×	×						×	×	Inventor
Tully, Charles	P	×													×					×		×	×	Silversmith
Turner, James	B	×						×							×								×	Silversmith
Vallance, J.	NY				×										×						×	×	×	Bank notes
Warner, George	NY						×								×	×							×	

TABLE II Illustrations in American Magazines, Selected Years, Compared with the *Gentleman's Magazine*

Magazine	Year	Views			Natural History			Natural Philosophy			History & Biography						literary	allegory	maps, American	maps, other	miscellaneous	multiples	signed
		nature	buildings	cities	plants	animals	medical	astronomy	science	practical machinery	portraits	action illustrations	cartoons	monuments	archaeology	curiosities							
Royal American	1774	2		1		2					4	2	3				2				1		13
Pennsylvania Magazine	1775									5	2	1						1	7				14
Gentleman's	1774	1	2			2				2	3			4	12					5		6	4
Gentleman's	1775		2			1	1	1				1		1	8				4	5		5	3
Columbian	1787	4	4	1		1				2	1			2	1	3	1					3	8
Massachusetts Magazine	1789		7									1				1	3	1					11
Massachusetts Magazine	1790	2	3								2	2					3	1					12
New York Magazine	1790	2	4	1									1				1		1				12
New York Magazine	1791	4	2							2		1		1	1	1	2		1	1		1	13
Gentleman's	1789	5	15								1			5	12	5			2			11	3
Gentleman's	1790		14				2			1	6			7	12	4						17	3
Gentleman's	1791	2	15	3							3	1		11	11	4		1				20	7

Bickham's *Musical Entertainer* and Other Curiosities

Nancy R. Davison

THE Bickhams, George, Sr., and George, Jr., practiced their art and published their books in London in the late 1730s and 1740s, the period in which such people as William Hogarth and John Gay flourished. They became engravers, and, occasionally, the publishers of several fine books, often didactic, on calligraphy, music, dance, and geography, as well as many single-sheet items on a variety of subjects.

Political stability and prosperity had returned to England during the early part of the eighteenth century as a result of peace at home and the pursuit of a vigorous mercantile policy. George Bickham, Sr.'s, instructive and well-illustrated writing manual, *The Universal Penman*,[1] found a ready market among the prosperous merchants, as did his *The British Monarchy: Or, a New Chorographical Description Of all the Dominions Subject to the King of Great Britain.*[2]

The arts were undergoing change in this new atmosphere, and although royal patronage had declined considerably in the last fifty years, the interest of the landed aristocracy and the middle classes was increasing rapidly. Lord Burlington's building projects and foreign paintings, especially those done in the "grand manner," fascinated a large portion of the public. Few

could afford new country houses or paintings, but they could afford Hogarth's engravings and books such as George Bickham's *Musical Entertainer*,[3] a beautifully illustrated collection of songs set for amateur musicians, or George, Jr.'s, 1738 publication, *An Easy Introduction to Dancing: or, The Movements of the Minuet Fully Explained . . .*,[4] also illustrated. Although the Bickhams engraved several other books and single items, these four titles represent their major efforts.

Little is known of the Bickhams' private lives. George Bickham, Sr., seems to have published his first works about 1709. In addition to some early portraits of writing masters and *The Universal Penman*, he did engravings after the paintings of Rubens and Rembrandt and a variety of other things. According to Samuel Redgrave, he was a member of the Free Society of Artists in 1763.[5] He retired in 1767 after a long career and died two years later. His son, George Bickham, Jr., who died in 1758, was active in the 1730s and 1740s. He did caricatures for the Bowles and portraits of himself and his father.[6] His books, especially *The Musical Entertainer*, are his best-known works, but he did many lesser engravings as well. The professional lives of the Bickhams were thoroughly intertwined. *The Universal Penman* contains vignettes engraved by George, Jr., although most of the work and credit belongs to George, Sr. The elder Bickham's brother John appears as the calligrapher and/or the engraver of several plates, but he does not seem to have done any major work of his own. Although *The Musical Entertainer* was engraved by George, Jr., the first editions were published and sold by George, Sr., who also engraved the title page. Several whole plates from *The Universal Penman* were used in *The Musical Entertainer*, and designs and motifs were freely passed back and forth between various Bickham publications.

The English merchant's economic stability and prosperity was reflected in his handwriting. Business and trade required a great deal of paperwork. Invoices, credits, bills, and so forth all had to be legible and more or less standardized in form and content. The need for a legible and easily executed script became apparent in England in the last quarter of the seventeenth century, and new copybooks for scribes appeared frequently be-

tween 1680 and 1740. There was great general interest in hand-
writing of all kinds, and especially in this businesslike English
hand that was easily written and easily read.

George Bickham, Sr.'s, *The Universal Penman* was the first
and only collection made of the forms of English calligraphy in
use during the first half of the eighteenth century. Printed from
engraved plates on one side of the paper only, *The Universal
Penman* was issued in fifty-two parts from 1733 to 1741. Sub-
scribers frequently bound the sections together to form one
volume; this elegant copybook was so popular and so common,
but so used, that few complete sets have survived.[7]

The frontispiece of *The Universal Penman* is a full-page en-
graving of "The Representative" of all good scribes (No. 57).
"Inscrib'd To the Writers in the Universal Penman," the plate
was designed and drawn by the French illustrator Hubert Grave-
lot and engraved by George Bickham, Sr. It shows an earnest
young man seated at a writing table in his study. The moon is
visible through the window, a lamp of midnight oil sits on the
desk, and the youth wears a long robe and a cap against the
evening chill. He has a copy of *The Universal Penman* open be-
fore him and, pen in hand, is scrutinizing what he has just writ-
ten: "If you would like a Master Write, Practice by Day as well
as Night. Bickham Sculp."

The second title page describes the contents of the work in
general terms. The full title reads: "The Universal Penman;
Or, the Art of Writing Made Useful To the Gentleman and
Scholar, as well As the Man of Business. Exemplified In all the
useful, and ornamental Branches of Modern Penmanship; with
some necessary Observations on the Excellency of the Pen, and
a large Number of select Sentences in Prose and Verse; various
Forms of Business, relating to Merchandize and Trade; Letters
on several Ocasions; . . . and Alphabets in all the Hands now
practis'd." A two-page introduction further explains the pur-
pose of the book: "Writing is the first Step, and Essential in
Furnishing out the Man of Business." Bickham also notes that
"Drawing is another necessary Qualification, and therefore I
have attempted to make the Decorations of this Work fit for the
imitation of those, whose Genius prompts them to the Study of

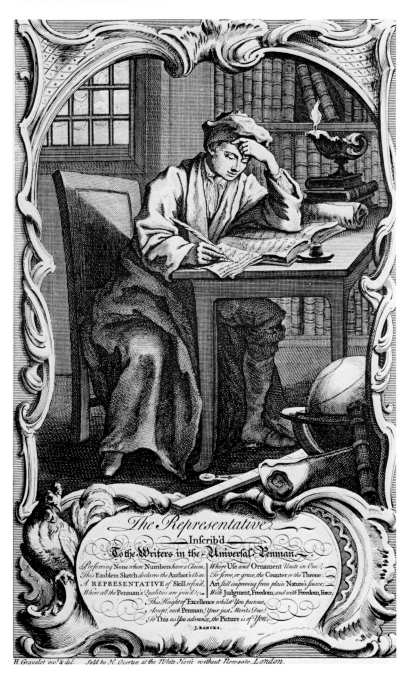

57. *The Universal Penman.*

that Art." However, he concludes, "But as Writing is the most Useful Accomplishment of ye two, I have given a larger Number of Specimens for that purpose; Exhibited in Precepts Divine and Moral, with many Examples in Trade and Business." A businessman had to write well and be prudent and attentive in his affairs, but philosophy, poetry, and painting were not out of place in his world.

The Universal Penman provides examples of different kinds of bills and receipts as well as models for handwriting. It also illustrates and articulates many of the values and virtues of a mercantile society. Industry, learning, honesty, and the avoidance of bad companions are all extolled in these pages. *The Universal Penman*, Hogarth's *Industrious Appentice*, and Franklin's *Poor Richard* all share and advocate the same ideals.

The Honest Merchant; or, Thorowgood to Trueman, plate 121, notes that "the Name of Merchant never degrades the Gentleman" and shows a portrait bust of a businessman in an almost royal setting (No. 58). The two allegorical female figures that flank the bust hold symbols of prosperity. The whole page symbolizes and illustrates the rising importance of the businessman and the merchant in English society.

The illustration for "Industry," plate 35, was engraved by George Bickham, Jr., and shows a personification of Industry overseeing the printing of *The Universal Penman* (No. 59). To the left a group of literary looking cherubs seem to be writing the text, while to the right the actual production of the book is in progress. The engraver works at a low table, copying his text with the aid of a large mirror, and a kneeling figure is either grinding ink or inking a copperplate for printing. Behind him, an undersized pressman is running the plate through the press and an equally undersized figure, perhaps one of the Bickhams, is holding a freshly printed page. Other pages are hanging up to dry in the corner. The pressman and the author are the only figures who are dressed in contemporary clothing, and they along with the press are out of scale with the rest of the composition. This small scene within a scene may have been copied from life or from a different source than the other figures. The

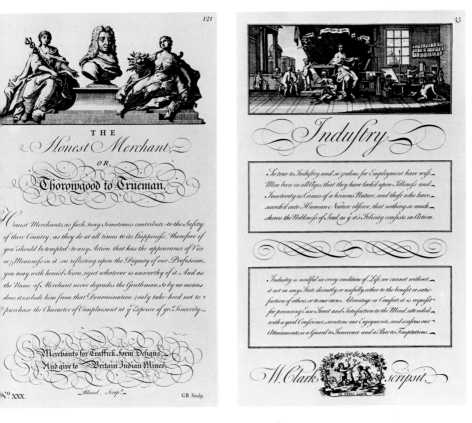

58. *The Honest Merchant; or Thorowgood to Trueman.*

59. *Industry.*

whole is unified by a banner that reads, "By Industry and Time all Arts are gain'd."

The illustration in honor of "Commerce," plate 115, shows nine men involved in a business transaction (No. 60). A "Bill of Lading" is being passed from one man to another in what appears to be a stage setting. Merchant ships appear both to the right and the left, but the men, some standing and others sitting, are supported by a wooden floor and backed by a paneled wall. This use of a stage set in a picture in England originated with William Hogarth. Another Hogarthian touch in this engraving

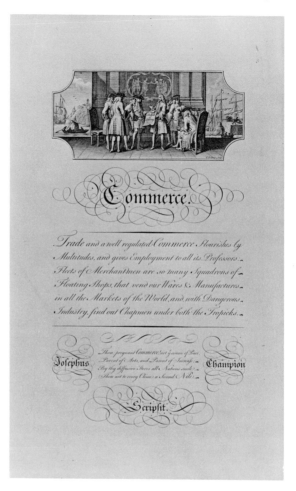

60. *Commerce.*

is the close relationship between the principal action and the figures in the wall decoration.

Not all the plates in *The Universal Penman* are sober, sedate, and didactic. Among the sample invoices, letters of credit, and odes to commerce are comments on wit and poetry. Of three pages on the subject of "Liberty," one is illustrated with a view of a country dance, another with a drinking scene, and the third

brackets its message with a fish and a bird, both exuberant and playful figures done by a master penman.

However, the stress finally is on business. Plate 129 represents "Business" as a guardian angel seated on a cloud above an active whaling scene. The angelic banner translates, "Without This, Nothing," and the text begins: "I'm sent the Genius of the British Isle," and continues further down, "Your proper Business is your Trades Increase." The poem's secondary theme is "The Sea's your native strength, Fish is yr Wealth," and this provides the theme for the illustration. British fishermen are shown netting fish and loading a cargo of dried fish on the left, while on the right the fire and cauldron are prepared for rendering the whales that are being harpooned in the center. This careful coordination between text and illustration is characteristic of much of the Bickhams' work. It is particularly noteworthy in *The Musical Entertainer* because most music illustration has had little to do with its music.

George Bickham, Jr., seems to have worked on a second writing manual. *The Gentleman's Magazine* for May 1733 contains an advertisement for *The Young Clerk's Assistant: Or, Penmanship made easy, instructive, and entertaining*. From the description of the work it was probably quite similar in appearance to *The Universal Penman*, but it seems to have been intended for a different audience. "Curiously Engraved by the best Hands, on 73 Copper-Plates," the book contains writing samples and poetry "Extracted from the most celebrated English Authors, *viz. Waller, Dryden, Addison, Pope, Gay, &c.* for the Amusement of the fair Sex." It also contains "A curious Drawing Book of Modes, design'd by the famous Mr *Barnard Picart*, and engrav'd by *G. Bickham*, jun. &c. for the early Improvement of young Gentlemen and Ladies in the Practice of the Pencil, as well as the Pen." The book cost 3s. 6d. and appears to have been a genteel copybook for young aristrocrats. In spite of its title, *The Young Clerk's Assistant* sounds as if it was meant for the country house, not the countinghouse.

George Bickham, Jr.'s, finest work, *The Musical Entertainer*, was also intended for the country house. A register of books in *The Gentleman's Magazine* for March 1737 announces the pub-

lication of part 4 of *The Musical Entertainer* and gives a full description of the work itself.

> The whole to be Curiously Engraved on Copper Plates, and Embellished, not only with all the variety of Penman-ship and command of Hand; but with Head-Pieces, in Picture-work and other Decorations; as Landskips adorned with Figures expressive of each Subject, in a New and more Accurate Manner than any thing of the like Nature.

> I. The whole Work shall contain One Hundred Folio Plates.

> II. Four Half-Sheets shall be Published Monthly or sooner, and delivered (Stich'd in Blue Paper,) at 6d. per Number.

The whole work was extremely popular, and it was expanded to two hundred folio plates published between 1737 and 1739. At 6d. for one section, the expense of the work could be stretched over a period of time.

The Musical Entertainer was not the first collection of songs to be printed in England, nor was it the only one to be illustrated. William Byrd and Thomas Tallis were given a monopoly on the printing and importing of music by Queen Elizabeth I in 1575. This era of the madrigal and Elizabethan court music marked the first creative period of English music. The second, the age of Henry Purcell, saw the establishment of music publishing as an independent and important business. The Playfords, John and his son Henry, not only published Purcell's music in the last half of the seventeenth century, but published books on music theory, instrumental instruction, and collections of psalms and songs as well. An advertisement run by Henry Play-ford in 1703, when his business was in decline, noted that he had "always made it his Business, and Endeavoured to serve the Publick as well as his Father before him, In Printing and Pub-lishing the best Instrumental and Vocal Musick, both English and Foreign, and is still going on, but finding it very Chargeable by Reason of the Dearness of Good Paper, and the Scandalous Abuse of Musick by selling single Songs at a Penny a Piece, which hinders good Collections."[8] Playford was supplanted by John Walsh as the major music publisher in London during the

first years of the eighteenth century. Walsh published the music
of George Frideric Handel as well as instruction books and
music periodicals. He had a flair for marketing and kept his
prices low enough in the face of intense competition so that his
music was readily affordable by many people.[9]

During the Playford period two major changes in English
musical taste had taken place and were reflected in the Playford
publications. First, songs for popular use, like catches and glees,
became very popular among both professional and amateur
singers. Formal church and court music no longer dominated
England. Second, opera was introduced in 1656 in a successful
effort to circumvent a Puritan ban on spoken plays.[10] Italian
opera's greatest popularity in England did not begin, however,
until Handel's *Rinaldo* was produced in London in 1711 and
Handel himself settled in England the next year.[11] Both trends
are indicated in the note on the contents of *The Musical En-
tertainer* in the March 1737 *Gentleman's Magazine*. "This Work
will Consist of Select Italian, English, and Scotch Songs, Fa-
vourite Cantatas, &c. the Words Composed by the Best Poets,
and set to Musick by the most Eminent Masters, adapted to the
Voice, Violin, German and Common Flute, Harpsichord, or
Spinet."

The violin, the German flute,[12] and the harpsichord were the
most fashionable instruments of the period, although other in-
struments were popular as well. The frontispiece of Peter Prel-
leur's *The Modern Musick-Master* of 1731 shows a group of
gentlemen playing these instruments together with the common
flute, the bassoon, the hautboy, and the cello. *The Modern
Musick-Master* is one of many books of music instruction
printed during the first half of the eighteenth century. It con-
tains "I. An Introduction to SINGING . . . II. Directions for play-
ing on the FLUTE . . . III. The Newest Method for Learners on
the GERMAN FLUTE . . . IV. Instructions upon the HAUT-
BOY . . . V. The Art of Playing on the VIOLIN . . . VI. The HARP-
SICHORD Illustrated & Improv'd,"—together with a "Large Col-
lection of AIRS, and LESSONS . . . and A Brief HISTORY OF
MUSICK, . . . To which is Added, A MUSICAL DICTIONARY"—
all for only 7s. 6d., or 1s. 6d. for the separate sections. Illustra-

tions are included, "representing the Manner of Performing on every Instrument." The illustrations and the text are printed from engraved plates. Although this use of engraving for the text was uncommon, the use of engraved plates for the music had all but replaced typographical music printing by the end of the seventeenth century.[13]

The Musical Entertainer is also printed entirely from engraved plates, as were all of the Bickhams' books. However, unlike *The Modern Musick-Master*, it offers no instruction and its illustrations are expressive, not didactic. The title page was designed and engraved by George Bickham, Sr. (No. 61). Apollo leaning against a double bass tops an elegant rococo framework that sets off the simple title and the name of the engraver, George Bickham, Jr. The next four pages are from *The Universal Penman* and refer to music. One of them is illustrated. It shows a group of musicians performing on the grounds of a country house. A spectator at this performance is almost unseen at first, but his presence gives the scene a sense of theater. The instruments are the same as those played by the gentlemen in *The Modern Musick-Master*, that is, German flute, harpsichord, and violin, but there are three singers instead of one and fewer instruments.

In many ways the illustration and the words to *A Peaceful Life*, plate 81, represent an ideal of English country living. An elegant country gentleman gestures toward a milkmaid who is milking a rather wild looking cow in a sylvan setting. The verse goes as follows:

> In these Groves, with Content and Tranquility,
> free from envy, care and Strife:
> Bless'd with Vigour, with Health, and agility,
> We enjoy a Peaceful Life.
>
> Endless Circles of Pleasure Surrounding us
> Ever chearful ever gay
> No Perplexities ever confounding us,
> Life in comfort slides away.

This idyllic life, however, is an idle rococo dream. The country estates were apt to be working farms as well as country seats

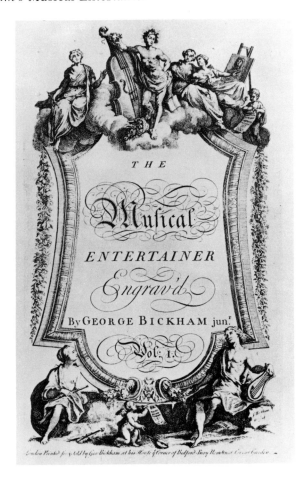

61. *The Musical Entertainer.*

for gentlemen, and the gentlemen's pleasures were frequently more vigorous than this song would imply. *The Return from the Chace,* "Set by Mr. Leveridge," a noted theatrical singer and composer, is a celebration of hunting and riding to hounds (No. 62). The final chorus concludes:

> Then let us let us now enjoy
> All we can while we may,
> Let Love crown the Night,
> As our Sports crown ye Day.

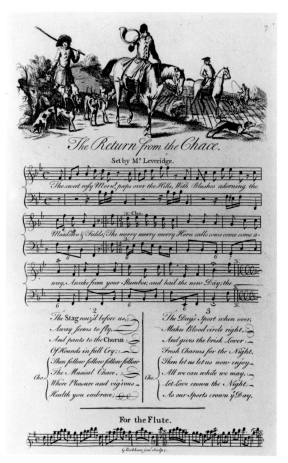

62. *The Return from the Chace.*

Hunting, especially fox hunting, was extremely popular during this period in England and sporting pictures of hunts and horses rivaled "conversation pieces" or composite portraits in popularity. George Bickham, Jr.'s, illustration for this song is very similar in subject and composition to many of the contemporary sporting pictures.

The Bickhams borrowed designs from many sources for their engravings. Plate 40, *The Releif or; Pow'r of Drinking*, an ode to wine and revelry, is engraved by Bickham, Jr., but the un-

acknowledged design is by William Hogarth. Hogarth's *A Midnight Modern Conversation* of 1732/33 is a satire on drunkenness that features several well-known professional men.[14] Bickham, Jr., did several caricatures for the Bowles' print publishing house during his career, and his lighthearted rendering of Hogarth's work was probably intended to spoof the song.

Concerts were frequently given in taverns during this period, and many informal singing societies met in taverns as well. This accounts for the large number of cheerful and sophisticated drinking songs to be found in *The Musical Entertainer.* The vignette for *The Earths Motion Prov'd*, plate 2, designed by Hubert Gravelot and engraved by George Bickham, Sr., shows another drinking scene. However, this one takes place in an unlikely looking shell-like gazebo. The theme of the song is that it really does not matter whether or not "ye Earth Goes round." If one drinks enough it will spin of its own accord. This lighthearted drinking scene takes on a more sober air in *The Universal Penman*, however. In plate 205 the imbibers raise their glasses in a solemn toast to Liberty, completely oblivious to the inebriated faun in the corner.

Ten percent of the songs in *The Musical Entertainer* are drinking songs. However, over half are love songs or songs like "Charming Cloe," an appreciation of a lovely woman.

> When charming Cloe gently walks,
> Or sweetly Smiles, or gayly talks,
> No Goddess can with her compare,
> So Sweet her Look, so soft her Air.

This song is a return to the rococo dream world, made explicit by the Watteau-like guitar player.

The illustrations for these love songs are also fashion plates. Style, taste, and fashion were all important in England in the eighteenth century. *The Beau* shown in plate 50 is one of a long line of fashion-conscious males that includes the Beaux of the 1740s, the Macaronis of the 1760s and early 70s, and the Dandies of the Regency. All three groups were roundly caricatured, and perhaps because of this the song remained popular in some areas until at least the 1790s. It appeared in the *Massachusetts*

Magazine of April 1791 and in *The American Musical Miscellany* printed in Northhampton, Massachusetts, in 1798. Although these two publications are American, they were based on British models.

If the life of a Beau truly was "brimful of nothing," one of the things he might do with his time was to visit one of the pleasure gardens. Vauxhall, as seen in the illustration to *Rural Beauty, or Vaux-hal Garden*, plate 21, opened in 1661, but it did not offer regular concerts until the 1730s (No. 63). The third verse of this song in *The Musical Entertainer* of 1737 begins "Hark! what Heavenly Notes descending," in explicit acknowledgment of the new feature of Vauxhall. The other attractions of the garden included tree-lined promenades and the opportunity to see people of fashion taking the air. Views like this one of the pavilion at Vauxhall and of other activities and features of English life in the 1730s are one of the most attractive and important elements of Bickham's illustrations for *The Musical Entertainer.*

Italian opera and Italian singers, especially the castrati like Farinelli, were still extremely popular in England during this period, even though a reaction was setting in. *The Ladies Lamentation for ye Loss of Senesino*, plate 38, recounts the hysteria among his fans that the castrato Senesino's departure induced. Bickham's occasional satiric touch is again visible in the vignette. While the great singer haughtily accepts the parting homage of his admirers, his servants carry a large box marked "Ready Money" down to the ship. His fortune is again remarked upon in *The Taste a Dialogue* by Mr. Handel, plate 66. This dialogue between the Italian characters Punchinello and Colombino mentions several of the Italian singers and Handel's brief rivalry with Niccolo Porpora in 1734.[15] Handel was the dominant musical figure in London during the first half of the eighteenth century and his Italianate operas began the craze for opera in England.

The passion for Italian opera was fading by 1740, however. The crotchets and demands of the Italian prima donnas, the feuds and turmoil involved in producing operas, and a weariness with performances in a foreign language were all elements

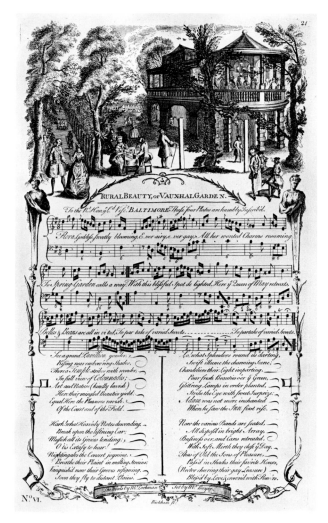

63. *RURAL BEAUTY, or VAUX-HAL GARDEN.*

in its decline in popularity.[16] Another factor was the increasing popularity of ballad opera. John Gay's *Beggar's Opera* of 1728 was a reaction to the encroachment of foreign music and performers upon English music. The music, selected and set by John Pepusch, an expatriate German, was drawn from many of the popular songs of the day.

New words were often added to old tunes as in the last act's "Upon Tyburn Tree," which is sung to the tune of "Greensleeves." The two female leads, Polly Peachum and Ludy Lockit, vie for the affections of Macheath the highwayman, but they also compete musically as each soprano tries to outdo the other in vocal virtuosity. This distant ancestor of *The Three-Penny Opera* is also a social and political satire. Polly Peachum's middle-class preoccupation with romantic love and marriage is viewed by her parents, a fence and a bawd, with horror and disbelief. On another level, it was widely believed that Macheath represented the prime minister, Sir Robert Walpole, and that Polly was his mistress and second wife, Moll Skerrett.[17]

The Beggar's Opera played the provinces as well as London and had many imitators. The play itself was not seen in the American colonies until 1750, when it was performed in New York. However, a distant cousin entitled *Flora; or, Hob in the Well* was performed in a Charleston, South Carolina, courtroom on February 8, 1735. This is thought to be the first performance of a formal musical play in America.[18]

According to Hugh Jones in his 1724 *The Present State of Virginia*, "The habits, life, customs, computations, etc. of the Virginians are much the same as about London, which they esteem their home."[19] Therefore, it is not surprising to find Bickham's *Musical Entertainer* listed in the *Virginia Gazette* for May 24, 1751, as "Just Imported, and to be Sold reasonably . . . in Williamsburg." It is also listed in the Ogle Inventory of 1755. Cuthbert Ogle, a well-to-do and successful musician and music teacher left London for Williamsburg, Virginia, in the fall of 1754 and he died there the next spring. His effects included several fine musical instruments and a carefully chosen selection of the best and most useful music books of the period. Among them was Bickham's *Musical Entertainer*.[20]

Flora; or, Hob in the Well was, of course, popular in England as well. In 1737/38 George Bickham, Jr., engraved and issued *Songs in the Opera of Flora*. A headpiece vignette shows Hob in his nightshirt about to be put into the well by a group of men armed with sticks. The scene takes place at night and was engraved by G. Bickham, Jr. It was designed by Gravelot.

Hubert Gravelot was a French draughtsman and engraver

who brought the rococo style of book and music illustration to England in 1732. He stayed in England for twenty-three years and during that time illustrated many English books. Among them are John Gay's posthumous collection of *Fables* (1737), Fielding's *Tom Jones* (1750), works by Shakespeare and John Dryden, and Richardson's novel *Pamela*, on which he collaborated with Francis Hayman. He was one of the first illustrators of the novel and did many designs for the Bickhams as well.

The London Magazine advertised a new Bickham publication in October 1738. "An easy Introduction to the Art of Dancing by G. Bickham jun. [Sold by T. Cooper, price 1s]" was immediately popular. Its engravings of dancers in the proper positions of the minuet and the complex movements of the dance provided, as promised, "an easy introduction" to an important social skill. However, this was not the first illustrated instruction book on dancing to be written and published in England. John Playford's *The Dancing Master*, a book of country dances, preceded Bickham's book by eighty-seven years. Because of its popularity, numerous editions were printed between 1651 and 1728, but they were so used that copies are now difficult to find.[21]

The elegant, dignified, and mannered minuet was the most popular dance of the eighteenth-century ballroom. Originally a French country dance, it became fashionable at the French court and spread rapidly from there. The minuet is stately and complex. Precise and formal gestures of hands and feet are important to the grace and beauty of the dance. It is not easy to learn without instruction, and as a result this dance made the fortunes, or at least the livings, of scores of French dancing masters, both in Europe and in England. Bickham's book, subtitled *The Movements in the Minuet Fully Explained*, was sold for a shilling at "The Musick-Shops in Town and Country" and provided the aspiring dancer with a chance to practice privately before venturing out into polite society. *The compleat Figure of the Minuet* is a diagram of the steps of the dance. The lady's side and the man's side are clearly differentiated, but this clarity soon dissolves into the complexity of the figure. The illustration for *Letting Hands go*, which appears with the proper music for the movement, is much easier to follow.[22]

The British Monarchy by George Bickham, Sr., is not con-

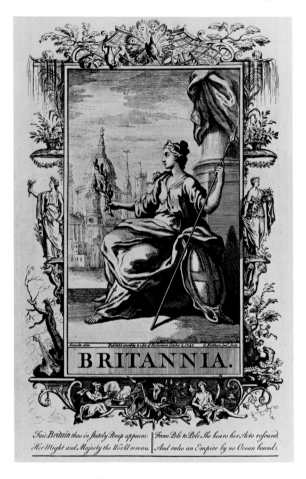

64. *BRITANNIA.*

cerned with fashionable and pleasant pastimes. Published in
1748, it is a study of the different regions of Britain and its
possessions designed for the London merchant seeking infor-
mation about new markets for his goods. The subscription list
in the front of the book includes merchants from all over En-
gland as well as one from Philadelphia. The frontispiece, drawn
by Gravelot and engraved by George Bickham, Jr., shows Bri-
tannia seated on a globe and holding a spear and an olive
branch (No. 64). Behind her the city of London is easily identi-

fied by the dome of St. Paul's Cathedral and the spires of the Wren churches. The verse reads:

> Fair Britain thus in stately Pomp appears:
> Her Might and Majesty the World reveres.
> From Pole to Pole She hears her Acts resound,
> And rules an Empire by no Ocean bound.

In 1748 when the book was published, the merchants of London were secure and prosperous. A long war with France, punctuated by the Jacobite rebellion of 1745, was over and times were good. The industrial revolution and the unpleasantness with America were mere shadows on the horizon as the merchants sought to expand their trade. A plate from *The Universal Penman*, although printed in 1741, also expresses a confidence and a pride in London and her merchants. *Telemachus His Description of the City of Tyre; Apply'd To the City of London*, plate 177, is illustrated with a view of London as seen from the river. The text reads: "This great City seems to float upon the Waters, and to be Queen of all the Sea; the Merchants resort hither from all Parts of the World, and its Inhabitants are the most famous Merchants in the Universe. When Men enter into this City, they cannot think it to be a Place belonging to a particular People, but rather to be a City common to all Nations, and the Center of all Trade and Correspondence."

The title page of *The British Monarchy* describes the contents of the book in a variety of alphabets. It is a sampler in itself, but George Bickham, Sr., announces that "Alphabets In all the Hands made use of in this Book" are also included along with maps and suitable illustrations. Many of the illustrations are heraldic in nature, such as the one of *The Arms of the City of London* engraved on the page for Middlesex County, plate 84. The two seated female figures are the same ones that flanked the kingly portrait bust of the merchant in *The Universal Penman*. They are also found on the cartouche of the Burgis map of Boston in New England, 1728. Perhaps there is a common antecedent. The text describes the air of Middlesex County as "extreamly Wholesom," and furthermore, "The chief Commodities are Corn, Cattle, and Fruits, and the Manufactures too

many to be enumerated." In "South Wales" the air is "various
. . . But in general it is very healthful," and in some areas the
soil is "equal to most in England for Feritility." The unusual en-
graving of seabirds in the illustration of plate 137 resembles
the drawings of animals that Gravelot did for Gay's *Fables* in
1737.

The section on *The American Colonies*, plate 164 (No. 65),
begins with the longitude and latitude and an attempt to de-
termine the size of the area (No. 66). "The whole Length, in a

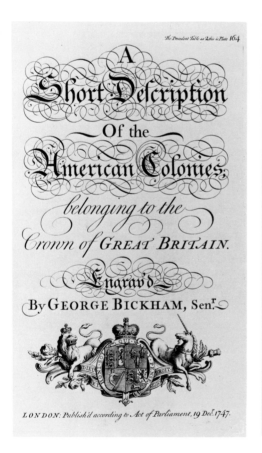

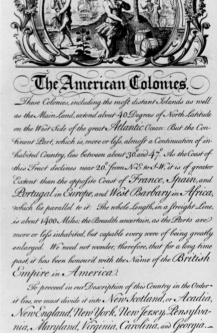

65. *A Short Description of the American* 66. *The American Colonies.*
Colonies.

streight Line, is about 1400 Miles; the Breadth uncertain, as the Parts are more or less inhabited, but capable every were of being greatly enlarged." The first illustration is, of course, an engraving of Indians. The vignette is defined by an elegant, ornamental frame that encloses a seated Indian with a bow, a palm tree, and a second figure to the left who is smoking a pipe. A Quaker and an Indian haggle over tobacco in the background, and a ship is lying offshore awaiting the cargo. The Bickhams' models for the Indians in *The British Monarchy* were drawn from the White–de Bry engravings in Thomas Hariot's *A briefe and true report of the new found land of Virginia* of 1590 either directly or at several removes. Another picture of Indians, *The Three Cherokees*, was offered for sale by George Bickham, Sr., around 1762. This engraving was derived from the other major model for images of American Indians, the Verelst–Simon mezzotints of the four Iroquois *Indian Kings* who visited London in 1709.[23] There is a strange tension in this picture, caused partly by the snarling dog that separates a modishly dressed English gentleman from the Indians. The gentleman, who gestures and tries to speak to the remote Indians is identified in the caption as "Their interpreter that was Poisoned."[24]

Conclusion of the American Colonies . . . The American Islands, plate 184, mentions the "Forts and Factories on Hudson's Bay, where [the English] carry on a profitable exclusive Trade in Furs and Skins" (No. 67). However, the illustration is a copy of the engraving for a plate on *Business*[25] in *The Universal Penman* and refers to a sentence further down the page, "Newfoundland is a large Island, famous beyond all others for the Cod-fishery." With this plate we come full circle, back to *The Universal Penman*, a primer of mercantile values. The young merchant penman in his study and the codfishery are both appropriate symbols for the England of the 1740s.

Taken together, the four major works of the Bickhams describe and document a way of life and a system of values. At the lowest level these books show us the fashions and amusements of the period, but they also show the climate of a certain style and ideal of life in London in the 1730s and 1740s.

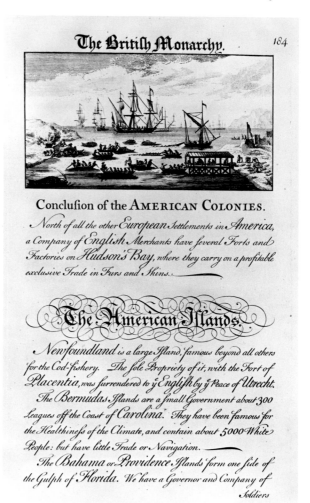

67. *Conclusion of the* AMERICAN COLONIES.

NOTES:

[1] 2nd ed., London, 1743; reprint ed., New York, 1941.
[2] London, 1748.
[3] London, 1748.
[4] London, 1737–1738.

[5] Samuel Redgrave, *A Dictionary of Artists of the English School . . .* , rev. ed. (Amsterdam, 1970), p. 40.

[6] *Dictionary of National Biography*, s.v. "Bickham, George, the younger."

[7] See the foreword by Philip Hofer, "The Importance of *The Universal Penman* in relation to modern calligraphy," to the 1941 reprint ed., p. 2.

[8] Charles Humphries and William C. Smith, *Music Publishing in the British Isles from the Beginning until the Middle of the Nineteenth Century*, 2nd ed. (New York, 1970), p. 11.

[9] Percy M. Young, *A History of British Music* (New York, 1967), p. 266.

[10] Percy A. Scholes, *The Oxford Companion to Music*, 10th ed. (London, 1970), p. 709.

[11] Ibid., p. 710.

[12] The German flute is the side blown flute that came to England with the Hanovers. The common, or English, flute is blown from the end. A separate flute part is printed at the bottom of most of the songs in *The Musical Entertainer*.

[13] Humphries and Smith, *Music Publishing*, p. 14.

[14] Joseph Burke and Colin Caldwell, *Hogarth: The Complete Engravings* (New York, 196–), pl. 141.

[15] Young, *History*, p. 306.

[16] Ibid., p. 298.

[17] Wilmarth Sheldon Lewis and Philip Hofer, comps., *"The Beggar's Opera" by Hogarth and Blake* (Cambridge, Mass.; New Haven, Conn., 1965).

[18] David Ewen, *New Complete Book of the American Musical Theater* (New York, 1970), p. xix.

[19] Hugh Jones, *The Present State of Virginia*, ed. Richard L. Morton (Chapel Hill, N. C., 1956), p. 80.

[20] John W. Molnar, "A Collection of Music in Colonial Virginia: The Ogle Inventory," *Musical Quarterly*, XLIX (April 1963), p. 158.

[21] Lillian Moore, *Images of the Dance: Historical Treasures of the Dance Collection 1581–1861* (New York, 1965), p. 5.

[22] Ibid., p. 20.

[23] Sinclair H. Hitchings, 'The Graphic Arts in Colonial New England," in John D. Morse, ed., *Prints in and of America to 1850*, Winterthur Conference Report 1970 (Charlottesville, Va., 1970), pp. 76–77.

[24] *The Three Cherokees* is in the collection of Colonial Williamsburg. The snarling dog is a transmutation of the totemic wolf in one of the portraits of the four *Kings of Canada* of 1709–1710. For further information on the use of these Indian prototypes, see Bradford F. Swan, "Prints of the American Indian, 1670–1775," in Colonial Society of Massachusetts, *Boston Prints & Printmakers 1670–1775* (Boston, 1973), pp. 241–282.

[25] The probable prototype for this view of fishing and whaling is located in the Mariners Museum, Newport News, Va. Dedicated "To the

Hono.ble the Court of Directors of the South Sea Company," the engraving is "a Representation of the Fishery of Great Britain" that was drawn by Thomas Baston and engraved by E. Kirkall about 1721. The verse reads:

> Peace now secur'd by Arts let Britain Reign,
> Your Woolen and your Fishing Trades regain
> Into your hands Heav'n has the Produce thrown,
> Raise these Machines and all the World's yor. own.

My thanks to Harold Sniffen, curator emeritus of the Mariners Museum, for finding this for me.

The Portrait Engravings of Charles Willson Peale

Wendy J. Shadwell

THE introduction to the section on Charles Willson Peale in a recent museum catalogue begins: "Born 1741; died 1827. Painter, inventor, saddler, scientist, museum proprietor, soldier, writer, and naturalist, Charles Willson Peale was one of the most versatile Americans of his day."[1] Despite this lengthy listing, two of Peale's significant accomplishments were omitted. One is that he was the progenitor of an extraordinary family of talented artists; the other is that he was a skilled mezzotint engraver. It is with the latter attainment that we are concerned here, more specifically with his portrait engravings, all of which were taken from his own oil paintings.

After study of those paintings available in the colonies in the 1760s, brief exposure to the artists John Hesselius and John Singleton Copley, and earnest self-instruction, Peale showed sufficient promise that a group of Marylanders, headed by John Beale Bordley, underwrote his expenses for a year's stay in London. He set sail in December 1766 and landed in February 1767, provided with a letter of introduction to Benjamin West from William Allen of Philadelphia. West proved generous and cooperative with his time and influence as he invariably did when a young fellow-American seeking artistic instruction

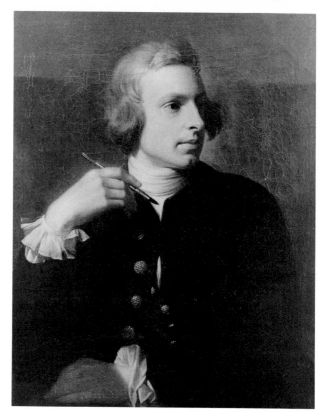

68. *Charles Willson Peale.*

came his way. Peale served as a model in West's studio and posed for his own portrait (No. 68), copied West's paintings, purchased and studied artists' manuals, attended exhibitions, made the acquaintance of Benjamin Franklin, and determined to specialize in miniature painting. Charles Carroll wrote to him from Annapolis in October 1767:

> I observe your Inclination Leads you much to Painting in miniature. I would have you Consider whether that may be so advantageous to you here or whether it may suit so much with the Taste of the People with us as Larger Portrait Painting which I think would be a Branch of the Pro-

fession that would Turn out to Greater Profit here. You Likewise mention the Copying of Good Painting by which I suppose you mean the Study of History Painting. This I look upon as the most Difficult Part of the Profession and Requires the utmost Genius in the artist. Few arrive at a High Point of Perfection in it and indeed in this Part of the World few have a Taste for it and very few can go thro' the Expence of Giving that Encouragement that such an artist would desire. But after all Consult and be guided by the best of your own Genius and Study that Branch to which your Disposition Leads you and that you Judge most suitable to your Talents. You had better be a Good Painter in Miniature than an Indifferent one in either of the other Branches.[2]

At the same time Peale's Maryland backers increased their financial support, enabling him to prolong his stay and to undertake a major commission in "Larger Portrait Painting."

Edmund Jenings, Bordley's half-brother and a warm friend and advisor to Peale in London, ordered a monumental portrait of William Pitt, by that time created the first Earl of Chatham, who was widely admired as the champion of colonial rights and liberties. As the subject was not free to pose for the painter, Peale used as his model a full-length statue sculpted by Joseph Wilton. Repeated exposure to this piece prompted Peale to attempt sculpture himself, and he is known to have modeled busts of himself, Jenings, and West. Many years later these busts became a featured exhibit in Peale's museum, and they may be seen in the Peale family portrait on a shelf at the upper right (No. 69). West is in the rear, Peale himself in the middle, and Jenings at the front. As Peale recorded in his autobiography, "He was not contented with knowing how to paint in one way, but he engaged in the whole circle of arts, . . . And also at Modeling, and casting in plaster of Paris. He made some essays at Metzo tinto scraping."[3]

This brings us to the other medium that Peale first undertook in connection with the Pitt commission (No. 70). I will not go deeply into the various allegorical and symbolic meanings in the portrait, as Dr. Sommer did that very thoroughly at our

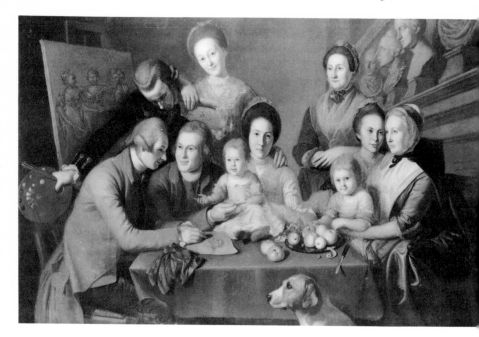

69. *The Peale Family.*

Winterthur meeting.[4] Briefly, however, Peale represented Pitt
as Wilton did, in Roman dress, holding the scroll, the Magna
Carta. A flame burns on the sacred altar of liberty in the fore-
ground. An American Indian with bow in hand and a dog at his
side is represented on the pedestal atop which stands British
Liberty, trampling on the petition of Congress at New York. The
building in the background is the Banqueting Hall at Whitehall,
whence King Charles I was led to his execution. Peale titled his
mezzotint *Worthy of Liberty, Mr. Pitt scorns to invade the Liber-
ties of other People* and published an explanatory broadside
which stated that "the Chief Object of this Design" was to mani-
fest "the Gratitude of America to his Lordship." It was also a not
too subtle warning to the British government that "Sic semper
tyrannis."

Peale painted two versions of this portrait. The larger one
Jenings presented to the gentlemen of Westmoreland County,

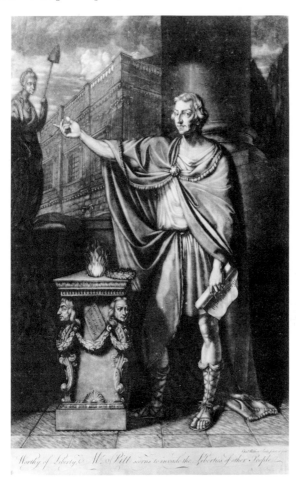

70. *Worthy of Liberty, Mr. Pitt scorns to invade the Liberties of other People.*

Virginia. In 1774 Peale gave the other to the state of Maryland to hang in the statehouse at Annapolis. The mezzotint, completed before Peale left England in March 1769, is his largest. It is signed but not dated. It is not known who instructed Peale in the art of mezzotint engraving, but this is a thoroughly competent production, especially for a first attempt. Two states appear to have been issued; only the second state bears the names

"Sidney" and "Hamden" engraved on the bust-length figures that decorate the front of the altar.

Although Peale later recorded that this venture had been a total failure and that he had not even recovered the cost of the paper, some advertisements and sales are known. He sold twenty impressions at fifteen shillings each in 1769 in Philadelphia, his best market for this work, and the impression he sent to Copley in Boston brought him an encouraging and complimentary letter of thanks.[5] The mezzotint was not, however, the success he had anticipated because the colonial populace never took to the appearance of their idol in classic garb and without his periwig. Too, Pitt's popularity waned in the 1770s.

This was the sole attempt that Peale is known to have made in the "grand manner" of art—in painting or engraving. Once he returned to America—to the land of his birth and the home of his beloved wife and family—he painted the realistic, straightforward likenesses that we treasure so highly today. His sitters—the great and famous, and the common man and woman—are portrayed naturally and unaffectedly. Peale subjects usually seem to be happy people; perhaps Peale's own generous and loving nature was contagious and his sitters reflect his contented state. In rejecting the grand manner of history painting and abandoning the portrait cum historical allusion that Sir Joshua Reynolds stressed in the 1770s, Peale doubtless saw the wisdom of Carroll's advice, which may have agreed with his own natural inclination, that "in this Part of the World few have a Taste for it."

A decade passed before Peale attempted another engraving. This was a bust-length portrait of George Washington, presumably based on the miniature he had painted of the general on September 28, 1777, "on the march to the Battle of Germantown." The difficulties inherent in making an engraving in the colonies during wartime are reflected in Peale's diary. October 16, 1778: "Began a drawing in order to make a medzo-tinto of Gen. Washington. Got a plate of Mr. Brookes and in pay I am to give him 20 of the prints in the first 100 struck off." October 30: "Pd. Mr. Willis 10/ for turning a roller of a press which I borrowed." Although Peale's lists account for at least eighty im-

pressions, some of which were complimentary copies, some sold, and others consigned to stationers or publishers for sale at five dollars each, not a single impression of this print is known today. We have only a reference by Pierre Eugène du Simitière, one of the recipients of a gift copy, describing Peale's 1778 Washington as "A small mezzotinto of a head of Gen. Washington."[6]

In the late nineteenth century Charles Henry Hart suggested that an unsigned mezzotint of George Washington (No. 71) had been engraved by Peale and that it was identical to the print

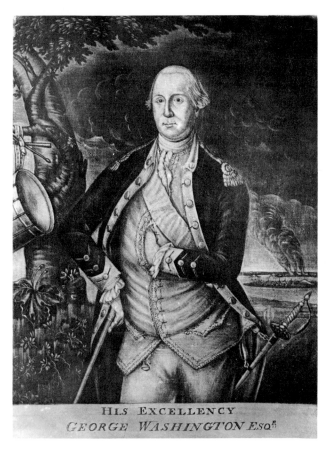

71. *HIS EXCELLENCY GEORGE WASHINGTON ESQR.*

recorded in Peale's diary in 1778. It is true that it is based on a Peale oil, one painted for John Hancock in 1776, but it is not "small"; it is a three-quarter length, not a head; Peale made no mention of a companion piece of Mrs. Washington; the Washington lacks a signature that Peale always included in his inscriptions; and the workmanship is vastly inferior to that which Peale had done ten years before. A couple of years ago I attributed it to Joseph Hiller, Sr., of Boston, and I mention it now only so you will understand that it does *not* fit into the scheme of Peale portrait engravings.[7]

Peale's own Washington mezzotint of 1778 was evidently not so disappointing a venture financially as we might now think from the lack of known impressions, for it gave him the idea of producing a series of portrait engravings. On October 15, 1779, he wrote to Edmund Jenings: "Amongst the articles which I have requested Mr. Carmichael to send [from Spain] are paper and Copper Plates for me to etch a Set of Heads of the Principal Characters who have distinguished themselves during this contest."[8] This request was never fulfilled, however, and Peale was forced to improvise materials himself in order to engrave the three-quarter-length Washington of 1780 (No. 72), which is his best known print. It is based on his full-length 1779 Washington oil, the original of which was commissioned by the Supreme Executive Council of Pennsylvania. Numerous replicas were ordered (No. 73), for it was one of Peale's most successful paintings. It shows Washington resting his hand on the muzzle of a cannon, behind which stands a soldier holding a horse's bridle and a flag, and in the background the battlefield of Princeton with Nassau Hall silhouetted against the winter sky.

Peale advertised in the *Pennsylvania Packet* on August 26, 1780: "The subscriber takes this method of informing the Public, That he has just finished a Mezzotinto PRINT, in poster size of his Excellency GENERAL WASHINGTON, from the original picture belonging to the State of Pennsylvania. . . . NB. As the first impression of this sort of prints are the most valuable, those who are anxious to possess a likeness of our worthy General are desired to apply immediately."[9] There are several

interesting variations between the oil and the print, besides the expected reversal of the image. The general wears a blue ribbon diagonally across his chest in the painting, but by the time the mezzotint was issued the army dress code had been altered and Peale reflected this by omitting the ribbon. The flag, which carried six-pointed stars in the painting, has the five-pointed ones that were ultimately accepted as conventional in the print. There was apparently sufficient demand for this likeness of

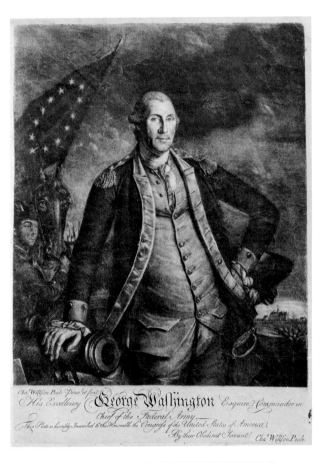

72. *His Excellency GEORGE WASHINGTON Esquire, Commander in Chief of the Federal Army.*

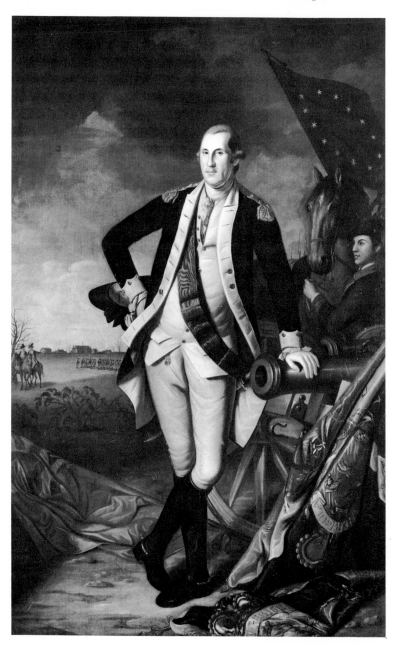

73. [George Washington.]

Washington for Peale to issue a second state. It differs from the first most obviously in the inclusion of the date 1780 after Peale's signature at the lower left.

Peale made a concerted effort, by contrast with his former sporadic endeavors, to establish a recognized business and to derive a reliable income from his mezzotints in 1787. This decision may have been fostered to some extent by the founding of the *Columbian Magazine* in Philadelphia in 1786 by his old comrade-in-arms, James Trenchard. This journal was, at first anyway, generously illustrated, and Peale provided a number of landscape and cityscape designs that were then engraved in line by Trenchard or James Thackara.

We know that the idea of engraving a series of portraits of the leaders of the War of Independence was in Peale's mind as early as 1779. On February 2, 1787, Peale wrote to Dr. David Ramsay:

> Of late I have begun one other great work, the making of Mezzotinto prints from my collection of portraits of Illustrious Personages. This undertaking will cost me much labour as I am obliged to take the plates from the rough and doing the whole business myself, even the impressing. I have just finished one of Doctr. Franklin which I am giving out as a specimen of the size & manner I intend this series of Prints. . . . My first intention was to have taken subscriptions for a Doz prints which I had selected out of the whole Collection of Heads, but on second thought I have judged it best to propose only one at a time which I expect I shall be able to deliver in 6 weeks after I begin the work. . . . By this business of Prints I hope I shall get something in return for my great Expense of time and labour in making my Collection of Portraits.[10]

To General Washington he wrote on February 27 that the Franklin was "a specimen of the size and manner of my intended Series of Prints yet I do myself injustice as this Print is much coarser than others will be."[11] On March 30 the project was announced and the Franklin mezzotint advertised in the *Pennsylvania Gazette*. Peale had painted Benjamin Franklin from life in the fall of 1785. This portrait, now at the Pennsyl-

vania Academy of the Fine Arts, was the model for the engraving (No. 74). Like the others that followed in the series it is a bust-length oval with two surrounding oval bands. The wide outer one carries a lengthy inscription identifying the subject and his career and accomplishments; the narrow inner band contains Peale's signature and the date. As Dr. Richardson has noted, Peale did not do justice to his efforts here; the print is good in tone and sympathetic in feeling, even if it has a slightly coarser grain than the later portraits in the series. So far as is known the last impressions of this plate were taken on August 6, 1788. It originally sold for one dollar unframed and three dollars glazed in a double oval frame with gilt liner.

The Marquis de Lafayette was Peale's next engraved subject. Peale wrote to the marquise on April 20, 1787, and said he was sending her an impression of the Lafayette mezzotint (No. 75) and also one of the Franklin. Peale painted Lafayette from life only once, in 1780–1781. He is known to have painted several replicas of that portrait, however, and it was from the one in his museum that he took the likeness. Both Sellers and Richardson commented upon the rarity of this print; in fact, Sellers could not locate a single impression in 1952. Five are known today, which gives it a rarity factor similar to that of the 1780 Washington and the Franklin. The next subject of Peale's oval series, the Reverend Joseph Pilmore (1739–1825), was a considerably less illustrious personage. He was the only subject not included in Peale's museum collection of oil portraits. In 1952 Sellers projected the existence of the painting on the basis of the print. The oil subsequently came to light in the private collection of a descendant living in Florida. It was offered for sale at Parke-Bernet in October 1973[12] but was bought in and is still in family hands.

After serving as a Methodist missionary in the American colonies from 1769 to 1774, Pilmore returned to his native England. In 1785 he immigrated to the United States, was ordained an Episcopal priest by Bishop Samuel Seabury, and in 1786 became rector of the united parishes of Trinity, All Saints', and St. Thomas's in Philadelphia. He later served as rector of Christ Church in New York City and of St. Paul's Church in Philadel-

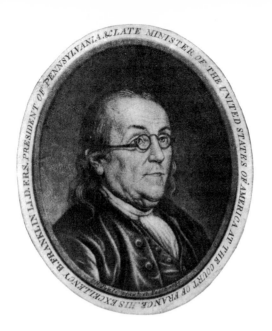

74. *HIS EXCELLENCY B. FRANKLIN L.L.D. F.R.S.*
PRESIDENT OF PENNSYLVANIA.

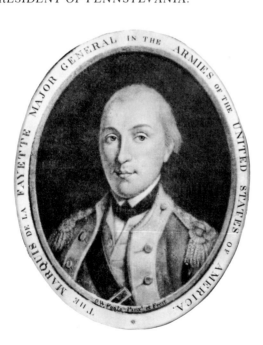

75. *The MARQUIS DE LA FAYETTE.*

phia. The *Dictionary of American Biography* describes him as "a man of massive frame and robust constitution. His bearing was dignified and his voice . . . sonorous. He must have been an amiable, kindly man, for there is a tradition in Philadelphia that he was known popularly as 'Daddy Pilmore.' "

Peale presumably felt there would be considerable demand for the likeness of a popular local clergyman. The print was advertised in the *Pennsylvania Packet* on May 18, 1787. It seems to have sold well and there are a number of impressions extant. There is a brilliant proof before letters at the Metropolitan Museum of Art (No. 76) and an impression from the completed plate at Winterthur (No. 77). Impressions of the restrike at the New-York Historical Society (No. 78) and at the Metropolitan (No. 79) present a very different appearance. The outer oval bands and inscriptions are missing. The outlines that remain are quite irregular as if hastily trimmed. At first glance it would seem that the plate had been cut down by a clumsy hand and later impressions pulled, perhaps long after Peale's death. Care-

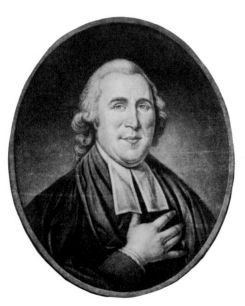

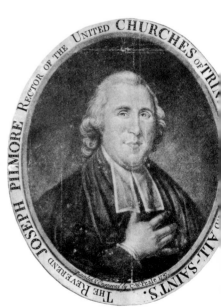

76. [The Reverend Joseph Pilmore.] 77. *THE REVEREND JOSEPH PILMORE.*

ful comparison of the edges of the ovals, however, reveals that they are different. This irregularity and variety held true for all eight impressions of the Pilmore restrike that have been examined. No two oval outlines are the same. It is surely not reasonable to conjecture that a maniacal printer ground a tiny bit off of the copperplate and pulled one impression, ground a bit more off the other side and pulled one, took a hairsbreadth off the top and pulled one, and so forth. Nor can the variety be explained by each impression having been cut out of a larger sheet with scissors. Indeed, this would account for the variations, but these impressions were printed on rectangular sheets with margins; they have not been laid in.

I was quite stymied about how to account for this situation until I had the good fortune to be examining the three copies in the New York Public Library under a raking light. Suddenly I realized that I could see the impress, blind not inked, of a number of the block letters forming the major, outer inscription on one impression. I examined another impression closely—the

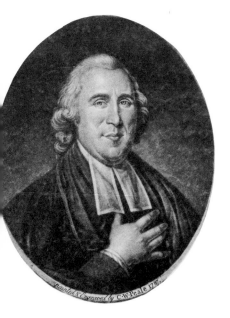

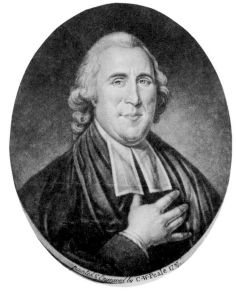

8. [The Reverend Joseph Pilmore.] 79. [The Reverend Joseph Pilmore.]

blind impress was there too, and on the third—varying in lo-
cation and intensity from impression to impression but defi-
nitely there. Later I checked the Historical Society's impression
—there too certain letters are discernible in relief. So the plate
was not cut down; the surrounding inscription was still intact
when this version was printed. But it must have been masked
in some way so that the letters were not inked, but the pressure
of the printing process left their impress in certain areas on the
surrounding paper. Inexpert masking that shifted slightly under
the weight of the rollers each time the plate was put through the
press or with each re-inking probably accounts for the varying
outlines of the inked ovals. It is also possible that the part of the
copperplate carrying the oval inscription, rather than being
masked, was simply not inked. Evidence of this tricky and un-
reliable procedure may be found on the National Collection of
Fine Arts impression, which has a slight residue of ink forming
a shadow around the oval.

I have a suggestion to offer as to why restrikes may have been
issued in this form. With the major lettering gone there is no
means of identifying the subject; one is left with a benign and
pious-looking clergyman and the inner inscription "painted &
Engraved by C. W. Peale 1787." It could have been offered
for sale by an unscrupulous print dealer as *any* clergyman by
Charles Willson Peale—one that Peale had never painted or
even seen. His signature presumably added a desirable fillip,
for the inner border with his name inscribed could have been
removed as easily as the outer one. It may be that this print is
masquerading as a different clergyman in some print collec-
tions, or it may be housed in the limbo of "unidentified clergy-
men." The only firm clue as to a date when this was done is
that this impression of the New-York Historical Society's Pil-
more was accessioned on May 12, 1899. This leaves virtually
all of the nineteenth century for the dastardly printer to have
done his dirty work.

We now come to the last of Peale's portrait engravings, the
only subject he ever repeated—George Washington. Washing-
ton came to Philadelphia in May 1787 to preside over the Con-
stitutional Convention. On May 29 Peale wrote to his former

commanding officer: "With the utmost reluctance I undertake to ask you to take the trouble of sitting for another portrait. It gives me pain to make the request, but the great desire I have to make a good mezzotinto print that your numerous friends may be gratified with a faithful likeness."[13] Washington sat for Peale early on three July mornings and the small bust-length oil that was the result is now in the Pennsylvania Academy of the Fine Arts. Peale advertised the print (No. 80) as forthcoming throughout August and into September in the local newspapers. On September 26, the *Pennsylvania Gazette* carried a notice that "A Messotinto Print of His Excellency General Washington, done by Charles Wilson Peale, of Philadelphia, from a portrait which he has painted since the sitting of the Convention; is now compleated; the likeness is esteemed the best that has been executed in a print."[14] This advertisement and one in

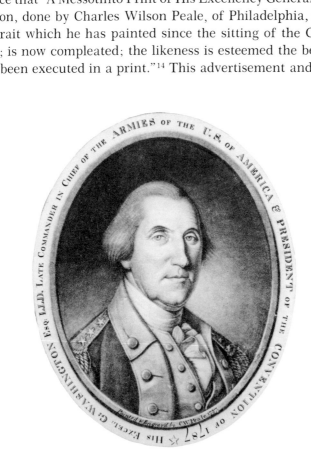

80. *HIS EXCEL: G: WASHINGTON Esq:*

the September 28 *Pennsylvania Packet* also list as for sale mez-
zotints of Franklin and Lafayette; there is no mention of the
Reverend Pilmore. The *Pennsylvania Packet* advertisement re-
veals in addition:

> Mr. Peale has by his practice overcome difficulties in the
> execution of Mezzotinto Prints, which he had to contend
> with; he therefore proposes to sell the prints, which are to
> compose his Collection of Portraits of illustrious Person-
> ages distinguished in the late Revolution, at two thirds of
> a dollar each, which is at or below the London prices; and
> the subscribers to this work who have been supplied with
> the first prints, shall be allowed the difference of price
> which they have paid above the present proposal, in de-
> duction from the price of the succeeding prints. The double
> oval frame between print and glass being gilt, cannot be
> afforded by the artist for less than one dollar.[15]

The oval Washington is known in early proofs before letters
and in two states, all issued in 1787. The first state was printed
in what Hart called "reddish brown" as well as in black ink. The
second state, the inscription of which mentions Washington's
service as president of the 1787 Constitutional Convention, Hart
records as having been printed in red and in black ink and in
colors.[16] An impression in red ink is not presently known, but
there is an impression, beautifully and delicately colored, in
the New York Public Library. The coat is blue, the lapels and
waistcoat are buff, and the face is a natural flesh tone. The only
reference by Peale to his novel undertaking of color printing
appears in his diary for July 30, 1788, when he recorded:
"Ground some colors and printed some plates of Genl. Wash-
ington."[17] The different color inks were applied to the plate by
hand at the same time and the colored impression pulled in one
operation. Peale's technical ingenuity and creative interest in
the use of color in engravings (foreshadowed by his use of red
and reddish brown inks) enabled him to produce what must
have been one of the earliest color printed engravings in the
United States. This accomplishment is a fitting climax to his
career as a portrait engraver.

On September 27, 1787, Peale wrote to Washington, "By this

post I take the liberty of sending a few Prints for your accep-
tance. I have not been able to execute a greater number of plates
as yet, but am preparing some others which I hope will be pub-
lished some time in the ensuing fall and winter."[18] The prints
sent at this time were probably several impressions of the Wash-
ington mezzotint and possibly one of the Lafayette. We know
Peale had already sent Washington one of Franklin, his first
endeavor in the oval series, back in February. All three hung in
the music room at Mt. Vernon during Washington's lifetime.

On November 17, 1787, Peale wrote to his friend and mentor
Benjamin West, "I have begun a work from my collection of
portraits of which I send you by Mr. Clarkson some proof prints.
— This is a work which I mean to pursue when I have no other
business to do, for the sale is not such as to induce me to pursue
it otherwise."[19] Peale never added any more notables to his
series of mezzotint portraits; he was evidently kept fully occu-
pied pursuing his museum and other business. His diary re-
cords him still printing impressions and touching up the plates
well into 1788, and the last sale noted is on May 29, 1790.
Peale's occasional experiments in the field of engraving never
occupied a major position in his artistic endeavors, nor did they
provide a significant part of his income. It was not until the
nineteenth century that an American artist could devote him-
self mainly to printmaking and earn a living at it. But Peale's
mezzotints remain one of the most valuable and interesting
surviving groups of eighteenth-century prints by a major artist.

APPENDIX

Locations of All Known Impressions of

Portrait Engravings by Charles Willson Peale

MR. PITT 1768 (Stauffer 2426) (Sellers 695)	State I	Boston Public Library; New-York Historical Society; Winterthur
	State II (with names "Hamden" and "Sid- ney" on busts)	Colonial Williamsburg; Pennsylvania Academy of Fine Arts; Yale
WASHINGTON 1780 (Stauffer 2428) (Sellers 916)	State I	Metropolitan Museum (2 imps.)
	State II (dated 1780)	Anne Brown Military Collection (ex-Mid- dendorf); Historical Society of Pennsyl- vania; New York Pub- lic Library
FRANKLIN 1787 (Stauffer 2423) (Sellers 282, 171)		American Philosophi- cal Society; Histori- cal Society of Dela- ware; Kennedy Galler- ies (ex-Middendorf); Library Company of Philadelphia; Metro- politan Museum; Penn- sylvania Academy of Fine Arts; Winterthur
LAFAYETTE 1787 (Stauffer 2424) (Sellers 450)		Historical Society of Delaware; Kennedy Galleries (ex-Midden- dorf); Metropolitan Museum; Mt. Vernon; Museum of Fine Arts, Boston
JOSEPH PILMORE 1787 (Stauffer 2425) (Sellers 692, 189)	before letters original version	Metropolitan Museum Independence Hall; New-York Historical Society; Rosenbach Foundation; Gurney Sloan Collection; Winterthur
	restrike (lacking oval surrounding inscription)	Metropolitan Museum; Middendorf Collection (2 imps.); National Collection of Fine Arts; New-York His-

		torical Society (2 imps.); New York Public Library (3 imps.); Donald R. Walters Collection; Winterthur; Yale
WASHINGTON 1787 (Stauffer 2429) (Sellers 940, 372)	before letters	Metropolitan Museum; New York Public Library; Yale
	State I (inscription ends: of America")	Independence Hall (black); New York Public Library (reddish brown ink)
	State II (inscription ends: of 1787")	Metropolitan Museum (black ink); New York Public Library (1 imp. black ink, 1 imp. colored); Winterthur (black ink)

NOTES:

[1] Albert TenEyck Gardner and Stuart P. Feld, *American Paintings: A Catalogue of The Metropolitan Museum of Art*, I (New York, 1965), p. 57.

[2] Charles Coleman Sellers, *Charles Willson Peale* (New York, 1969), p. 62.

[3] Ibid., p. 65.

[4] Frank H. Sommer III, "Thomas Hollis and the Arts of Dissent," in John D. Morse, ed., *Prints in and of America to 1850*, Winterthur Conference Report 1970 (Charlottesville, Va., 1970), pp. 142–155.

[5] Sellers, *Charles Willson Peale*, p. 82; Charles Coleman Sellers, *Portraits and Miniatures by Charles Willson Peale* (Philadelphia, 1952), p. 173, no. 695.

[6] Sellers, *Charles Willson Peale*, p. 166; Sellers, *Portraits and Miniatures*, pp. 224–225, no. 903.

[7] Charles Henry Hart, *Catalogue of the Engraved Portraits of Washington* (New York, 1904), pp. 3–4; Wendy Shadwell, "An Attribution for His Excellency and Lady Washington," *Antiques*, XCV (February 1969), pp. 240–241.

[8] Sellers, *Charles Willson Peale*, p. 183.

[9] Sellers, *Portraits and Miniatures*, p. 231, no. 916.

[10] Edgar P. Richardson, "Charles Willson Peale's Engravings in the Year of National Crisis, 1787," *Winterthur Portfolio*, I (1964), p. 169.

[11] Ibid., p. 170.

12 Sotheby Parke-Bernet, Inc., New York, sales catalogue, October 25, 1973, no. 3561, lot 8.

13 Richardson, "Peale's Engravings," p. 173.

14 Ibid., p. 174.

15 Sellers, *Portraits and Miniatures*, p. 238, no. 940.

16 Hart, *Catalogue of Portraits of Washington*, pp. 4–5.

17 Sellers, *Portraits and Miniatures*, p. 238, no. 940.

18 Ibid.

19 Richardson, "Peale's Engravings," p. 181.

The Prodigal Son in England and America: A Century of Change

Edwin Wolf 2nd

"A certain man had two sons," *Luke*, XV, 11, reads. The parable of the Prodigal Son continues:

> And the younger of them said to his father, "Father, give me the portion of goods that falleth to me." And he divided unto them his living. And not many days after, the younger son gathered all together, and took his journey into a far country, and there he wasted his substance with riotous living.

When he had spent his all, a famine unfortunately occurred—caused no doubt by an embargo on palm oil by the descendants of Ishmael—and the penniless Prodigal went hungry. In dire straits, he hired himself out as a swineherd. From there on things went uphill. Strange as it may seem in a moral story, it was the young man's stomach and not his conscience which impelled him to return to his father's house a chastened and penitent wanderer. He was reclothed and readorned, and then the family sat down to a banquet at which there was served a "fatted calf," or veal, presumably then as now the most expensive kind of meat available. When the prissy elder son complained at the man-of-the-year award going to one who had sinned, the father in periphrastical words gave the obvious explanation: a sinner was saved.

My interest in the Prodigal Son began with a slow-burning fuse almost thirty years ago. After the brothers Rosenbach moved their establishment from 1320 Walnut Street, where they had conducted their business since early in this century, to 1614 Locust Street, many long forgotten cartons were churned up to the surface. In one of these I found a number of copperplates, that is, coppers and not engravings. Most of them had been made for the *Columbian Magazine* and early nineteenth-century children's books, an inheritance from Dr. Rosenbach's bookseller uncle, Moses Polock, through his predecessor firms, Johnson and Warner and McCarty and Davis.

One of the coppers was entitled *Takes Leave of his Father* (No. 81), a subject that was recognizably an illustration of the Prodigal Son parable. With it was a late pull from an abused half-plate, *Returns home a Penit[ent]* (No. 82), another episode from the same series.[1] The copper was signed "W. P." On its other side was the title page for *A New Spelling Alphabet for the Instruction of Children*, engraved by Kneass and corrected by pounding with a pean hammer on the Prodigal Son side. The half-plate was obviously printed from a once existent similar copper, cut in half, and used on the verso for we do not know what. It bears evidence of hard usage.

At that time I had no clue to the date of the engravings or to the circumstances surrounding their publication. By chance in 1970 I came across a little print in the collection of the Historical Society of Pennsylvania that answered some questions about the Rosenbach engravings and then raised many more that triggered my explorations into English and American versions of the series. The engraving I discovered bore the general title *The Prodigal Son*, the specific title *He receives his Patrimony*, and the further information "Printed by Js. Brown, Phila." and "W. P. Sculp. 1795" (No. 83).[2] Plainly, it was a contemporary printing of the first of the set of The Prodigal Son of which the Rosenbach copper and fragment were part.

Joseph Brown, the copperplate printer and presumably publisher, was a known factor. Early in 1795 he added his name to the second issue of the *Prospect of the new Lutheran Church* in the course of being consumed by flames on the night after

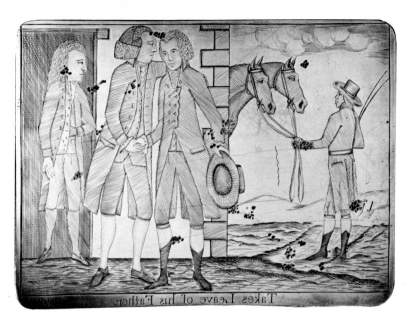

81. *Takes Leave of his Father.*

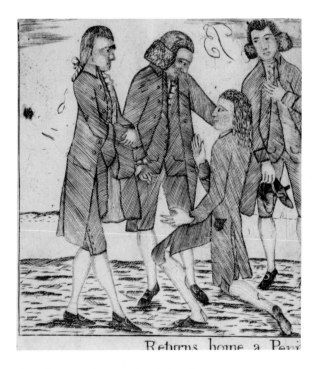

82. *Returns home a Penit* [ent].

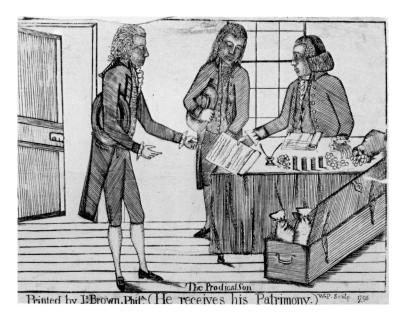

83. *The Prodigal Son (He receives his Patrimony).*

Christmas 1794. The print was etched by Frederick Reiche, and a colored copy from the Historical Society of Pennsylvania was exhibited at the print conference in 1973.[3] The big question was the identity of W. P. I have a suggestion, a man who did engraving of sorts and was enough of a virtuoso to have put his hand to the little prints under consideration. Let us look at William Priest, an examination warranted by the fact that I believe his engravings of The Prodigal Son to be the earliest executed in America.

Priest came to the United States as a member of the orchestra with the English dramatic company of Wignell and Reinagle in 1793.[4] The yellow fever epidemic prevented the fall opening of the theatrical season in Philadelphia, so the company went to Annapolis and Baltimore before coming to the new Chestnut Street Theatre. Their first performance on February 17, 1794, was O'Keefe's opera, *The Castle of Andalusia*.[5] All historians of the Philadelphia theater comment on the emphasis placed by

Wignell and Reinagle on the musical aspects of their presentations. Charles Durang, the historian of the early Philadelphia stage, wrote, "The orchestra department was under the direction of Manager Reinagle and the musicians were deemed equal in general ability with the stage artists—the celebrated violinist from London, George Gillingham, the leader. In truth, the orchestra contained about twenty musicians, many of them of great notoriety as concerto players on their respective instruments."[6] William Priest was one of these.

There is a record of "Twelve duets for 2 clarinets adapted from Pleyel by Mr. Priest of the New Theatre, Philadelphia," advertised for sale by Harrison in New York in May 1794.[7] No copy of the music is known. But we do know from two pieces of evidence that Priest not only arranged music, but engraved it. An edition of "The President's March" bears the imprint, "Philadelphia. Engraved and published by Wm. Priest. Sold at the music stores in the United States. And by Preston and son, No. 97 Strand, London. Price 25 cents."[8] Furthermore, in Dunlap and Claypoole's *American Daily Advertiser* of January 3, 1795, and the *Pennsylvania Packet* of the same date, appeared the following advertisement:

MUSIC ENGRAVING

In all its branches correctly performed by Wm. Priest, Musician of the New Theatre. For particulars enquire at No. 15, Apple Tree Alley between Fourth and Fifth streets.

Priest, the putative engraver of the Prodigal Son series of 1795, was in Philadelphia that year and was doing engraving of sorts.[9]

The next theatrical season of the Wignell and Reinagle company in Philadelphia ran from December 1795 until the beginning of July 1796. It was not a successful run. Many of the principal actors left, and the unpleasant competition with Hodgkinson's New American Company made matters difficult. During this period we learn from the *Philadelphia Gazette* that Priest played the trumpet at a concert of vocal and instrumental music at Oeller's Hotel on April 21, 1796, when Miss Huntley sang the "Trumpet Song," composed by Raynor Taylor, who

incidentally had arranged as a piano duet "The President's March" that Priest engraved.[10] It is indicated that he also played the bassoon.

Late in July 1796 the versatile Mr. Priest turned up in Baltimore. In the *Federal Gazette and Baltimore Daily Advertiser* for July 25 and August 5 he advertised:

<div style="text-align:center">

P A I N T I N G
In Imitation of Paperhangings,
</div>

By a mechanical process, which, from its facility, enables the artist to paint a room, staircase, &c. upon lower terms than it is possible to hang with paper of equal beauty.

<div style="text-align:right">William Priest,</div>

RESPECTFULLY informs the public, that he has imported an assortment of COLORS, which he warrants equal to those used in the best London manufactories of Paperhangings. He offers his services as above or in laying plain grounds in distemper with plain or festooned borders.[11]

I take it that the ingenious Mr. Priest used a roller with a design or pattern in high relief, but however he executed his painting, we do find him active in a form of graphic art. His stay in Baltimore was brief. He was in Philadelphia on his way to Boston in September. He sailed from there to England on March 12, 1797.[12] In 1802 Priest published what is to me a most unsatisfactory account of his American tour. He told all about what he saw and practically nothing about what he did, but it does place the trumpet player and music engraver in Philadelphia in 1795 and the wallpaper painter in Baltimore in the summer of 1796. Until a more likely candidate than William Priest appears to fit the initials W. P. on the Prodigal Son engravings, he must remain the presumptive artist who made the first American set.

This was only the first step in my immersion in the Prodigal Son, a tentative toe as it were. When I began to look for an English prototype upon which Priest might have based his designs, I found myself in over my head. I had no idea, and I do not believe others knew, that so many versions existed. As they turned up in print collections elsewhere and by purchase in the Library

Company of Philadelphia, I searched for some explanation of the unbelievable popularity of the theme.

The series as depicted by printmakers exists in sequences of four or six episodes. The first, "receiving his patrimony," shows the Prodigal standing before a table as his father hands him his share of the paternal fortune. The second, "taking leave," varies considerably in different versions, being set inside or outside, with a waiting horse or a coach. One or another of these first two scenes is omitted in the four-sequence set. The third, "revelling with harlots," "in excess," or "wasting his substance," is invariably set in a brothel. The fourth, "in misery," has the Prodigal sitting, standing, or lying down with a variable number of pigs in attendance. No version omits either of these last two subjects. The fifth, "returns reclaimed," is always set outdoors, but sometimes the Prodigal kneels before his father and sometimes a servant kneels before the Prodigal. The last, "feasted on his return," is a standard dining table scene, usually with musicians playing in a gallery. One or another of the last two scenes is omitted in the four-sequence set.

Following the tremendous success of Hogarth's *Rake's Progress*, that vividly moralistic series of engravings, a market for prints of that type became known and was exploited in England.[13] I hasten to state that I am aware of the many sets that Continental artists produced from the early sixteenth century on, but I limited my investigations to what was in the eighteenth century the mother country of most colonial North Americans. There was one catch to the Hogarth prints; the Rake came to a very bad end indeed. The Prodigal on the other hand came home. So, I imagine, the parable was a natural, not for sale to the nobility who had had prodigal sons for generations, but to the rising bourgeoisie, the London bakers and brewers, the mercers and merchants. These men of humble origin were making fortunes and setting themselves up as country squires. Their sons were enjoying the advantages of money, as sons of the nouveaux riches have throughout the ages. The Prodigal Son was the hosier Sir Samuel Stockin's son to life. His return to the flourishing business of his father was devoutly to be wished for. As visual prayers, the sets of prints flowered on the walls of En-

glish middle-class homes, redolent with the smell of candle wax and roast beef. And, since English middle-class virtues and vices had widespread appeal for colonial and later national Americans, they bought English Prodigal Sons and created their own versions long after the craze for them had died down across the Atlantic.

The earliest and possibly the first prints to have been executed in England in the new à la mode manner—the Bible in modern dress—were after the designs of Le Clerc. They appeared initially as etchings finished with a burin and colored by hand in about 1755 from the shop of Robert Sayer.[14] Having been satisfied no doubt with his market, Sayer then turned the designs over to the mezzotinter Richard Purcell who produced a series of six richly textured prints. Learning nothing from his work on this moral series, he was, as a biographical dictionary states, "dissolute, even depraved, in his life," and died in misery about 1765, a Hogarthian, not a biblical, end.[15] Which Le Clerc painted the originals I still do not know: David, a German who worked for a while in Paris, or Sebastien II, a Frenchman.[16] A certain Teutonic heaviness in the designs inclines me strongly to the former. The set, about 1760, was issued by Robert Sayer, and then reissued in 1775 with Henry Parker's name added in the imprint.[17]

Let us look for a moment at the manner in which the episodes were depicted. The atmosphere in the Purcell mezzotints throughout is one of heavy European baroque; the elegance is florid. The furniture, the accessories, and the costumes are of the early part of the eighteenth century. *Receives his Patrimony* (No. 84) shows the father at his table sprinkled with coins handing his son what must have been the equivalent of a letter of credit. *Taking Leave* is placed at the foot of a balustrade stairs before which the father embraces the son, as what seems to be a troop of cavalry stands ready to accompany the heir on his way. *In Excess* is unusual in that the Prodigal is carousing with three Paphians, heroically unaided by any male companions, and that after downing at least the better part of four bottles of wine. A maid straightens up a card table of interesting design. As in all the versions there is fruit as well as liquor bottles and glasses

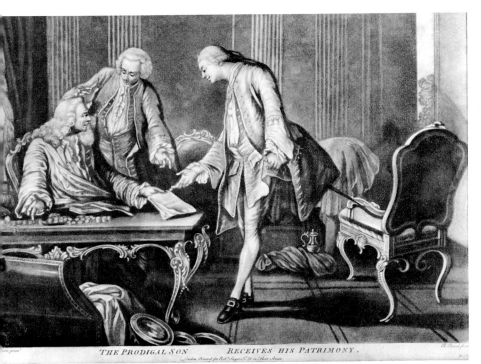

84. *THE PRODIGAL SON RECEIVES HIS PATRIMONY.*

on the table. I do not understand the sexual significance of fruit, for any kind of fruit, not just the serpent's apple, appears. Perhaps the lascivious scene in the cinematic *Tom Jones* was based on historical grounds.

In Misery is the least appealing of the scenes, but in the baroque version the Prodigal stands rather proudly in his sty. *Returns Reclaimed* has him kneeling before his father, somewhat overdressed and over-coiffured for one who has just left his pigs. In the background the fatted calf is being slaughtered. The details of *Feasted on his Return* are quite interesting in this as in other sets. The number of musicians varies, and they play strings, woodwinds, and brasses. It is no wonder the young man felt so much at home in the bordello; he there found chairs, glasses, and bottles similar to those in the patriarchal mansion.

Granted, papa's chairs were a trifle fancier than the madam's.

Le Clerc's paintings, or possibly the English mezzotints, found an enthusiast on the Continent. The Augsburg engraver, Johann Jakob Haid, and his son Johann Elias executed a set that is grosser and less skillful than Purcell's rendering.[18] And this was further debased by less accomplished members of the prolific Haid family who signed themselves, in a later set of six mezzotints, only "chès Haid."[19] The Le Clerc series is one of the few that seems to have been widely copied. A very large engraving, the only one of the set I have seen, "Sold by I. Marshall" about 1790, is obviously the Purcell mezzotint *Receives his Patrimony* in reverse.[20] Furthermore, I have come across portions of two different sets of Leeds china plates sent to Holland and there decorated with scenes from the Le Clerc series.[21] I wonder how and where else it was used.

The printseller most attuned to the taste of the times was Carington Bowles, whose brightly hand-colored mezzotints of genre scenes poured out of his shop to meet a seemingly unlimited demand both in England and, as Joan Dolmetsch has pointed out, in colonial America as well.[22] Bowles issued the Prodigal Son in many different shapes and formats. Early in 1775 he put out a series which in some ways is my favorite.[23] No artist's or engraver's name appears in this or any other later English print of the subject. It is English in every sense, and bold in conception. The Prodigal is red-coated and white-wigged, until he runs into trouble. Booted and spurred, with tricorne hat, sword, Negro attendant, and dappled horse as he takes his leave, he is just such a young Briton as I picture came with the army two years later to occupy Philadelphia and to teach Quaker ladies that fancy was more fun than plain (No. 85).

With companions less elegant than he, the Prodigal is offered the charms of two damsels with the kind of fancy headdresses which in these prints seem to set off ladies of easy virtue. Here the peach is a not-too-subtle symbol of eroticism. I can only guess that the well-defined face of the proprietress is the caricature of a notorious bawd; in the whole series she is the only person with other than bland features.

We can skip quickly over the next two scenes, except to point

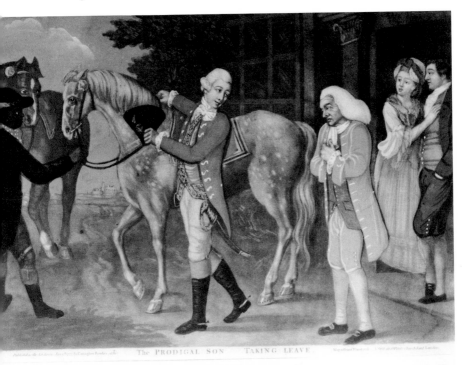

85. *The PRODIGAL SON TAKING LEAVE.*

out that the Prodigal wears his natural hair and is garbed in an unnaturally torn costume, almost as though playacting. It is one of the characteristics of almost all the prints that they are endowed with a theatrical quality. The backgrounds are stage sets; the personae act out their parts with more flourish than occurs in normal life; we are in effect being shown a morality play continually being brought up to date. Unlike the earlier set, in the Bowles 1775 mezzotint the Prodigal stands when he *Returns Reclaim'd* and the servant kneels. Except for the bonnet, Madame is dressed almost exactly the same as the madam.

This version has a touch of English country life that is a part of most of the series thereafter. At the table where the Prodigal is feasted sits the local vicar, almost always shown eating with

gusto. The musical trio here includes a violin, cello, and horn. The chair in the foreground is of a provincial Chippendale design; the carpet is of English, rather than oriental, manufacture.

Later in 1775 the imaginative Mr. Bowles gave six for one in a very large print that included the whole parable (No. 86).[24] It is pleasantly and neatly engraved, but there is little of notable individuality in the presentation. It might be recorded, however, that the merchant in *Receives his Patrimony* has acquired the family portrait of a cavalier and that all the costumes are a bit more countrified. The architectural details of the Georgian family home, the farm outbuildings, and the paneling in the bordello are carefully drawn. The carpets are Turkey; the trio in an unusual gallery consists of two violins and a clarionet; the rags have that dramatic off-the-shoulder look.

To supply cheaper prints a number of publishers put out small, uncolored etchings. Carington Bowles was in the forefront with a charming set of 1788.[25] A feature of *Taking Leave* is the extraordinarily high-wheeled phaeton—an eighteenth-century hot rod—in which the Prodigal is about to ride down the road to ruin. The brothel scene shows overdressed young ladies who miraculously retain their calm and are hardly disheveled after much wine and some fondling. The chairs, as the century draws near the end, are Hepplewhite in the French manner. A similar set once again appears around the family table in *Feasted on his Return*. A seven-man orchestra with two French horns, a clarionet, and strings entertains—curiously enough—a solely male company as the fatted calf in the form of a good English rib roast is brought in on a platter.

The printseller John Marshall in 1790 also put out a set of six small, oval etchings.[26] The workmanship is not of high quality, but the effect is pleasant. The artist is the only one to draw the departure and the return before the same estate wall. A chaise now takes the Prodigal from home. But if this is a more leisurely mode of travel, the saved energy is expended in drunken revelry, for the "excess" in this interpretation is excess alcohol. The Prodigal kneels in the homecoming scene. The welcoming banquet is dominated by two badly proportioned vasiform Hepplewhite chairs. Portraits now go back to Jacobean

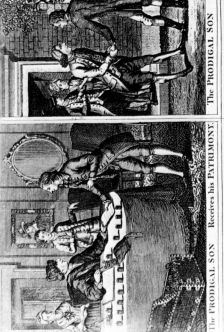

The PRODIGAL SON Receives his PATRIMONY.

The PRODIGAL SON TAKING LEAVE.

The PRODIGAL SON In EXCESS.

The PRODIGAL SON In MISERY.

The PRODIGAL SON RETURNS RECLAIM'D.

The PRODIGAL SON FEASTED on his RETURN.

Printed for Carington Bowles, at his Map & Print Warehouse, N°69 in St. Pauls Church Yard, London. Published as the Act directs

86. The PARABLE of the PRODIGAL SON.

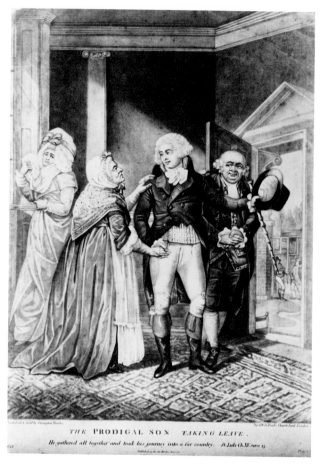

THE PRODIGAL SON TAKING LEAVE.

He gathered all together and took his journey into a far country. St. Luke Ch. XV. verse 13.

87. *THE PRODIGAL SON TAKING LEAVE.*

times, but one of the ladies wears a towering hat which must have been le dernier cri.

We now come to one of the most polished sets that has so far come to my attention. A series of four colored mezzotints of 1792, it too was published by Carington Bowles.[27] Although unsigned, according to Mrs. George in her British Museum catalogue, the designs were those of Robert Dighton, alas, a person who would be anathema to the world of curators; he was found to have abstracted prints from the British Museum. The costum-

ing of the Dighton set is characteristically fin de siècle. The Prodigal is just the kind of rake who would have been found in the company of that profligate bed bouncer, the Prince of Wales, and his drinking companion and mediator of fashion, Beau Brummell. The two of the set I have seen show interiors of neo-classic sophistication, although the elaborate triumphal arch entry to the brothel does seem considerably overplayed. In the departure scene the father really looks the part of one whose barons of beef brought him a baronetcy (No. 87). *Revelling with Harlots* is more replete with bits and pieces of sporting life than any of the other renderings. The paintings of a boxing match and a horse race suggest the afternoon's pastime. Two masquerade tickets and a cock-fighting program discarded on the floor and the enveloping cape on the sofa are evidences of the events of the early evening. Cards, dice, an empty hock bottle, and a partly consumed one of burgundy tell of the goings-on of the more immediate past. The gaming table and Hepplewhite chair are clearly delineated. The hat of the lady looker-on tops all in height. I am, however, puzzled by the presumably stimulating approach of "kitchy, kitchy, koo" under the chin, which I find difficult to believe would have roused the obviously besotted Prodigal to manly action.

Another printselling firm, Laurie and Whittle, carried on where Carington Bowles left off. A series of handsome colored mezzotints issued in 1794 provides us with the first definite bond between English prints and an American copyist.[28] I have not seen a copy of the first of the set of four, but from the imitations I do know what it will look like. The second, *Revelling with Harlots*, is in the best rakish tradition (No. 88). The Prodigal is shown as a two-fisted drinker; his inamorata is seductively —if that is the word for it—ensconced on a striped sofa; her cat grins knowingly; on the wall is a painting of the Halt leading the Blind. *In Misery* is more interesting than in other versions (No. 89). The composition is good. Two farm ladies look at the pig's keeper over a fence with some not very well defined feeling—interest, surprise, or disdain. *Returned Reclaimed* is placed in a formal setting within a courtyard where a fountain plays. The father wears a sober but rich black velvet suit; the

ladies, with high-crowned hats, are attended by a turbaned Negro page.

Sometime, probably between 1795 and 1800, the Laurie and Whittle mezzotints of 1794 were engraved in reverse by a quite competent American artist.[29] The prints are unsigned and bear no imprint. The coloring is reminiscent of the bold, unsubtle watercolors applied to the Plen and Papacin copies of the English engravings of *The Seasons*, probably executed at about the same period.[30] It is amusing that in one minor difference between the English mezzotints and the American engravings the

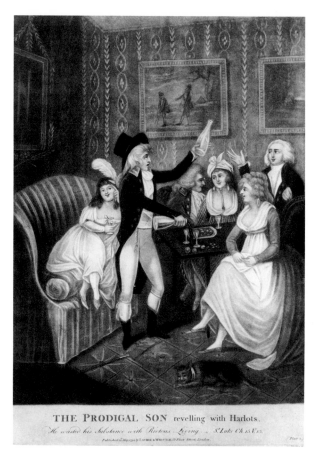

THE PRODIGAL SON revelling with Harlots.

He wasted his Substance with Riotous Living — St Luke Ch. 15. V. 13.

Published as May 1794 by LAURIE & WHITTLE, 53 Fleet Street, London.

88. *THE PRODIGAL SON revelling with Harlots.*

copy shows the same striped wallpaper in both the paternal home and the brothel, the latter of which is puritanically titled *Revelling with Girls.*

Until the appearance of the anonymous American engravings, it had been supposed that the primitive watercolors by Mary Ann Willson—an artistically very distant relative of Charles Willson Peale who also used the so-often-by-proof-correctors-miscorrected double 'l' in Willson—were copied from the Laurie and Whittle series.[31] But why did the lady reverse them? Reversing is a regular procedure of an engraver who copies

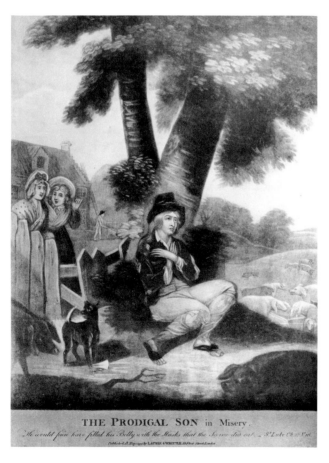

THE PRODIGAL SON in Misery.

89. *THE PRODIGAL SON in Misery.*

directly on the copperplate. It is now apparent that Miss Willson
made her drawings from the anonymous American prints that
were already reversed.

We return to the products of the London printsellers. A cheap
set of engravings issued by M. Denton in 1795 is so primitive
that were it not for the imprint they could be taken for Ameri-
can.[32] In fact, they resemble in style and costume—but not in
the interpretation of the scenes—Priest's set of exactly the
same date. We know of only four of Denton's six. *Receives his
Patrimony*, with a full complement of characters including the
vicar, is more lively than other versions (No. 90). More mod-
ern dress is represented in men's fashions by the long dark coat,
full waistcoat, and ruffled shirt. The scalloped frames on the
mirrors are unusual; the chairs are Sheraton. This is how Amer-
icans of the Federal period, as well as their contemporaries in
England, looked and decorated their homes. Although the faith-
ful dog participates in the departure and return scenes of many
of the series, in this one a cat scratches at the mother's skirt in
Feasted on his Return. The chairs and mirrors are as in the first
episode. The fatted calf is a suckling pig; the orchestra con-
sists of a clarionet, bassoon, French horn, and violin; a silver
ewer of classical design sits on a serving table.

Another inexpensive set of etchings was published by Haines
and Son in 1796.[33] The curved balustrade in *Taking Leave* is
reminiscent of Le Clerc's interpretation, but only faintly so. *Rev-
elling with Harlots* is really the first in which the members of
the party seem to be actively enjoying themselves and the fe-
males are décolletées enough to suggest that the end was not
yet. As in Le Clerc's version, which this in no other way resem-
bles, a domestic straightens up a gaming table. The feasters in
the last scene, seated on shield-backed chairs—mark, how the
styles modernize—are all men. The account of the revels in the
discreetly undelineated sequel to the wild party would not have
been for ladies' ears, at least not those of ladies of the upper
middle class whose ears were more delicate than those of the
less inhibited nobility.

A second Laurie and Whittle set of 1797 I pass over quickly.[34]
It consists of four small mezzotints executed by a hand that

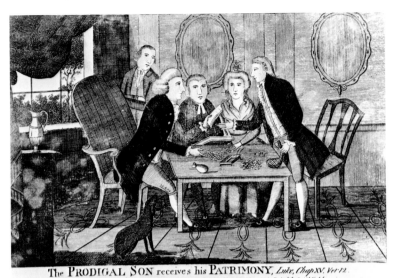

The PRODIGAL SON receives his PATRIMONY, *Luke, Chap XV. Ver 12.*
London. Pub.ᵈ as the Act directs Jan.ᵗ 10, 1793 by MDonston Hospital Gate W Smithfield.

90. *The PRODIGAL SON receives his PATRIMONY.*

lacked elegance. All that is worthy of notice are the modish low-brimmed hat of the Prodigal in *Taking Leave*, the dark wallpaper in *Revelling with Harlots*, and the feathers-upon-towers bonnet of the number two damsel and the wheel-back chair upon which she sits.

Two late eighteenth-century English sets can only be noted from fragmentary evidence. They were described in the Old Print Shop *Portfolio* for May 1944; their present location is unknown. One set is a pair of hand-colored mezzotints, two scenes to a plate, without publisher's name or date, but very much in the mode of the end of the century. The other set of six colored engravings, published by Paul Barnaschina in 1799, was illustrated by *Receiving his Patrimony*.[35] It is a fascinating twice-as-long-as-high print full of people and very handsome, very rich Hepplewhite furniture (No. 91).

Before considering the only English nineteenth-century Prodigal Son I know of and its American derivatives, I mention two unsigned and undated American sets that appear to have been

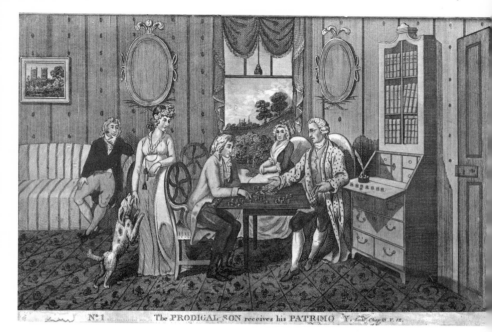

N° 1 The PRODIGAL SON receives his PATRIMO Y *First Chap 15 v. 12.*

91. *The PRODIGAL SON receives his PATRIMO[N]Y.*

issued between 1805 and 1815.[36] By a curious coincidence the Library Company secured portions of both sets that were certainly identical. The earlier prints, so denominated because they are on laid paper, are rather skillfully executed etchings. There is nothing striking about *Taking leave* and *Return'd home* except the plain, somber garb of the father (No. 92). Was he perhaps a good Quaker concerned lest his well turned out son enter the red door of an Episcopal church when he arrived in town? The mother with her cap and shawl is in keeping, although the daughter wears the feather of fancy in her bonnet.

The complementary series providentially consists of the other four episodes, somewhat cruder engravings on wove paper. My guess is that they were copied from the etchings. The only unusual aspects are that an overseer with a whip appears in *Feeding Swine*, and that a harlot is seated with more than usual abandon on the Prodigal's lap, while one of his companions reaches farther into a bodice than in any other version.

A single reverse engraving on glass, *Returned to His Father*, published by W. B. Walker in London in 1805, is tantalizing but incomplete evidence of the English origin of several series of American prints and drawings.[37] It shows the Prodigal kneeling before his father as his mother and sister to the left look on; a Georgian house can be seen in the background to the right. A set of four primitive watercolors by a better than average anonymous artist at the Abby Aldrich Rockefeller Folk Art Center contains one scene that is an exact copy of the glass print. Whether the other subjects derive from Walker's series cannot at present be stated with assurance, for, with minor changes, the Doolittle *Returned to His Father* is a copy of the Walker print and hence similar to the anonymous watercolor, but the other three watercolor scenes are not the same as those subjects by Doolittle.[38]

We come inevitably to that overpuffed, overpriced, overhack-

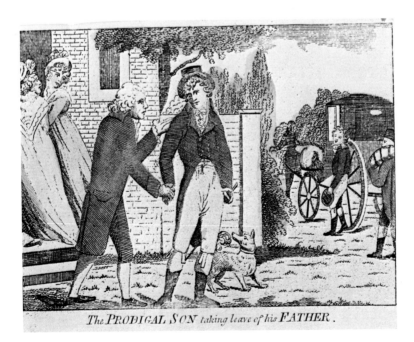

92. *The PRODIGAL SON taking leave of his FATHER.*

neyed set by Amos Doolittle, published by Shelton and Kinsett at Cheshire, Connecticut, in 1814.[39] They are essentially etchings finished by engraving (No. 93). The costuming derived from the English original does give the feeling of the era of James and Dolley Madison. In the only scene we can compare with its prototype, the positions of the Georgian house and the two women have been reversed. An oversized urn has been added on the wall. *Receiving his Patrimony* shows the Prodigal in a curious chair with coiled and recoiled curlicues; a filled

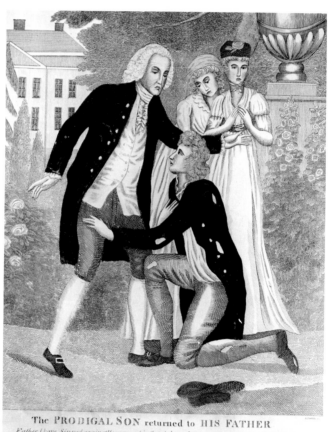

The PRODIGAL SON returned to HIS FATHER

Father I have Sinned againstHeaven and in thy sight and am no more worthe to be called thy Son

Published by Shelton & Kinsett Cheshire Connec Dec'r 1 1814

93. *The PRODIGAL SON returned to HIS FATHER.*

bookcase is in the background; the elder brother stands behind the table with his left hand tucked into his vest in a quasi-Napoleonic pose. As in most versions, *Revelling with Harlots* has the elements of comedy. The Prodigal sits with his love-of-the-evening's leg affectionately draped over his thigh. The focal point of the composition, however, the triangulation so much admired by art critics, is achieved by the thoughtful girl who tries to rouse the somnolent companion by pouring wine on his head. The bowl of fruit, remarked upon earlier, is still on the table. As in no other interpretation, the Prodigal *In Misery* considers his plight with his back to a graveyard, contemplating no doubt the Puritan fire and brimstone that lies only sin deep below.

These prints in turn were copied exactly as colored lithographs by D. W. Kellogg and Co. of Hartford in the late 1830s.[40] I find the copies aesthetically more pleasing than the Doolittle etchings, the woodenness of which was made pliant by the lithographer. Chiseled features have given way to a reasonable facsimile of flesh and bones. Further identical copies of the Kellogg lithographs were made by an anonymous lithographer.[41] They bear no imprint, have a single framing line instead of a double one outside the picture margin, and omit the *St* before *Luke* in the citation of the biblical quotation.

The regular chronological progress of the American sets becomes confused at this point. Two known lithographs only of four are part of a series signed "F K" in the body of the print, but without any publication notice.[42] *Receiving his Patrimony* is a reversed copy of the Doolittle–Kellogg version, but with a latticed window, the corner of a large painting, and no books in the background. The curlicue chairs, the inkstand on the table, and the Napoleonic stance of the elder brother remain the same. Strangely enough, *Revelling with Harlots* is not reversed, but the Prodigal's charmer is no longer so lasciviously seated.

Which copied which is difficult to say. Nathaniel Currier, probably in the 1840s, published a series of which I have seen only two.[43] *Receiving his Patrimony* is as in the anonymous lithograph, one step removed from the Doolittle–Kellogg ver-

sion, with the same background as the F K print (No. 94). In fact, all is the same except that the father's chair has become more solidly early Victorian. *Wasting his Substance* has similar furniture, but it resembles no other representation of that scene. Did Currier make an eclectic selection of sources? Is there still another set between Doolittle and Currier, or is this the Walker original that Doolittle discarded in favor of another? In the Currier print the obviously drunken Prodigal, holding himself on his feet with a chair tucked under his arm as a crutch, pours wine from a decanter onto the floor. It is significant that the title in this set employs the participle "Wasting" instead of the more usual "Revelling." For the period, the costumes seem a bit old-fashioned, a carryover from the prototype.

The latest of the representations of The Prodigal Son that has surfaced are two longitudinal colored lithographs.[44] *Receiving his Portion*, probably issued about 1840, still bears part of the imprint of H. R. Robinson of New York and Washington, but the date of publication is gone. The father sits in just such a chair as Lincoln might have bought for his home in Springfield. The Prodigal holds a shiny stove-pipe hat. The ship prints on the wall are indications of the source of the wealth being handed to the young man. The departure is cleverly worked into the scene. A serving man carries out a Saratoga trunk to the waiting carriage. Another lithograph, *In Misery*, trimmed down to the picture margin, is well drawn and well executed on stone. It may be part of the Robinson set.

A handful of primitive watercolors are really on the periphery of my main subject, for they bear no relationship to the Anglo-American sets. The earliest of them stems from an individualistic interpreter of the Pennsylvania-German tradition of the late eighteenth century.[45] It is difficult to classify the pointillist who drew the colonial loving and drinking scene, which has character, recognizable ladder-back chairs, a symbolic cat with a mouse in its mouth, the Prodigal with a pigtail, and no resemblance to any other version.

Far more common is a later four-scene series, also of Pennsylvania-German origin, most examples of which have been attributed to Friedrich Krebs.[46] He may well have drawn the first,

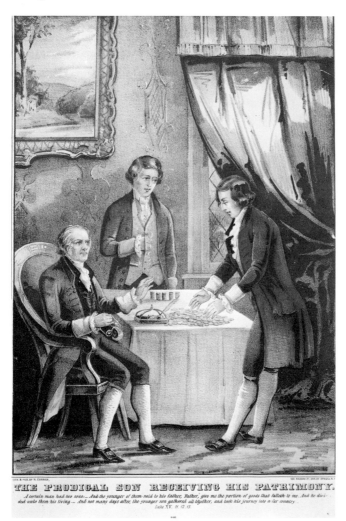

94. *THE PRODIGAL SON RECEIVING HIS PATRIMONY.*

which was produced up Dutch country way, but a marked variation in quality between the sets and a difference in the handwriting of the legends make it certain that Krebs himself did not do all of them. To a far greater extent than in any of the engravings that were copies, these watercolors follow their origi-

nal. They are simple drawings with no background. The two sets that I would feel confident were by Krebs are both executed two scenes to a sheet. The only subject that needs explanation is the one with harlots which, following the very early German tradition, shows the Prodigal being chased away from the brothel by irate ladies of pleasure. "Ja er kein Geld mehr hat," the legend reads, "da ward er sehr veracht."

A more sophisticated, much later, but no less puzzling all-on-one-sheet parable is most strange.[47] It is a watercolor by Ruby Devol of Westport, Massachusetts. The episodes do not appear in their proper sequence, although the biblical text is written out in full. The gayest scene in the comic-strip presentation is an all-male hoedown. The only woman in the whole drawing, shown in another box, looks most demure.

Most of the printmakers who issued the Prodigal Son in England were rugged individualists. The designs of Le Clerc, however, were frequently used, first as etchings published by Sayer, then as mezzotints also by Sayer and reissued by Parker and Sayer, soon also as mezzotints by the Haid family of Augsburg, on Leeds china, and finally as engravings by Marshall. A highly finished set of colored mezzotints put out by Laurie and Whittle in 1794 was copied a few years later by an American engraver, who in turn was copied by Mary Ann Willson, a primitive watercolorist. At least one engraving, published by Walker in 1805, has turned up that was copied by a primitive artist and Doolittle. Doolittle was copied exactly in a set issued by Kellogg and at least in part by an anonymous lithographer and Currier. There are still gaps in the story. I shall be dependent upon the kindness of curators, collectors, and dealers to help me fill them in.

NOTES:

[1] The copper and half-plate reprint are in the collection of the Philip H. and A. S. W. Rosenbach Foundation, to whose director, Clive E. Driver, I am obliged for photographs and permission to use them. No copy of *A New Spelling Alphabet* has been found; from the plate it can be dated about 1810–1815.

2 The print is published by kind permission of Nicholas B. Wainwright, director of the Historical Society of Pennsylvania, Philadelphia.

3 *Made in America, Printmaking 1760–1860* (Philadelphia, 1973), p. 12. H. Glenn and Maude O. Brown, *A Directory of the Book-Arts and Book Trade in Philadelphia to 1820* (New York, 1950), p. 25, list Joseph Brown as a copperplate printer at various addresses from 1786 to 1817.

4 William Priest, *Travels in the United States of America; commencing in the year 1793 and ending in 1797* (London, 1802), consists of a series of letters describing the country with but minor references to his own activities. Priest describes himself on the title page as "musician, late of the theatres Philadelphia, Baltimore and Boston."

5 Charles Durang, *The Philadelphia Stage, from 1749 to 1821* (Philadelphia, 1855), scrapbook of clippings from the *Sunday Dispatch*, p. 31.

6 Ibid., p. 32.

7 Oscar George Theodore Sonneck and William Treat Upton, *A Bibliography of Early Secular American Music*, rev. ed. (Washington, D. C., 1945), p. 439.

8 Ibid., p. 342, dated "ca. 1795"; R. Taylor, "The President's March" (Philadelphia [1795]).

9 Brown and Brown, *Directory*, p. 25, from city directories, list Priest at 157 Mulberry Street in 1794 and 15 Apple Tree Alley in 1795.

10 *Philadelphia Gazette*, April 9, 18, 1796; O. G. Sonneck, *Early Concert-Life in America (1731–1800)* (Leipzig, 1907), pp. 144–145.

11 Nina Fletcher Little, "Itinerant Painting in America, 1750–1850," *New York History*, XXX (April 1949), p. 208, recorded that Priest advertised in 1796, but did not cite the newspaper. I am grateful to P. William Filby and Carol Burke of the Maryland Historical Society, Baltimore, for turning up the exact issue of the *Federal Gazette* with his advertisement.

12 A letter mentioning his stay in Baltimore and speaking of his forthcoming departure for Boston is dated from Philadelphia, September 13, 1796, in Priest, *Travels*, p. 142. His last letter, written after his arrival in England, stated he had embarked on March 12, 1797. Ibid., p. 210.

13 David Kunzle, *The Early Comic Strip* (Berkeley, Calif., 1973), pp. 298–356, illustrates and describes many moral series by Hogarth and his followers, but, although he discusses two earlier Continental versions of the Prodigal Son, he does not mention a single English one.

14 A single print, *Returns Reclaimed*, turned up just as the revision of this article was being completed. The imprint reads: "London, Printed for Robt. Sayer, Map & Printseller at the Golden Buck near Serjeants Inn Fleet Street." The date is merely an educated guess. The lower left-hand corner of the copy secured by the Library Company is defective; there is no signature of an artist or engraver to the right.

15 George C. Williamson, ed., *Bryan's Dictionary of Painters and Engravers*, 4th ed. (New York, 1904), IV, 168.

16 The artist's name is given on the prints as "Le Clare," which is how Le Clerc would have been pronounced. E. Bénézit, *Dictionnaire critique et documentaire des Peintres, Sculpteurs, Dessinateurs et Graveurs*, V (Paris, 1956), pp. 464–465.

[17] The imprint of the first issue reads "London, Printed for Robt. Sayer No. 53 in Fleet Street," and that of the second issue "London, Printed for Henry Parker, Printseller, opposite Birchin Lane, Cornhil, & Robert Sayer, Printseller, near Serjeants Inn, Fleet Street." Sayer was at 53 Fleet Street from 1726 to 1775; Parker moved opposite Birchin Lane in 1775, in which year he retired from business. H. R. Plomer, G. H. Bushnell, and E. R. McC. Dix, *A Dictionary of the Printers and Booksellers Who Were at Work in England Scotland and Ireland from 1726 to 1775* (London, 1968), pp. 190 and 223. I believe these were the six prints "12 inches wide by 10, price 3s. the set" advertised in *Sayer and Bennett's Enlarged Catalogue of New and Valuable Prints . . .* (London, 1775; facsimile reprint, 1970), p. 82. Five of the six prints of the first issue, lacking *Returns Reclaimd*, in the collection of Colonial Williamsburg were brought to my attention by Joan Dolmetsch, curator. Five of six prints of the second issue, lacking *Receives his Patrimony*, are in the Library Company of Philadelphia.

[18] Williamson, ed., *Bryan's Dictionary*, III, p. 5, states that Johann Jakob Haid died in 1767. The prints are signed "J. J. Haid et filius," the son being Johann Elias, born in 1739. A set is in the New York Public Library.

[19] A set of six is in the Library Company of Philadelphia.

[20] The imprint reads, "Sold I. Marshall & Co. at No. 4, Aldermary Church Yard London." John Marshall was at this address in 1790, but not as early as 1785. Mary Dorothy George, *Catalogue of Political and Personal Satires Preserved in the Department of Prints and Drawings in the British Museum*, VI (London, 1938), no. 6801. The print, alas, in very poor condition, was in 1973 in the possession of Gordon Wright Colket, Gladstone, New Jersey.

[21] A very colorful set of four of six plates captioned *Den Verlooren Zoon* (Receiving his Patrimony), *Zijn Afscheid Nemen*, *Zijn Hoerery*, and *Zijn Berouw*, was in 1970 in the possession of David Stockwell, Greenville, Delaware. A somewhat plainer and less skillful plate, No. 2 *Zijn: Afscyd*, was in 1970 in the possession of Whimsy Antiques, Arlington, Vermont.

[22] In her paper at the Sixteenth Annual Conference at Winterthur in 1970, but not in its published form.

[23] The imprint reads, "Published as the Act directs, Jan. 2d. 1775, by Carington Bowles, at his Map & Print Warehouse, No. 69 St. Pauls Church Yard, London." The prints are numbered 311–316. A set of six is in the Library Company of Philadelphia.

[24] The imprint reads, "Printed for Carington Bowles, at his Map & Print Warehouse, No. 69 in St. Pauls Church Yard, London. Published as the Act directs 1. Aug. 1776." A copy is in the Lewis Walpole Library. I am indebted to Wilmarth S. Lewis and Genevieve B. Butterfield, curator of prints, for photographs of this and other prints at Farmington and permission to reproduce them.

[25] The imprint reads, "Printed for & Sold by Carington Bowles. No. 69 St. Pauls Church Yard, London. Published as the Act directs, 22 Sepr. 1788." It is possible that this set was that listed in 1795. *Bowles and Carver's new and enlarged Catalogue of accurate and useful Maps, Plans, and Prints* (London, 1795), p. 154, under sixpenny drawing books as "Book 113, *Six historical Prints of the Prodigal Son, Luke* xv. finely en-

graved in ovals." Three of the set of six, *Taking Leave*, *In Excess*, and *Feasted on his Return*, are in the Library Company of Philadelphia.

[26] The imprint reads, "Published as the Act directs. March 8th. 1790, by John Marshall, No. 4. Aldermary Church Yard, London." A set of five, lacking *Receiving his Patrimony*, is in the Library Company of Philadelphia. Mrs. T. Hannas of Bromley, Kent, has a puzzle of the Marshall print *In Misery* in an earlier state before the cross-hatching was added on the fence.

[27] The imprint reads, "Printed for & Sold by Carington Bowles. No. 69 St. Paul's Church Yard, London. Published as the Act directs 1 Aug. 1792." The plates are numbered 618–621. A full set of four with the date erased is in the British Museum. George, *Catalogue*, VI, nos. 8227–8230. Copies of *Taking Leave* and *Revelling with Harlots* are in the Lewis Walpole Library.

[28] The imprint reads, "Published 12th. May, 1794. by Laurie & Whittle. 53 Fleet Street, London." Copies of *Revelling with Harlots* and *In Misery* are in the Library Company of Philadelphia, and of *Returned Reclaimed*, trimmed to the picture margin, in the New York Public Library.

[29] The existence of these prints was called to my attention by Carl L. Crossman of the Childs Gallery. He believed them to be by Cornelius Tiebout, although there is no indication of that on the prints. If they were by Tiebout, they were certainly engraved after he returned from England in 1796, for they are superior in technique to his earlier work. The set of four was owned by Angela M. Noel of Boston at the time this article was prepared; the set has since been acquired by Colonial Williamsburg.

[30] *The Annual Report of the Library Company of Philadelphia for the Year 1969*, p. 54; *The Annual Report for 1972*, p. 65.

[31] National Gallery of Art, *101 American Primitive Water Colors and Pastels from the Collection of Edgar William and Bernice Chrysler Garbisch* (Washington, D. C., 1966), pls. 36–39; Jean Lipman and Alice Winchester, *The Flowering of American Folk Art 1776–1876* (New York, 1974), p. 76 and pl. 103, where it is stated erroneously that the Willson drawings derive from the Doolittle prints.

[32] The imprint reads, "London pubd. as the Act directs Jany 10, 1795 by MDenton Hospital Gate W. Smithfield." A set, lacking *Revelling with Harlots* and *Returned Reclaimed*, is in the Library Company of Philadelphia.

[33] As much of the imprint as can be deciphered reads, "London Published 25 October 1796 by Haines & Son [illeg.] Buildings Fetter Lane." A set of four, *Taking Leave*, *Revelling with Harlots*, *In Misery*, and *Feasted on His Return*, is in the Henry Francis duPont Winterthur Museum.

[34] The imprint reads, "Published 12th. April 1797. by Laurie & Whittle, 53 Fleet Street, London." The first plate has the serial number 240. A set of four is in the Lewis Walpole Library.

[35] The imprint of the second set is given as "Pub. by Paul Barnaschina, No. 4 Leather Lane, Holbourn. 1799." I am indebted to Kenneth Newman for a photograph of it.

[36] *Annual Report for 1970*, pp. 47–48.

[37] The imprint reads, "London Pubd. June 17, 1805, by W. B. Walker. Fox & Knot Court, Snow Hill." The single print on glass is in the Abby Aldrich Rockefeller Folk Art Center. I am grateful to Barbara Luck, registrar, for the photograph.

[38] The watercolor *Revelling with Harlots* has only figures without background and is somewhat similar to the central grouping in the Doolittle version. The other two watercolors definitely bear no resemblance.

[39] The imprint reads, "Published by Shelton & Kinsett Cheshire Connec. Decr. 1. 1814." *American Printmaking the First 150 Years* (Washington, D. C., 1969), p. 53 and nos. 110–113. Copies are in a number of collections.

[40] The imprint reads, "Lith. of D. W. Kellogg & Co. Hartford. Conn." A set, lacking *In Misery*, is in the Library Company of Philadelphia.

[41] A copy of *In Misery* was acquired with the Library Company set of Kellogg lithographs.

[42] These are in the American Antiquarian Society. I am grateful to Georgia B. Bumgardner, Andrew W. Mellon curator of graphic art, for her assistance.

[43] The imprint reads, "Lith. & Pub. by N. Currier,—152 Nassau St. Cor. of Spruce N. Y." The two subjects I have seen are in the Library of Congress, kindly called to my attention by Alan Fern. Another copy of *Receiving his Patrimony* is in the Library Company of Philadelphia.

[44] *Receiving his Portion* is in the American Antiquarian Society. The bottom of the print is defective, obliterating most of the imprint. The trimmed *In Misery* is in the Library Company of Philadelphia.

[45] Lipman and Winchester, *Flowering of American Folk Art*, pl. 102. The drawing is in the Abby Aldrich Rockefeller Folk Art Center.

[46] Drawings by Krebs are illustrated in Donald A. Shelley, "The Fraktur-Writings or Illuminated Manuscripts of the Pennsylvania Germans," *The Pennsylvania German Folklore Society*, XXIII (1961), pls. 34, 64, 89–91, 195–200, 249, and give samples of his distinctive handwriting. Examples of *In Misery* and *Returned Reclaimed*, two scenes on one sheet, in the Free Library of Philadelphia and the Henry Francis duPont Winterthur Museum are by Krebs. A full set of four on two sheets in the Free Library of Philadelphia with the legends in Gothic letters, a full set of four on separate sheets in the collection of the Pennsylvania Historical and Museum Commission, and *Taking Leave* and *Running from Harlots* on one sheet in the Karolik Collection, Museum of Fine Arts, Boston, are not by Krebs.

[47] The drawing is in the Abby Aldrich Rockefeller Folk Art Center.

Political Satires at
Colonial Williamsburg

Joan D. Dolmetsch

THE print holdings of the Colonial Williamsburg Foundation
were greatly enhanced in 1960 when it purchased, intact, an
important and rare collection of eighteenth-century political
satires. This acquisition came at a time when there was renewed
interest in and emphasis on such historical documents. It was
not until 1966, however, that an opportunity was presented to
do an in-depth study of the collection.[1]

At about this time Wendy Shadwell was engaged in prepar-
ing a catalogue to accompany an exhibition of the former Mit-
tendorf Collection of Americana.[2] During our exchange of cor-
respondence on some of the satires, evidence emerged suggest-
ing that there were far more variations in impressions of many
of them than had previously been recorded. Many museums and
historical societies found that they had works of far greater
historic value than had formerly been supposed, and it was ob-
vious that there was a need to place these prints on view more
often for professional study.

In 1973 a number of Philadelphia societies combined forces
to sponsor a symposium for print curators. The Library Com-
pany mounted an excellent exhibition of prints, which included
some of these important satires, and which were studied and

enjoyed not only by those attending the meeting, but by the public as well.[3] A similar exhibition was prepared for those attending the 1974 symposium in Williamsburg, and it was expanded for public viewing during the Bicentennial.

It would be difficult to establish a precise date when the collecting of prints became fashionable. Documentation concerning the holdings of great Italian princes, Spanish grandees, Dutch merchants, and English gentlemen has long excited curators. By the mid-eighteenth century the hobby had gained such popularity that those who could afford it went so far as to design and set aside rooms in their homes to accommodate and display their treasured prints.

Having been exposed to such customs in their homelands, early colonists were quick to continue similar print purchases once they arrived on these shores. It may be argued that twenty-five prints of one subject matter does not really constitute a collection, but when it can be documented that one gentleman of Lancaster County, Virginia, had this number of engravings of "Scences" in his possession as early as 1690, it suggests that he had more than a casual interest in them.[4] William Byrd II of Westover recounts in his diaries the many visits he made to print dealers in London to select new items, and then expounds on the pleasure he gained from the study of the prints when he was once more in Virginia.[5] Still another Virginia resident seemed dedicated to acquiring views of foreign countries, since his library contained one hundred views of Brabant and Flanders.[6] But such lovely and decorative engravings are vastly different from the provocative, sometimes vulgar, and often wicked political satires that were to become such a potent force in eighteenth-century life.

To pinpoint the collecting of political materials is far more difficult. Since a majority of these items were considered treasonable, it is not surprising to find that a minimum of publicity and advertising was devoted to them. Once cannot help but wonder how many of them would have been kept were it not for the fact that they were a commercial publishing venture, and the public had to expend a penny or two to purchase them just as for other prints. Many collections existing today were formed

by political figures who often were the butt of the satire.

Realizing how difficult it was to document eighteenth-century collecting of these satires, it was most interesting to find the following notice in a 1766 Williamsburg newspaper:

TO BE SOLD

By the Subscriber in NORTHUMBERLAND, A CURIOUS collection of Prints and PAMPHLETS relating to all the transactions in *Europe* for some years past, containing about 200 prints, or pictures, representing all the persons and characters of note in *Europe,* viz. Crowned Heads, Ministers of State, Politicians, Patriots, Admirals, Generals &c. &c. in a very striking, expressive, and historical light, with their proper characters, schemes, &c. in the hieroglyphick or caricatura manner, with the most severe and entertaining satires on some, and the greatest applause to others. There are about forty pamphlets of prose and verse on both sides of the question, by CHURCHILL, &c. The purchasers shall have them at 50 percent, advance on the first cost.[7]

JOSEPH McADAM.

The McAdam family had resided in Northumberland County, Virginia, for almost a half-century when this advertisement appeared, and would continue to do so through the period of the Revolution. There is no indication as to why Mr. McAdam sold what surely must have been a very select collection of political satires, and it is not a point of great significance. What is important is the historical documentation that collecting such material was practiced here in the colonies at a pre-Revolutionary date. Other such references must exist, and it is hoped that research will bring them to light.

It is unfortunate that McAdam's collection had to be dispersed, but its end is typical of that of most such material. There are, however, at least two large groups of eighteenth-century satires that have remained relatively intact up to the present day. The first is the splendidly annotated collection formed by Horace Walpole, which is located in the New York Public Library Print Division. The other, perhaps less well known, is the Peel Collection at the Pierpont Morgan Library

in New York.[8] Ranging in period from Cromwell to George IV, well over 3,300 prints are pasted in twelve oversize scrapbooks. The history of the collection is contained in the first volume, and states that many of the prints were from the collection of Thomas William Acton Hamilton, who in 1818 assumed the name and arms of Edmund Burke. Thomas was the grandson of Juliana French, Burke's sister, and it was through this branch of the family that many of the prints were retained. In 1852 the collection was offered for sale at Christies, and Sir Robert Peel, a well known nineteenth-century political leader, acquired them and added to the scrapbooks those prints that he already owned. Burke's name or initials are on many of the prints. The collection had not been published at the time this article was written.

In the late nineteenth and early twentieth centuries, interest in early political satires was limited and prices were reasonable, thus allowing a new group of collectors the luxury of purchasing these interesting prints. One of these, R. T. H. Halsey, has become almost a legend to print curators. By profession a broker, his avocation, art, was to become a dominant force in his life. After collecting political satires concerning the American Revolution for a number of years, he published a group of them in *The Boston Port Bill as Pictured by a Contemporary London Cartoonist*, printed as a limited edition for the Grolier Society in 1904. It has since become a collector's item. Halsey displayed an insatiable appetite for acquiring such prints, and in 1939 was able to mount an exhibition of over 150 of them, which he termed "impolitical prints," for the New York Public Library.[9] He is also credited with encouraging friends to collect political prints.

One such associate was H. Dunscombe Colt. In a conversation I had with Colt's son some years ago, he likened this friendship to those of stamp and coin collectors. Halsey and Colt were close friends, admiring each other's collections until a choice item appeared on the market, when a fierce fight to acquire it might take place. Having started collecting later than Halsey, Colt was at somewhat of a disadvantage. However, Colt was able to duplicate many of the most important satires, and while Halsey confined his interest to the Revolution and the

events immediately surrounding it, Colt ventured further afield into works that commented on England's problems over a longer time span.

Neither man left heirs interested in retaining this material, and so both collections were eventually placed on the market. In 1952 the major portion of the Halsey Collection went to the John Carter Brown Library. In 1960 the Colt Collection was acquired by Colonial Williamsburg, whose philosophy has always been that the background of a collector and his collection is important in the study of such material, and the Colt name has been retained in the identification of this group of prints.

No one can discuss eighteenth-century political satires without acknowledging the research, development, and leadership provided by the personnel of the British Museum. Without the dedicated work of Frederic George Stephens and Edward Hawkins in the nineteenth century, and of the late Mary Dorothy George in the twentieth, scholars studying the field of social and political printmaking would have a more difficult time.

Since the Colt Collection contains so many important and rare satires, the final selection of the prints to be discussed and illustrated in this study has been difficult. An attempt has been made to include satires whose style influenced others made in the period, or whose delineation was particularly well suited to the event that had prompted the work.

The European State Jockies Running a Heat for the Ballance of Power (No. 95), published in 1740, depicts the many and varied conflicts that would involve England and the Continent over the next forty years. The struggle over sea power and for control of the new and rich lands of North America are depicted in an almost classically designed print, which brings together many satiric devices that would later be excerpted and used as single themes.

In 1744 King George's War, involving England and France, began, and the French lost important holdings in North America. Peace was finally achieved in 1748 in a conference held at Aix-la-Chapelle, and the satire *The Congress of the Brutes* appeared. It depicted allegorically the meeting in which a group of noisy animals gathered around a conference table fought

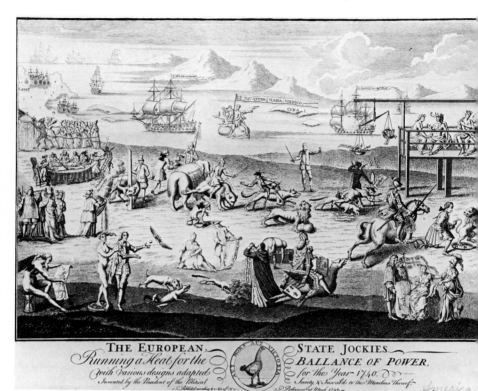

95. *THE EUROPEAN STATE JOCKIES Running a Heat for the BALLANCE OF POWER.*

over peace terms, each hoping to benefit his own country's interests.

Peace was brief, and hostilities resumed in 1754 with the outbreak of the French and Indian War. *British Resentment or the French fairly Coopt at Louisbourg* (No. 96) depicted English sympathy for the North American colonies. The British fleet has blockaded Louisbourg, and its citizens are shown caged after their capture. The defeat of the French is symbolized by one of its boats being swept over Niagara Falls. The satire was the work of L. Boitard, a French émigré, who continued to execute works such as *Britain's Rights maintaind: or French Ambition dismantled*, which he engraved in 1755. In it he combined animals and mythological gods with humans to symbolically

portray the struggle over colonial American land rights.

During this period George II died and George III assumed the English throne, but the change of monarch had little effect on British policies in North America. New oppressive acts taxing the colonies in order to enrich England's treasury were passed. The colonists' open rebellion against these measures provided satirists with many new ideas.

In 1762 England and France began peace negotiations, but Britain and Spain were still at war. A broadside, *The Asses of Great Britain* (No. 97), closely resembles the type of satire that the Virginia gentleman, McAdam, owned. A series of ten verses accompanies the picture, the first of which reads:

> Permit me good People (a Whimsical Bard)
> And Snarl not ye Critical Class
> If once I presume without fee or Reward
> To Prove that each BRITON'S an ASS.

96. *BRITISH RESENTMENT or the FRENCH fairly COOPT at Louisbourg.*

97. THE ASSES OF GREAT BRITAIN.

Among those who are taunted in the satire are Lord Bute, shown riding a saddled and bridled British lion; the famous evangelist, the Reverend George Whitefield, admiring in a mirror his reflection as an ass; and a devoted English subject who stares in awe at the three Cherokee Indians who had recently arrived from the colonies to pay homage to the king. Each of those depicted is represented by an appropriate verse to prove the author's ass theories.

In 1763 treaties were signed by England, Spain, and France, and English ministers could now focus all of their attention on the colonies. In 1764 Grenville announced terms for the imposition of a Stamp Act. The Sons of Liberty were organized in America, and in 1765 a call was issued for the convening of a colonial congress in New York to deal with these new British taxes. Britain was forced to retreat, and the Stamp Act was repealed in 1766. This serious confrontation led to the issuing of a satire that has become almost legendary in the history of such works, *The Repeal, or the Funeral of Miss Ame-Stamp*. An English harbor is used for a setting. Boats stand idle at anchor and merchandise intended for the colonies piles up as an embargo on English goods is enforced in retaliation for the Stamp Act. A group of English leaders responsible for the act carry a small coffin containing the remains to a vault for final burial following the repeal.

The popularity of this print was such that it was quickly imported into the colonies and copied for publication in Philadelphia. In the past few years Edwin Wolf, Librarian of the Library Company of Philadelphia, has documented in the annual reports of the library many variations on this satire.

Many other satires concerning this momentous confrontation were designed and published in England. *The Statue, or the Adoration of the Wise-Men of the West* featured, at the center, a statue of the minister who supposedly read the funeral oration for the Stamp Act. A group of loyal tax supporters stand admiring it, while at the rear the vault containing the remains is now tightly sealed. A figure of a fury with scourge in hand hovers over the scene suggesting punishment for such support.

Benjamin Franklin tried his hand at the art of a satire, *Magna*

Britannia. It was so successful that it was copied in England and was printed on the same plate as another, the maker remaining anonymous. In the Franklin work the figure of Britannia is shown with all of her colonial appendages removed; in the companion an American Indian with only a snake for protection attempts to prevent an English attack on female America, who is running toward France for protection.

Between 1769 and 1774 English and colonial disputes grew, and each new confrontation produced a satiric comment. *What may be doing Abroad, What is doing at Home*, two engravings published on one page, showed at the top foreign leaders, minus England, seated at a conference table discussing how to divide among themselves the kingdom of Great Britain. At home ministers of state discuss affairs in private, only to be overheard by the king, who listens from the doorway. *The ever-memorable Peace-Makers settling their Accounts* shows the Devil controlling a minister's discussion.

The Boston Massacre and the Boston Tea Party brought the colonies to the point of an open break with England. In 1774 British regiments arrived in Boston and the port was closed. This event produced the satire *Liberty Triumphant; or the Downfall of Oppression* (No. 98). The action takes place on a map with the coast of North America to the right, and England to the left. At the upper left the crestfallen figure of Britannia complains to a winged figure, the genuis of Britain, about the conduct of her degenerate sons, the colonies. Below her, ministers chained and led by the powerful Lord North now debate colonial policies. On the American shore Indian Princess America protects the country with the aid of her braves. At the top, Goddess of Liberty holds the liberty pole and cap and asks a winged figure of fame to proclaim the ardor of her sons.

The continued pro-colonial sympathies of the English satires served to encourage their copying in the colonies. *The able Doctor, or America Swallowing the Bitter Draught* first appeared in the *London Magazine* in 1774. America has been thrown to the ground and is being tormented by English leaders who peer under her skirt and forcibly pour hot tea down her throat. With-

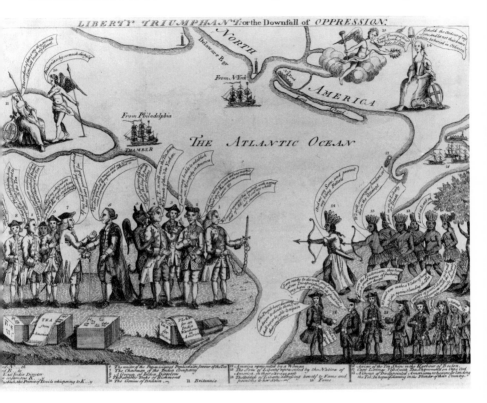

98. *LIBERTY TRIUMPHANT; or the Downfall of OPPRESSION.*

in the year Paul Revere copied the satire for the *Royal American Magazine*.

1774 marked the beginning of publication of the group of satires that Halsey described in his book *The Boston Port Bill*. The series began with *A Political Lesson*, designed and engraved by J. Dixon and published by John Bowles on September 7, 1774. General Gage had ordered the Massachusetts legislature moved from Boston to Salem following the Bostonians' resistance to the closing of the port. On his way to join the group Gage is thrown from his horse, the symbol of the rebellious colony.

In October of the same year Bowles issued another Boston

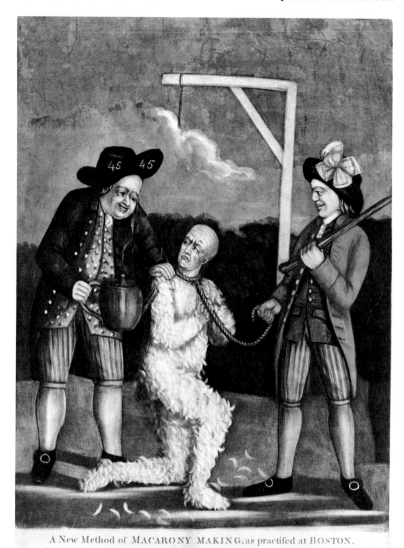

A New Method of MACARONY MAKING, as practifed at BOSTON.

For the Custom House Officers landing the Tea:. And they drench'd him so well both behind and before,
They Tarr'd him, and Feather'd him, just as you see. That he begg'd for Gods sake they would drench him no more.

Printed for Carington Bowles, at his Map & Print Warehouse, N.º 69 in S.ᵗ Pauls Church Yard, London. Published as the Act directs, Oct 21.ᵗ 1774.

99. *A New Method of MACARONY MAKING, as practised at BOSTON.*

satire, *A New Method of Macarony Making, as practised at Boston* (No. 99). In the verse beneath, the actions were well described:

For the Custom House Officers landing the Tea,
They Tarr'd him, and Feather'd him, just as you see,
And they drench'd him so well both behind and before,
That he begg'd for God's sake they would drench him no
more.

In the same month, Robert Sayer and J. Bennett, rivals of Bowles, published a similar satire. However, the background now showed the "Liberty Tree" and what may well be the first pictorial rendering of the tea party.

In November the Sayer and Bennett firm continued their publication of pro-colonial satires with *The Bostonians in Distress.* The port has been closed, and the Bostonians are enclosed in a cage that is suspended from a tree. This device was used in the satire depicting the similar plight of the citizens of Louisbourg during the French and Indian War. (See No. 96.)

In February 1775 the Revolutionary struggle moved into the New York area. Sayer and Bennett published *The Patriotick Barber of New York.* The accompanying verse explained that a disguised captain from an English ship used in the blockade of the harbor came into town for a shave, but the barber soon discovered his true identity and sent him from the shop, lather still covering half of his face.

By February of 1775 the citizens of Williamsburg became the subject of a satire showing their rebellion. *The Alternative of Williams—Burg,* as it was titled, offered them a choice between signing articles of loyalty to the colonial cause or being tarred and feathered as were the pro-English Bostonians.

In March Edenton, North Carolina, was chosen as the setting for a society of patriotic ladies (No. 100). The good women of the town are depicted pledging not to drink tea or to wear clothing manufactured in England until England lifts all taxes and embargoes.

While these satires of 1774–1775 were probably the most significant to appear during the period, they were certainly not

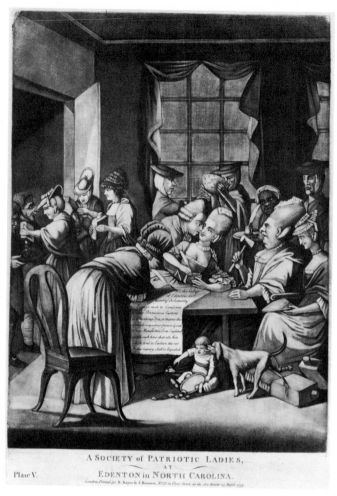

A SOCIETY of PATRIOTIC LADIES,
AT
Plate V. EDENTON in NORTH CAROLINA.
London, Printed for R. Sayer & J. Bennett N°53 in Fleet Street, as the Act directs 25 March 1775.

100. *A SOCIETY of PATRIOTIC LADIES, at EDENTON, in NORTH CAROLINA.*

the only ones. In the *Westminster Magazine* of 1775 there appeared *The Political Cartoon, for the Year 1775* (No. 101). Historically, this seems to be the first use of the term "cartoon" for a satire. Although some have argued that the use was in the artistic sense of the meaning, the very nature of the print belies this. English leaders are depicted being driven to the brink of a

chasm in a carriage whose horses are labeled "Pride" and "Obstinacy." Across the ocean America is shown in flames.

Mary Darly, famous for "Macaroni" social satires, turned the device to political use in 1776. In an engraving *Bunkers Hill or America's Head-Dress*, the action of the battle is placed in the exaggerated coiffure of an elegant lady. Troops, cannons, banners, and tents nestle in her curls.

From the Darly shop in 1777 came one of several lewd satires, *Poor old England endeavoring to reclaim his wicked American Children*. In a rare symbolic form, England is shown as an elderly man. He holds a scourge that is extended and is connected to the noses of Americans in an attempt to pull them home. One, however, has turned his back, and indecently exposes his bottom to England, while at the same time he turns his head to jeer.[10] Beneath the title is a quotation credited to

101. *The Political Cartoon, for the Year 1775.*

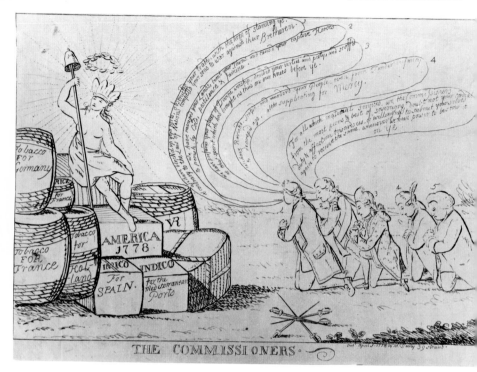

102. *THE COMMISSIONERS.*

Shakespeare: "And therefore is *England* maimd & forc'd to go with a Staff."

The Darly shop continued to issue large numbers of satires during the Revolutionary period. In 1778 they published *The Commissioners* (No. 102) in which Indian Princess America sits blissfully on barrels and cartons of merchandise, while English leaders kneel at her feet as they plead for a peaceful settlement to the dispute so that trade may be resumed. The satire was published before the appointed commissioners had given final consent to undertaking the mission. As it turned out, only three of the five pictured agreed to go. Within three months the embarrassed Darlys published a second satire, now showing the correct number and utilizing for the design a report that had reached London that the mission had met with American repre-

sentatives who were attired in long gowns and wore fuzzy fur caps.

In 1778 the Darlys issued *A View in America in 1778* (No. 103), a satire that is open to interpretation. Blacks fought on both sides during the Revolution, and many were injured or killed. In this print a black lies gravely wounded on the ground. An Englishman stands over the black and blames his plight on colonial troops gathered nearby. A mysterious gentleman garbed in a heavy fur-trimmed coat and a wide hat, probably intended to represent von Steuben, points to a figure that is sketched into the cuff of his coat. It was at this time that Charles Lee was being termed a traitor by the Americans, and it is possible that this buried figure, so obviously important in the print, may be intended to represent Lee. If so, then the implication of the satire would be to liken the black to Lee, both perfidious characters.

Pro-colonial satires were made on the Continent as well as in England. While several were published in France, an even

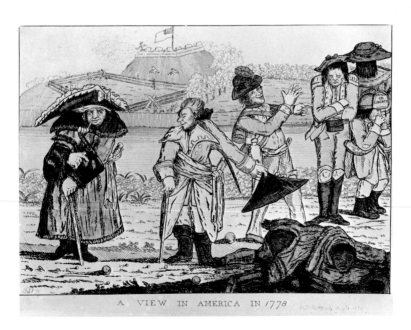

103. *A VIEW IN AMERICA IN 1778.*

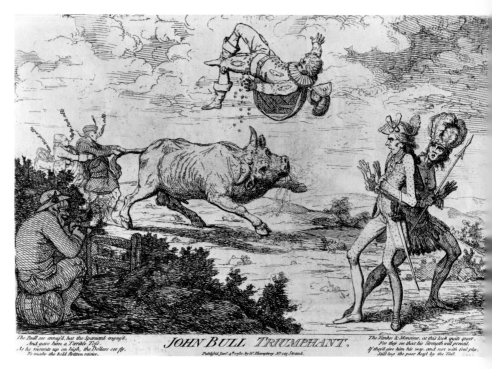

The Bull see enrag'd, hat the Spaniard engag'd,
And gave him a Terrible Toss;
As he mounts up on high, the Dollars see fly,
To make the bold Britton rejoice.

JOHN BULL TRIUMPHANT.

Publish'd Jan.ᵗ 4ᵗ 1780. by W. Humphrey N.º 227 Strand.

The Yankee & Monsieur, at this look quite queer,
For they see that his Strength will prevail,
If they'll give him his way, and not with foul play,
Still keep the poor Angl. by the Tail.

104. *JOHN BULL TRIUMPHANT.*

larger group issued from Dutch makers. These tended to depict
the British not only beleaguered by the colonial conflict, but also
under stress from European neighbors.

About 1780 one of the great English satirists, James Gillray,
attempted to change the image of Britain from a weeping fe-
male to the more virile figure of a bull or a male. *John Bull
Triumphant* (No. 104) correctly prophesied coming events.
The bull that had been down has regained some of its strength
and now frightens both France and America as it tosses Spain
into the air.

Following the Yorktown battle, which helped end the Revo-
lution, a Dutch satirist issued a print that features Yorktown.
(No. 105). On one shore America sits under a canopy receiving
submissive English leaders who carry the peace treaty in their

hands. The foreground represents the English shore. To the right a British subject kneels before an open chest from which rats pull the last of England's bank notes, while his companion, the English lion, displays an injured paw. To the left a lean and hungry cow, symbolic of England's reduced commerce, is taunted by Holland, Spain, and France, who point to victorious America.

The peace negotiations produced prints as biting and humorous as those concerning the war. In most of them England's utter defeat is lamented. Gillray published *Britania's Assassination* (No. 106) that shows America running off with Britain's head, Spain with her leg, and Holland with the shield.

The Royal Hunt, or a Prospect of the Year 1782 represented the English temple of "Fame," symbolic of her overseas hold-

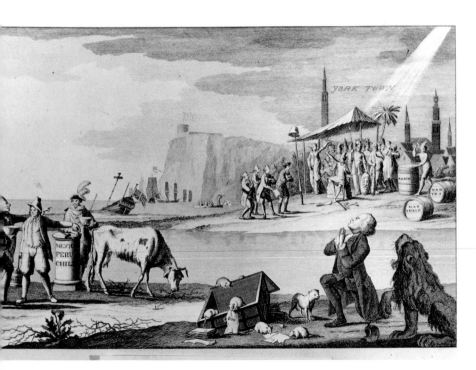

105. [York Town.]

ings, in the process of being demolished by enemies. It was followed immediately by a more optimistic satire, *Anticipation; or, the Contrast to the Royal Hunt,* in which the temple is being restored, while the formerly weeping Britannia now holds out the olive branch of peace.

People seem to prefer happy endings to unfortunate events, and satirists viewing the peace that followed the Revolution gladly obliged their customers. *The Reconciliation between Britania and her daughter America* (No. 107) certainly fulfilled this wish, as Britannia says to her daughter America, "Be a good Girl and give me a Buss," and is reassured by America who replies, "Dear Mama say no more about it."

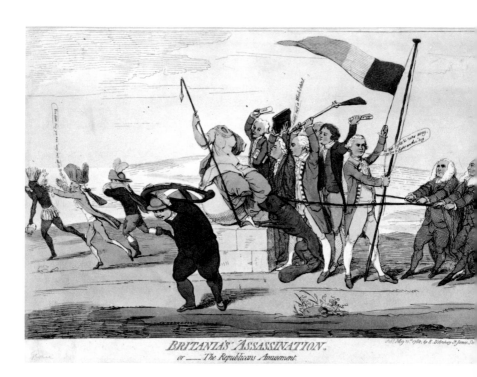

106. *BRITANIA'S ASSASSINATION.*

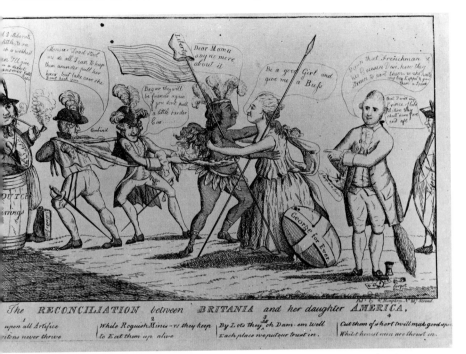

107. *The RECONCILIATION between BRITANIA and her daughter AMERICA.*

NOTES:

1 This article was prepared as a preliminary study for a catalogue, *Rebellion and Reconciliation: Satirical Prints on the Revolution at Williamsburg*, published in 1976 by the Colonial Williamsburg Foundation.

2 See the catalogue of the exhibition for further notes and comments: Museum of Graphic Art, *American Printmaking, The First 150 Years* (Washington, D. C., 1969).

3 Catalogue of an exhibit at the Free Library, published by the Library Company of Philadelphia, *Made in America: Printmaking 1760–1860* (Philadelphia, 1973).

4 For this and other references to print collecting in the American colonies, see Joan Dolmetsch, "Prints in Colonial America: Supply and Demand in the Mid-Eighteenth Century," in John D. Morse, ed., *Prints in and of America to 1850*, Winterthur Conference Report 1970 (Charlottesville, Va., 1970), p. 59.

⁵ References to William Byrd's purchases of prints are scattered throughout his diaries. See Louis B. Wright and Marion Tinling, eds., *The Secret Diary of William Byrd of Westover, 1709–1712* (Richmond, Va., 1941); Louis B. Wright and Marion Tinling, eds., *The London Diary (1717–1721)* (New York, 1958); and Maude H. Woodfin, ed., Marion Tinling, trans., *Another Secret Diary of William Byrd of Westover, 1739–1741, and Other Writings* (Richmond, Va., 1942).

⁶ Dolmetsch, "Prints in Colonial America," p. 66.

⁷ *Virginia Gazette* (Purdie and Dixon), October 17, 1766.

⁸ Herbert M. Atherton surveyed and used a few of the Peel prints for a recent publication, *Political Prints in the Age of Hogarth: A Study of the Ideographic Representation of Politics* (Oxford, 1974).

⁹ R. T. Haines Halsey, *"Impolitical Prints": An Exhibition of Contemporary English Cartoons Relating to the American Revolution* (New York, 1939).

¹⁰ After the first printing, the indecently exposed figure was altered. While this may have been more pleasing, it greatly diminished the effect of the satire.

Index

Page numbers that are <u>underlined</u> denote illustrations

Abbot, John, 21
Abby Aldrich Rockefeller Folk Art
 Center, 165
*Able Doctor, or America Swallow-
 ing the Bitter Draught*, 184–185
Addison, Joseph, 105
Administration of the Colonies, 21
Aitken, Robert, 32; and 18th-cen-
 tury American magazine illustra-
 tion, 71–84
Aix-La-Chapelle, W. Ger., 179
Allen, William, 123
Almanacs: American, 51–70; En-
 glish, 53, 54, 56, 58, 64, 65, 66;
 French, 53
Alternative of Williams—Burg, 187
Amelia: or the faithless Briton, 84,
 <u>85</u>
America, colonial: almanacs in,
 51–70; depicted in political sat-
 ires, 175–196; 18th-century mag-
 azine illustration in, 71–97;
 18th-century prints in, 33–36;
 English prints in, 12; London's
 images of, 11–31; Prodigal Son
 in, 145–174
American Antiquarian Society, 53
American Colonies, <u>118</u>, 119
American Daily Advertiser, 149
American Magazine, 74
American Museum Magazine, 73,
 75
American Musical Miscellany, 112
American Universal Magazine, 89
*America Triumphant and Britan-
 nia in Distress*, 53

Ames, Nathaniel, 65, 68–69
Analysis of Beauty, 9
Anatomy, diagrams of, 54, <u>55</u>, 56,
 60
*ANATOMY. Names and Characters
 of the 12 Sig* [ns], 55
Annapolis, Md., 127, 148
Anne, Queen, 58–59
Antibes, Fr., <u>40</u>, 44
*Anticipation; or, the Contrast to
 the Royal Hunt*, 194
Argyll, Duke of. *See* Campbell,
 John
Arms of the City of London, 117
Arnold, Benedict, 29, 63
ASSES OF GREAT BRITAIN, 181,
 <u>182</u>, 183
Astrological diagrams, 54, 56
Astronomical Diary, 65
Atlantic Neptune, 24, 25, 33
Audubon, John James, 15

Bailey, Francis, 63
Bailyn, Bernard, 61–62
Baléchou, Jean Joseph, 37
Baltimore, Md., 148, 150
Baltimore Oriole, 89
Bandol, Gulf of, <u>41</u>, 42
Banneker, Benjamin, 56, 59
Barber shop prints, 2, <u>3</u>
Barnaschina, Paul, 163
Bastille, 89
Baugean, Jean-Jérôme, 36
Bayonne, Fr., 46, <u>47</u>, <u>48</u>
Beau, 111
Bedwell, Thomas, 92

Beggar's Opera, 113, 114
Belcher, Jonathan, 17–18
Belcher, Jonathan, Jr., 16–17, 18
Bennett, John. *See* Sayer and Bennett
Bewick, Thomas, 13
Bickerstaff's Boston Almanack, 60, 63, 67, 68–69
Bickham, George, Jr., 98–122
Bickham, George, Sr., 98–122
Bickham, John, 99
BILLIARDS, 2, <u>3</u>, 5
Blackstone, Sir William, 76
Blake, William, 13
Blaskowitz, Charles, 24
Blewitt, Mary, 24–25
Blodget, Samuel, 14
Bodleian Plate, 15, <u>16</u>
Boitard, Louis Peter, 180–181
Bonner, John, 18
Bordeaux, Fr., 45, 46
Bordley, John Beale, 123, 125
Boston, Mass., 184, 185, 187; almanacs in, 62–63; maps and views of, 15, 16, 18, 23, 29, 80, 83, 117
Bostonians in Distress, 187
Boston massacre, 14, 15, <u>52</u>, 62, 184
Boston Port Bill as Pictured by a Contemporary London Cartoonist, 178, 185
Boston tea party, 184, 187
Botetourt, Norborne Berkeley, Baron de, 1
Bouffleurs, Allée de, 46, 47
Bowen, Emanuel, 1
Bowles, Carington, 13, 35, 99, 111, 154, 155, 156, 158, 159
Bowles, John, 13, 185, 186
Bowles, Thomas, 13, 14
Boydell, John, 33
Boyle, Richard, 3rd Earl of Burlington, 18
Brabant, 176
Briefe and true report of the new found land of Virginia, 119
Britain's Rights maintained: or French Ambition dismantled, 180–181
BRITANIA'S ASSASSINATION, 193, <u>194</u>
BRITANNIA, 116, 117
Britannic Magazine, 32
British Monarchy, 98, 115–116, 117, 119

British Museum, 179
BRITISH RESENTMENT or the FRENCH fairly COOPT at Louisbourg, 180, <u>181</u>
Brobdingnagian, 15, 16
Brookes, Mr., 128
Brown, Joseph, 146
Brown, William, 24
Bry, Theodore de, 119
Buck, James, 18–19
Buck, Nathaniel, 33
Buck, Samuel, 33
Buffallo, 86, <u>88</u>
Bumgardner, Georgia B., 51–70
Bunbury, Henry William, 5
BUNKERS HILL or America's Head Dress, 27, <u>28</u>, 29, <u>189</u>
Burdett, John, 2
Burgis, William, 12, 15, 18, 21, 23, 24, 32, 117
Burke, Edmund, 13, 178
Burlington, Lord. *See* Boyle, Richard
"Business," 105, 119
Bute, Earl of. *See* Stuart, John
Byrd, William, 106
Byrd, William, II, 176

Cadbury, John, 58
Caesars, prints of, 2
Callender, Joseph, 67–68, 77
Calligraphy. *See Musical Entertainer*
Campbell, Archibald, 3rd Duke of Argyll, 18
Campbell, John, 2nd Duke of Argyll, 18
Careening, 39, 41
Carey, Mathew, 73, 75
Carmichael, Mr., 130
Carroll, Charles, 124–125, 128
Carter, Susannah, 52
Cartoons, political, 62–65, 188–189. *See also* satires
Carwitham, John, 18, 23, 34–35
Castle of Andalusia, 148
Catesby, Mark, 21, 24
Cette, Fr., 44, <u>45</u>, 46
Chapman, Gerald, 12
Charles I, 126
Charles II, 12
CHARLES LEE, Esqr., 27
Charleston, S. C., 114; maps and views of, 15, 16, <u>17</u>, 18, <u>35</u>, 82, 83

Charlestown, Mass., 2, 82, 83
Charles Willson Peale, 124
"Charming Cloe," 111
Château Trompette, 46
Chatham, Earl of. *See* Pitt, William
Chowning's Tavern, 2
Christian VII, 52
Christiana Campbell's Tavern, 2
Cist, Charles, 73
Clarke, Thomas, 89
Clarkson, Mr., 141
Clough, Samuel, 56
Cochin, Charles Nicolas, 36, 40, 41, 50
Collier, John, 77–78
Collinson, Peter, 13, 14
Colonial Williamsburg: Bodleian Plate at, 15; 18th-century British prints at, 1–10; political satires at, 175–196
Colossea statua Rhodi, 34
Colt, H. Dunscombe, 178–179
Colt Collection, 179
Columbian Magazine, 72, 73, 74, 75, 84, 89, 92, 133, 146
Comaus, Annibald, 37–38
"Commerce," 103, 104
COMMISSIONERS, 190, 191
Company of Stationers, 54
Compleat Figure of the Minuet, 115
Compton, Spencer, Earl of Wilmington, 18
Conclusion of the AMERICAN COLONIES, 119, 120
Congress of the Brutes, 179–180
Constellation, 32
Continental Almanack, 63
Cook, Capt. James, 24, 33, 67, 68
Cook, Thomas, 78, 90
Cooper, T., 115
Copley, John Singleton, 52, 123, 128
Copyright act (1735), 12
CORNWALLIS turned NURSE, and his MISTRESS a SOLDIER, 63
Correct View of The Late Battle of Charlestown, 82, 83
Coverly, N., 53
Cromwell, Oliver, 60, 178
Currier, Nathaniel, 167, 168, 170

DAMON, and MUSIDORA, 81, 82
Dancing Master, 115
Darly, Mary, 189, 190

Darly, Matthew, 29, 190, 191
Davies, Capt. Thomas, 92–93
Davison, Nancy R., 98–122
Death of Able, 53
De Brahm, Willem Gerard, 25
Denton, M., 162
Des Barres, J. F. W., 24, 25, 29, 33
Devol, Ruby, 170
Dewing, Francis, 12
Dickinson, John, 60, 61
Dieppe, Fr., 48–49
Dighton, Robert, 158–159
Dixon, Jeremiah, 15
Dixon, John, 185
Dolmetsch, Joan D., 12, 154, 175–196
Doolittle, Amos, 78, 89, 165, 166, 167, 168, 170
Dryden, John, 60, 105, 115
Duff, William, 76
Dunlap and Claypoole, 149
Durang, Charles, 149

Earths Motion Prov'd, 111
East Perspective View of Philadelphia, 13
Easy Introduction to Dancing, 99, 115
Eclipse, diagrams of, 54, 55
Eden, William, 29
Edenton, N. C., 187, 188
Edinburgh Castle Tavern, 2
Elizabeth I, 106
England. *See* Great Britain
English Farmer brought home drunk, 66
EUROPEAN STATE JOCKIES Running a Heat for the BALLANCE OF POWER, 179, 180
Evans, G. N. D., 25
Evans, Lewis, 13–14, 15, 18, 21, 24
Ever-memorabie Peace-Makers settling their Accounts, 184
Exact View of the Late Battle at Charlestown, 2

Fables (Gay's), 115, 118
Faden, William, 13
Farinelli, Carlo, 112
Farmers Almanack for the Year 1714, 58
Federal Gazette and Baltimore Daily Advertiser, 150
Federal Hall, N. Y., N. Y. *See* PERSPECTIVE VIEW of the FED-

ERAL EDIFICE in the CITY of NEW YORK
Fielding, Henry, 115
Flanders, 176
Flora; or, Hob in the Well, 114
Fort George with the City of New York, 34–35
Foster, John, 14, 54, 55, 56
Fourdrinier, Pierre, 35
Fowle, Z., 53
Fox, Henry, 65
France, 179, 181, 183; almanacs in, 53; depicted in political satires, 180, 184, 191–192, 193; ports of, 36–50
Franklin, Benjamin, 13, 14; and almanacs, 53, 54, 56, 57, 102; Peale's engravings of, 124, 133–134, *135*, 140, 141; and political satires, 183–184
Franklin, James, 12
French, Juliana, 178
French and Indian War, 180, 187
Frugal Housewife, 52
Fry, Joshua, 1
Fry and Jefferson's *Map of Virginia,* 1

Gage, Gen. Thomas, 185
Gainsborough, Thomas, 13
Gauld, George, 24–25
Gay, John, 98, 105, 113, 115, 118
Gentleman's Magazine, 27, 72, 74, 78, 90, 91–92, 105, 107
George II, 181
George III, 53, 181
George IV, 178
George, M. Dorothy, 11, 158, 179
Georgetown, B. G., 39
GEORGE WASHINGTON, Esqr., 27
Gillingham, George, 149
Gillray, James, 13, 192, 193
Gleason, Ezra, 62
Governor's Palace, 3
Gravelot, Hubert, 100, 111, 114–115, 116, 118
Great Britain, 12, 33; depicted in satires, 175–196; 18th-century magazine illustration in, 71–97; Prodigal Son in, 145–174
GREEN HILL. The Seat of Samuel Meredith Esqr. near Philadelphia, 86, *87*
Grenville, George, 183

Groce, George, 77
Grolier Society, 178
Guilbert, Joseph, 24
GULILLMUS LILLIUS, 59
Gulliver's Travels, 16

Haid, Johann Elias, 154
Haid, Johann Jakob, 154
Haid family, 154, 170
Haines and Son, 162
Halsey, R. T. H., 178, 179, 185
Halsey Collection, 179
Hamden, Richard. *See* Hampden, Richard
Hamilton, Sinclair, 52–53, 56, 58
Hamilton, Thomas William Acton, 178
Hampden, Richard, 128
Hancock, John, 130; portrait of, 90, *91*; view of the seat of, 86, *87*
Handel, George Frideric, 107, 112
Hariot, Thomas, 119
Hart, Charles Henry, 129–130, 140
Hart, Thomas, 25, 27
Harvard University, 18, 19
Haskell, Daniel, 15
Havana, Cuba, 18
Hawkesworth, John, 67, 68
Hawkins, Edward, 179
Hayman, Francis, 115
Heads of New Zealand chiefs and New Zealand war canoe, 68
Heap, George, 15, 35
Hebert, Lawrence, 12, 14
Hecatomopolis, 36
He receives his Patrimony, 146, *148*
Hesselius, John, 123
Hieroglyphic, 64, 65
Hill, Draper, 29
Hill, Samuel, 81, 85–86, 89
Hiller, Joseph, Sr., 130
Hind, A. M., 53, 58
HIS EXCEL: G: WASHINGTON Esq:, 139
HIS EXCELLENCY B. FRANKLIN L.L.D. F.R.S. PRESIDENT OF PENNSYLVANIA, 133–134, *135*
HIS EXCELLENCY GEORGE WASHINGTON ESQR., 129, 130
His Excellency GEORGE WASHINGTON Esquire, Commander in Chief of the Federal Army, 130, *131*

Historical Society of Pennsylvania, 72, 146, 148
Hitchings, Sinclair, 11–31
Hodgkinson, John, 149
Hoffman, Jonathan, 86
Hogarth, William, 2, 5–10, 11, 12, 13, 98, 99, 103–104, 111, 151
Holland, Samuel, 24
Hollis, Thomas, 18
Honble. JOHN HANCOCK. Esqr., 90, *91*
Honest Merchant; or, Thorowgood to Trueman, 102, *103*
Hood, Graham, 1–10
Hopkins, Adm. Esek, 27
Howard, Lord, 61
Howdell, Capt. Thomas, 23
Howe, Gen. William, 29
Hubbard, William, 14
Huntley, Miss, 149
Hurd, Thomas, 24
Hutchinson, Thomas, 62

Ilay, Lord. *See* Campbell, Archibald
Illustrations: in almanacs, 51–70; animals in, 86; armorial bearings, 84; in the Bickhams' works, 98–122; in 18th-century magazines, 71–97; narrative, 84
Indian Kings, 119
Industrious Apprentice, 9, 102
"Industry," 102, *103*
Insurgent, 32

Jefferies, Judge, 61
Jefferson, Peter, 1, 13
Jefferys, Thomas, 13, 18, 25, 35
Jenings, Edmund, 125, 126–127, 130
JOHN BULL TRIUMPHANT, *192*
John Carter Brown Library, *179*
Johnson, Guy, 23
Johnson, Sir William, 23
Johnston, Thomas, 14
JOHN WILKES, Esq., 60, *61*
Jones, Hugh, 114
Jong, D. de, 36
Jukes, Francis, 35

Kellogg, D. W. and Co., 167, 170
King George's War, 179
King Philip's War, 14
King's Arms Tavern, 2
Kittredge, George, 56

Kneass, William, 146
Krebs, Friedrich, 168–169, 170

Ladies Diary: or, the Woman's ALMANACK, 58, *59*
Ladies Lamentation for ye Loss of Senesino, 112
Ladies Magazine, 84
Lafayette, Marie Joseph Paul Yves Roch Gilbert du Motier, Marquis de, 134, *135*, 140, 141
Lane, Michael, 24
La Rochelle, Fr., 47–48, *49*
Laurie and Whittle, 159, 160, 161, 162–163, 170
Lawson, Alexander, 32
Le Bas, Jacques Philippe, 36, 39, 40, 41, 46, 47
Le Clerc, David, 152, 154, 162, 170
Le Clerc, Sebastien, II, 152, 154, 162, 170
Lee, Charles, *27*, 191
Letting Hands go, 115
Leveridge, Richard, 109
Lewis, Benjamin, 76, 77
"Liberty," 104–105
"Liberty Tree," 187
LIBERTY TRIUMPHANT; or the Downfall of OPPRESSION, 184, *185*
Library Company of Philadelphia, 72, 150–151, 164, 175–176
Lilly, William, 58, *59*
Linnaeus, Carl, 90
Locke, John, 60
Lockit, Lucy, 114
London, 116–117, 119; images of colonial America in, 11–31; maps and views of, 16; printmakers in, 11, 12, 13, 14, 15, 18
London Magazine, 33, 72, 74, 115, 184
LOSS of EDEN,!—AND EDEN,! LOST, 29, *30*
Louis XV, 36, *37*, 49
Louisbourg, N. S., 180, 187
Louvre, 48, 50
Love in a Village, or The Charms of Simplicity, 84, *85*
Low, Nathaniel, *63*
Lownes, Caleb, 77

McAdam, Joseph, 177, 181
McAdam family, 177
Macaulay, Catharine, 60

Macheath, 114
McHenry, James, 59
Madrague, Golfe de Bandol, 41, 42
Magazines: in America, 71–97; in
 England, 72, 74, 76, 77, 78, 80,
 84, 93, 94
Magna Britannia, 183–184
Man of signs. *See* anatomy
*Map of Pensilvania, New-Jersey,
 New-York* . . . , 13, 14
*Map of South Carolina and a Part
 of Georgia containing the whole
 Sea-Coast*, 25
*Map of the British Empire in Amer-
 ica with the French and Spanish
 Settlements adjacent thereto*, 18
*MAP of the most INHABITED part
 of NEW ENGLAND*, 18, 19
Marigny, Abel François Poisson,
 Marquis de, 36–37, 41, 42, 43,
 44–45, 46, 49
Mariners Museum, 33, 35, 38, 40
MARQUIS DE LA FAYETTE, 135
Marriage A-La-Mode, 5, 6, 7, 8, 9,
 10
Marseilles, Fr., 37, 38, 39, 41, 45
Marshall, I., 154
Marshall, John, 156, 170
Marshall, William, 58
Maryland, 15, 127
Mason, Charles, 15
*Massachusetts, Connecticut, Rhode
 Island, New Hampshire and Ver-
 mont Almanack*, 65
Massachusetts Calendar, 52, 62
Massachusetts Magazine, 72, 75,
 81, 84, 85, 86, 89, 111–112
Mather, Cotton, 52
Merlini Anglici Ephemeris, 58
Middle colonies, 14, 18
Middlesex Co., Eng., 117–118
Middleton, Charles, 33
Midnight Modern Conversation, 7,
 9, 111
Millar, George, 33
Mitchell, John, 1
Mittendorf Collection, 175
Modern Musick-Master, 107–108
Modern Universal British Traveller,
 33
Moll, Hermann, 13
Montresor, John, 25
*Monumental Inscription on the
 Fifth of March*, 62

Moore, Francis, 64
MOOSE DEER, 86, 88
Mortimer, John Hamilton, 13
Mott, Frank Luther, 74, 75
Mount, William, 13
Musée de la Marine, 50
Music: in England, 106, 107, 108,
 109, 111, 112–113, 114, 115; in
 Philadelphia, 148–149
Musical Entertainer, 98–122

National Collection of Fine Arts,
 138
*Natural History of Carolina, Flor-
 ida, and the Bahama Islands*, 21
*Natural History of the Rarer Lepi-
 dopterous Insects of Georgia* . . . ,
 21
Nautical prints, 32–50
Necker, Jacques, 89–90
Netherlands, 12, 36, 192, 193
*Neu-Eingerichteter Americanischer
 Geschichts-Calender*, 56–57
New American Company, 149
*New and Complete System of Geog-
 raphy*, 33
*New and Universal System of Ge-
 ography*, 33
Newbery, John, 51
Newcastle, Duke of. *See* Pelham-
 Holles, Thomas
New England, 14, 18, 19
Newfoundland, 119
*New invented Machine for the
 Spinning of Wool or Cotton*, 82,
 83
New Jersey, 13
New Machine to Go without Horses,
 89
*New Method of MACARONY MAK-
 ING, as practised at BOSTON*,
 185, 186, 187
*New Spelling Alphabet for the In-
 struction of Children*, 146
New York, N. Y., 21, 187; maps and
 views of, 13, 15, 18, 23, 26, 35,
 89, 90
*New York from Hobuck Ferry
 House*, 35
New-York Historical Society, 138
New York Magazine, 72, 78, 84, 86,
 89, 93
New York Public Library, 137, 140,
 177, 178

Noddle-Island Or How Are We De-cieved, 29
Norman, John, 12
North, Lord Frederick, 184
North America, 1, 35; survey of coasts of, 24–25
North View of Fort Johnson, 23

Ogle, Cuthbert, 114
O'Keefe, John, 148
Okey, Samuel, 12
Oliver, Andrew, 52
Otis, James, 60
Overton, Henry, 13
Oxford Magazine, 33
Ozanne, Nicholas, 36

Page, Thomas, 13
Page, Thomas Hyde, 25
Palliser, Sir Hugh, 24
Pamela, 115
Paoli, Pasquale de, 60
Papacin, P., 160
PARABLE of the PRODIGAL SON, 156, *157*
Parker, George, 58
Parker, Henry, 13, 152
Parker, Peter J., 71–97
Parker and Sayer, 170
Parrot of Paradise and *Red Wood*, *22*
Passaic Falls, N. J., 92
Patriotick Barber of New York, 187
Peaceful Life, 108
Peachum, Polly, 114
Peale, Charles Willson, 123–143, 161
Peale Family, *126*
Peel, Sir Robert, 178
Peel Collection, 177, 178
Peep show prints. See vues d'optique
Pelham, Henry, 14
Pelham, Peter, 12
Pelham-Holles, Thomas, 1st Duke of Newcastle, 18
Pennsylvania, 13, 15, 84
Pennsylvania Academy of Fine Arts, 133–134
Pennsylvania Gazette, 73, 133, 139
Pennsylvania Herald, 75
Pennsylvania Historical Society. See Historical Society of Pennsylvania
Pennsylvania Magazine, or Ameri-can Monthly Museum, 72, 73, 74, 75, 78, *79*, 81–82, 83, 84
Pennsylvania Packet, 130, 136, 140, 149
Pepusch, John, 113
PERSPECTIVE VIEW of the FED-ERAL EDIFICE in the CITY of NEW YORK, 89, *90*
Peter the Great, 90
Philadelphia, Pa., 128; almanacs in, 63; maps and views of, 13, 15, 16, 33, 35, 84; musical theater in, 148–149
Philadelphia Gazette, 149
Picart, Barnard, 105
Pierpont Morgan Library, 177–178
Pilmore, Rev. Joseph, 134, *136*, *137*, 138
Piranesi, Giambattista, 23
Pitt, William, 1st Earl of Chatham, 60, 125, 126, *127*, 128
A Plan of Mr. Fitch's Steamboat, 89
A PLAN of the CITY of NEW-YORK & its Environs, *26*
Playford, Henry, 106, 107
Playford, John, 106, 107, 115
Plen, B., 160
Pleyel, Ignay, 149
Political Cartoon, for the Year 1775, 188, *189*
Political Lesson, 185
Pollard, Robert, 77
Pompadour, Jeanne Antoinette Poisson, Marquise de, 36
Poor old England endeavoring to reclaim his wicked American Children, 189–190
Poor Richard improved, 56, *57*
Poor Richard's Almanack, 53, 56, *57*, 102
Poor Robin's Almanack, *55*, 56
Poor Will's Almanack, 56
Pope, Alexander, 105
Popple, Henry, 13, 18
Porpora, Niccolo, 112
Port de La Rochelle, 47–48, *49*
Port de Marseille, 38, *39*
Port neuf, ou l'Arsenal de Toulon, *42*, 43
Port vieux de Toulon, *43*
Portraits: in almanacs, 58, 59, 60, 61, 62; engraved by Peale, 123–143; in magazines, 80, 89–90, 91
Port Royal, Jam., 18
Ports: views of, 32–50

Portsmouth, Eng., 33
Ports of France, 36, 39, 40, 48, 49
Poupard, James, 77
Pownall, Thomas, 14, 21, 23, 24
Prelleur, Peter, 107
"President's March," 149, 150
Preston and Son, 149
Priest, William ("W. P."), 146, 148, 149, 150, 162
Printing Office, 2
Prints: barber shop, 2, *3*; billiards, 2, *3*, 5; of caesars, *2*; nautical, 32–*50*; peep show, *20*, 33–34, 35; tavern, 2, *4*; at Williamsburg, 1–10, 175–196
Prodigal Son, 145–174
Prodigal Son (He receives his Patrimony), 146, *148*
PRODIGAL SON in Misery, 159, *161*
PRODIGAL SON RECEIVES HIS PATRIMONY, 152, *153*, 162, *163*, *164*
PRODIGAL SON RECEIVING HIS PATRIMONY, 168, *169*
PRODIGAL SON returned to HIS FATHER, *166*
PRODIGAL SON revelling with Harlots, 159, *160*
PRODIGAL SON TAKING LEAVE, 154, *155*, *158*, 159, 164, *165*
Prospective Plan of the Battle fought near Lake George, 14
Prospect of the new Lutheran Church, 146, 148
Public Advertiser, 65
Purcell, Henry, 106
Purcell, Richard, 152, 154
Puritan theology, 54

Quebec, Que., 18, 29
Quincy, Eliza Susan, 18

Rake's Progress, 2, 151
Raleigh Tavern, 2, 5
Ramsay, Dr. David, 133
Razor's Levee, or ye Heads of a new Wig Ad———n on a broad Bottom, 2, *3*, 5
RECONCILIATION between BRITANIA and her daughter AMERICA, 194, *195*
Recueil de Petites Marines, 36
Redgrave, Samuel, 99

Reiche, Frederick, 148
Releif or; Pow'r of Drinking, 110
Remick, Christian, 80
Repeal, or the Funeral of Miss Ame-Stamp, 183
Return from the Chace, 109, *110*
Returns home a Penit[ent], *146*, *147*
Revere, Paul, 12, 14, 51, 52, 62, 77, 78, 80, 86, 90–91, 185
REVEREND JOSEPH PILMORE, *136*, *137*
Revolution, American, 24, 25, 27, 29, 30, 60, 61–62, 81; political satires on, 178–194
Reynolds, Sir Joshua, 128
Richardson, Edgar P., 134
Richardson, Samuel, 115
Rinaldo, 107
Rivington, James, 68
Roberts, Bishop, 15
Robertson, Archibald, 35
Robinson, H. R., 168
Rochefort, Fr., 48
Roman emperor prints, 2
Romans, Bernard, 2
Rome, It., 23
Rose Tavern, 2
Rowlandson, Thomas, 13, 29
Royal American Magazine, 51, 72, 74, 75, 80, 81, 84, 185
Royal Hunt, or a Prospect of the Year 1782, 193–194
RURAL BEAUTY, or VAUX-HAL GARDEN, 112, *113*

Sachem of the Abenakee Nation, rescuing an English Officer from Indians, 69
Saint John's, Nfld., 18
Sallieth, Mathias de, 36
Sandby, Paul, 21
Satires, political, 62–65, 175–196
Saunders's Almanack, *55*
Savage, Edward, 32, 52, *71*
Savannah, Ga., 35
Sayer, Robert, 152, 170
Sayer and Bennett, 187
Scenographia Americana, 21, 23, 92
Schenk, Pieter, 36
Scoles, John, 93
Scull, Nicholas, 35
Seabury, Bishop Samuel, 134
Seasons, 160

Seat of his Excellency the Vice President, 86
Seat of John Hancock, 86
Seddon, Thomas, 73
Seider, Christopher, 62
Sellers, Charles Coleman, 134
Senesino, Francesco Bernardi, 112
Sète. *See* Cette
Seven Years' War, 48, 49
Sewell, Dr. Joseph, 52
Shadwell, Wendy J., 123–144, 175
Shakespeare, William, 115, 190
Shelton and Kinsett, 166
Short Description of the American Colonies, 118, 119
Sidney, Algernon, 60–61, 128
Simitière, Pierre Eugène du, 78, 81, 129
Simon, John, 119
Sir Wilbraham Wentworth, 80, 81
Skerrett, Moll, 114
[*Slowtime*], 4
Smith, James Edward, 21
Smither, James, 12, 15, 84
Sniffen, Harold W., 32–50
SOCIETY of PATRIOTIC LADIES, at EDENTON, in NORTH CAROLINA, 187, 188
Sommer, Frank H., III, 125
Songs in the Opera of Flora, 114
Sons of Liberty, 183
South Carolina, 25
South Wales, 118
South West View of the City of New York, in NORTH AMERICA, 23
Spain, 181, 183, 192, 193
Sports: in England, 109
Spotswood, William, 73
Stamp Act, 62, 183
Statue, or the Adoration of the Wise-Men of the West, 183
Stauffer, David N., 77
Stephens, Frederick George, 179
Steuben, Baron von, 191
Stokes, I. N. Phelps, 15
Storer, Ebenezer, 18
Strutt, Joseph, 40
Stuart, John, 3rd Earl of Bute, 65, 183

Table Mountain, Cape of Good Hope, 33
Takes Leave of his Father, 146, 147
Tallis, Thomas, 106
Tanner, Benjamin, 77

Taste a Dialogue, 112
Tavern prints, 2, 4
Taylor, Raynor, 149–150
Telemachus His Description of the City of Tyre, 117
Thackara, James, 133
Thiervoz, Gen., 44, 46, 47
Thomas, Isaiah, 51, 52, 57–58, 62, 65, 74, 75
Three Cherokees, 119
Three-Penny Opera, 114
Tiebout, Cornelius, 77, 86, 89
Titmouse, 89
Tom Jones, 115, 153
Topographical Description . . . of the Middle British Colonies, 14
Tory turned Rope-Dancer, 63
Toulon, Fr., 42, 43, 44
Town and Country Magazine, 72
Townshend, George, 65
Trenchard, James, 73, 84, 85, 133
Tristram Shandy, 7
"Trumpet Song," 149
Tully, Christopher, 82
Turner, Charles, 13
Twelve Remarkable Views of North America, 35

Universal Magazine, 72, 86, 89, 90
Universal Penman, 98–122
"Upon Tyburn Tree," 114

Vallance, John, 85
Vandières, Marquis de. *See* Marquis de Marigny
Vauxhall Gardens, 112
Veiw of a pass over the South Mountain from York Town to Carlisle, 92, 93
Verelst, William, 119
Vernet, Claude Joseph, 36–50
Vernet, Virginia Parker, 36, 37, 49
VIEW IN AMERICA IN 1778, 191
View in Hudson's River of Pakepsey & the Catts-Kill Mountains, 22
View of CHARLES TOWN the Capital of South Carolina in North America, 35
View of the CASCADE, of Velika Gubaviza, 91, 92
View of the SEAT of his Excellency JOHN HANCOCK, Esqr. BOSTON, 86, 87
View of the Town of Boston, 80

Views of Ports and Harbours of the Netherlands, 36
Views of Ports, Harbours, Docks, and River Scenery of Great Britain, 33
Virginia, 1
Virginia Gazette, 114
Vue de la rade d'Antibes, 40
Vue de la Ville et du Port de Bayonne, 46, 47, 48
Vue du Port de Cette, 44, 45
Vue du Port de Marseille, 37, 38
Vues d'optique, 20, 33–34, 35

Walker, W. B., 165, 168, 170
Wallace, David, 77
Waller, Edmund, 105
Walpole, Horace, 18, 29, 177
Walpole, Sir Robert, 114
Walsh, John, 106, 107
Washington, George, 27, 70, 89; Peale's portrait engravings of, 128, 129, 130, 131, 132, 133, 138, 139, 140, 141
Washington, Martha, 130
Washington family, 52
Weatherwise, Abraham, 63
Weatherwise's Town and Country Almanack, 53, 63, 66–67
Webber, John, 33
Webster, Noah, 74
Wentworth, Sir Wilbraham, 80, 81
West, Benjamin, 123, 124, 125, 141

Westminster Magazine, 72, 74, 84, 90, 188
Westmoreland Co., Va., 126
Wharton, George, 58
What may be doing Abroad, What is Doing at Home, 184
White, John, 119
Whitefield, Rev. George, 183
Whittemore, Nathaniel, 58
Wicked Statesman, or the Traitor to his Country, at the Hour of Deat[h], 62, 63
Wignell and Reinagle, 148, 149
Wig Shop, 2
Wilkes, John, 60, 61
Williamsburg, Va., 187; 18th-century prints at, 1–10; political satires at, 175–196
Willis, Mr., 128
Willson, Mary Ann, 161, 162, 170
Wilmington, Earl of. *See* Compton, Spencer
Wilton, Joseph, 125, 126
Winkelbauer, Stefanie Munsing, 71–97
Wolf, Edwin, 2nd, 145–174, 183
Wonderful MAN FISH, 66, 67
Worthy of Liberty, Mr. Pitt scorns to invade the Liberties of other People, 126, 127, 128

Yorktown, Va., 39, 192, 193
Young Clerk's Assistant, 105